CITY HARVEST

100 RECIPES FROM GREAT NEW YORK RESTAURANTS

FLORENCE FABRICANT

FOREWORD BY **ERIC RIPERT**

PHOTOGRAPHS BY **NOAH FECKS**

CITY HARVEST
RESCUING FOOD FOR NEW YORK'S HUNGRY

RIZZOLI
NEW YORK

New York Paris London Milan

CONTENTS

7 A Note from City Harvest

8 Foreword by Eric Ripert

10 Introduction by Florence Fabricant

12 Recipe Index

14 **APPETIZERS**

42 **SALADS**

64 **SOUPS**

78 **PASTA AND GRAINS**

100 **FISH AND SEAFOOD**

118 **POULTRY**

132 **MEAT**

152 **SIDES**

168 **DESSERTS**

194 **COCKTAILS**

209 Index of Restaurants by Neighborhood

210 Restaurant Guide

215 Acknowledgments

216 Conversion Chart

 Index

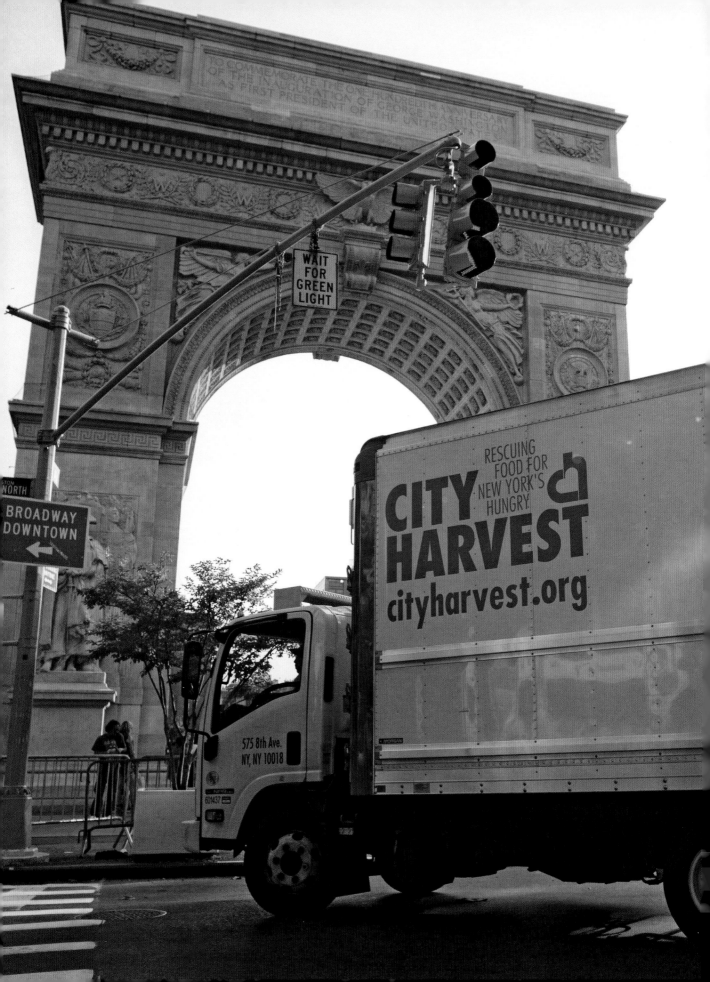

A NOTE FROM CITY HARVEST

In 1982, the seeds of City Harvest were planted when one of its founders asked a restaurant to donate cooked potatoes to the soup kitchen where she volunteered. That thirty-gallon donation, originally slated to go to waste, led to the creation of the world's first food rescue organization.

The restaurant community recognized the simple logic of donating excess food for hungry New Yorkers and continues to support City Harvest in many ways by opening their hearts and their kitchens to nourish our work. We enjoy relationships with each of the chefs in this cookbook, and we hope that their recipes will fill your days with delicious meals.

City Harvest is dedicated to helping feed the more than 1.4 million residents who are struggling with hunger in New York City. We collect surplus food from restaurants, grocers, bakeries, manufacturers, farms, and Greenmarkets and deliver it free of charge to several hundred soup kitchens and food pantries across the five boroughs.

Since its inception, City Harvest has rescued over five hundred million pounds of food. We place a high priority on delivering fresh produce and nutrient-dense items. In addition to helping meet the immediate need, City Harvest takes a long-term approach to fighting hunger through our *Healthy Neighborhoods* programs. These programs increase the availability of produce in low-income communities and help make the healthy meal choice an easier one for residents. As part of this initiative, New York City chefs conduct cooking demonstrations at our Mobile Market distributions of free, fresh fruits and vegetables. They also participate in nutrition education classes for teens, families, and seniors.

City Harvest is the largest private hunger relief organization in New York City, and we are proud to count among our supporters the men and women in the restaurant community. Florence Fabricant has compiled their recipes with recommendations on how to best enjoy these dishes beyond one meal. This thoughtful approach to food mirrors City Harvest's philosophy. Each day we strive to maximize our city's food resources and ensure that we deliver excess food to New Yorkers who struggle to fill their plates.

City Harvest connects good food from Grand Central to after-school programs on the Grand Concourse, from Brooklyn Heights to families in Jackson Heights, and from Union Square to seniors near Tompkins Square—today and every day for as long as it's needed. The purchase of this cookbook helps fill our trucks with good food and keep them on the road seven days a week. Thank you for joining with us.

—**JILLY STEPHENS, EXECUTIVE DIRECTOR, CITY HARVEST**

FOREWORD

ERIC RIPERT

The recipes listed in this book are the collected works of my friends and fellow chefs—all of whom are not only amazing cooks but also generous City Harvest supporters. To that end, I hope that each dish brings joy into your kitchen, but the heart of this book goes much deeper than that, as a portion of the proceeds will directly benefit essential City Harvest programs and initiatives. From the detailed planning that goes into retrieving the city's excess food, to matching and delivering that rescued food with soup kitchens, food pantries, and community food programs, to eventually, and most importantly, getting it into the hands of New Yorkers who need it most, there is a lot of work to do, and every new supporter helps!

Every day I walk through New York City from my home to my restaurant, Le Bernardin. In this short walk I am always amazed by the sheer diversity and scope of people and experiences you are exposed to by walking down any given street. However, for everything that is wonderful about this city, nearly one in five people are struggling for the very basic human necessity that is a good, nutritious meal. In a city like New York, this is unacceptable; and for those hungry in New York, City Harvest is nothing short of a miracle.

I am passionate about this book and this organization for so many reasons. I was inspired to get involved at City Harvest almost twenty years ago, eventually becoming Chair of the organization's Food Council for sixteen of those years. As a chef, I identify with their mission deeply, and truly believe that there is nothing more important than a needed meal. As a chef, I was also exposed to how much wasted food there can be in restaurants, and Le Bernardin was no exception. City Harvest constructed a bridge over this divide. As the first—and still the only—food rescue organization in New York City, they take good, fresh food which would otherwise go to waste, and provide free, healthy meals to residents in need. In addition to food rescue, City Harvest extends its presence in all five boroughs through *Healthy Neighborhoods* programs, including Mobile Market distributions of fresh produce, nutrition education courses, and budget shopping tours. All these programs are designed to benefit the more than 1.4 million people who go hungry in New York City every year and provide long-term solutions to fighting hunger.

I have had the lucky opportunity to get to know the amazing City Harvest team who turns these astounding numbers into a reality. From Executive Director Jilly Stephens to Donte Moore, who rescues the food from the Le Bernardin kitchen each day, to the City Harvest Food Council, chaired by Geoffrey Zakarian and made up of sixty dedicated food industry professionals, who help donate food in addition to raising awareness and funds. I am continually astounded by the organization's compassion and unwavering dedication to

realizing its goals. The office is always in motion. The trucks are literally always on the go, making sure their deliveries reach over five hundred community food programs on time. It's admirable and inspiring—terms that I have come to realize define the people behind the organization very well.

It is important to remember that we are all neighbors, made up of one community, and because of this we need to lend a helping hand and heart wherever we can. The outpouring of sensitivity and kindness that City Harvest receives on a daily basis—from food donors, volunteers, board members, individuals and businesses that support the work, and more—plays a large role in their success, and shows how important their work is to the city.

Here, we share our recipes and experiences with you, who in turn are providing something special as well: your support for City Harvest and dedication to the New York community. I hope your support doesn't stop here.

INTRODUCTION

In 1983 I was at a formal dinner in Paris, seated next to a French museum official. We got to talking about funding for cultural institutions. My dining companion was pretty smug about how government support plays the major role in France, and indeed, in most of Europe, while in America, budget gaps are often filled by private and corporate sources. American orchestras and museums frequently have to scramble to make ends meet.

I was envious of the French system, though I pointed out that there are some non-profit initiatives that go beyond the scope of government. America has a long history of private donors helping those most in need.

City Harvest, a grassroots organization that collects excess food from caterers, restaurants, bakeries, television and movie sets, and other sources and donates it to soup kitchens instead of letting it be discarded, had recently been started. It was just one example. I described it to Monsieur Musée, who was flabbergasted that private citizens would undertake such a project. He thought it was extremely clever but doubted it would work in Paris.

City Harvest is one of those brilliant concepts that was staring all of us in the face. Some smart neighbors seized the opportunity. And it took off. The result is that now, more than thirty years later, the organization collects nearly 150,000 pounds of food daily and distributes it to a network of 500 community organizations, helping feed the more than 1.4 million food-insecure men, women, and children each year.

As a regular supporter of City Harvest, I was pleased and flattered to be given the opportunity to assemble and write the group's first cookbook. I worked with the City Harvest team to solicit recipes from a long list of restaurants, caterers, and food producers that regularly donate to City Harvest, asking each to propose two dishes for the book. I edited that original list down to about 125 recipes that seemed appropriate, sorting them into categories like soups, poultry dishes, and so forth. That was the easy part.

Then the actual recipes that we requested began rolling in. The majority of them were approachable and seemed adaptable for home kitchens. There were some that sounded delicious but which I rejected because they called for equipment like immersion blenders, sous-vide machines, and paint guns; required exotic ingredients like "silver-strength gelatin sheets," truffle peelings, and Japanese long yams; or needed five or six separate recipes before the final dish could be consolidated.

As I tested the recipes I did a little fancy footwork with a number of them, omitting extra garnishes like the deep-fried Vidalia onions to top Marc Forgione's clever baked latkes, the strawberry confit and guanciale to finish Daniel Humm's surprising strawberry gazpacho,

gooseberries in Daniel Boulud's velvety squash soup, and the pea puree and tempura maple leaves that decorated Anita Lo's rich calves liver and bacon. I simplified the mosaic of vegetables meant to top Jean-Georges Vongerichten's codfish.

But I also discovered that Harold Moore's complex recipe for coconut cake was worth the effort and that Dominique Ansel's warm pistachio moelleux proved that this pastry chef is capable of much more than the iconic Cronut, the croissant-doughnut that made him famous.

A number of recipes and techniques have already become part of my personal repertory. Adding some mascarpone to a risotto, as Markus Glocker of Bâtard has done, guarantees creaminess; just warming heirloom tomatoes and adding some sweet vermouth, as in Ryan Hardy's late summer soup, are surprising touches; mixing uni and butter to dress pasta, as Saul Bolton suggests, smooths the uni; and stewing wild striped bass with potatoes, tomatoes, and fennel according to Ben Pollinger proves that every fish casserole does not have to be bouillabaisse.

Some recipes needed drastic cutting. Just one eggplant, not four, and reducing the rest of the ingredients accordingly, yielded more than enough of Moscow 57's eggplant dip. Similarly, I made Michael White's mushroom soup recipe, which called for two cases of mushrooms and eight quarts of liquid, with a pound of mushrooms and a little more than a quart of liquid because no one needs a lifetime supply of this soup regardless how delectable. I also cut the amount of dressing required for many of the salads and other dishes so home cooks would not be left with a bucket of unused sauce.

The number of servings varies from dish to dish; I did not standardize them for the book. But just as I have often trimmed recipes, cooks should feel free to increase the amounts to serve more people if desired. It will work with a majority of the recipes.

Occasionally I upgraded the ingredients. I found that many of the chefs used canola oil, a cheaper option, where I would prefer neutral grapeseed or extra virgin olive oil. Though I did not make revisions that I felt might compromise the recipe in a number of instances, I reviewed changes like these with the chefs, for their approval. As a home cook, you too should feel comfortable making substitutions that do not derail a recipe. Ground beef, veal, or even turkey in place of pork would work in Andrew Feinberg's pasta dish. If Eric Ripert's halibut tempts you but your fish market has none on hand, consider other fish steaks or thick fillets like wild striped bass or cod.

I also organized many of the recipes so they could be served family style, on a platter, instead of requiring individual plating in the kitchen. It's the way I usually serve at home and much more convenient in a non-professional setting. But certain aspects of restaurant service, like using warm plates and wiping the rim of the dish so there are no drips, should also prevail at home. I did not specify these touches; they go without saying.

For each recipe I have included some background on the restaurant and the recipe, and have also added tips and hints, shopping advice, and the proper tending of ingredients. Also, the recipes all come with a "Second Helping," often a creative way to use any leftovers. I felt this angle was especially appropriate for a cookbook that celebrates City Harvest, an organization that is all about rescuing good food and wasting nothing.

RECIPE INDEX

APPETIZERS

Chipotle Grilled Shrimp with Tomatillo,
 Roasted Corn, and Feta Salsa 28
Forager's Treasure of Wild Mushrooms 34
Guacamole 16
Kimchi Deviled Eggs 20
Marinated Hamachi with Harissa and Uni 23
Roasted Hen-of-the-Woods Mushrooms 37
Russian Eggplant 19
Shrimp Ceviche 25
Squid Stuffed with Pork in Lime Broth 30
Stuffed Dates Wrapped in Bacon 33
Tarte Menton 38
Tuna Tartare 26
Twice-Baked Upside-Down Comté Cheese
 Soufflés 40

SALADS

Artichoke Salad with Shaved Parmesan 44
Asian Slaw 46
Asparagus and Prosciutto Salad with
 Baked Eggs 52
Brussels Sprout Salad 55
Cabbage Salad 107
Grilled Endive Salad with Citrus Dressing 49
Migliorelli Farms Snap Pea Salad 49
Quinoa Salad 58
Roasted Beet Salad with Beet Vinaigrette 60
Sushi Bar Wedge Salad 50
Warm Mushroom Salad with Apples
 and Celery 63

SOUPS

Cauliflower Soup with Capers and
 Black Olives 70
Crab Soup Serena 76
Cold Corn Soup 66
Fall Squash Soup 72
Lentil Soup with Pancetta 74
Mushroom Bouche 75
Strawberry Gazpacho 67
Warm Tomato Soup 69

PASTA AND GRAINS

Beet and Goat Cheese Risotto 93
Broccolini Fettuccine 80
Bucatini Ricci di Mare 82
Cheddar and Black Pepper Buns 139
Classic Macaroni and Cheese 84
Fideos with Mussels, Chorizo,
 and Almonds 81
Fusilli with Sausage, Cannellini Beans,
 and Chilis 86
Grain Risotto with Corn Puree and
 Grilled Corn 96
Linguine with Clams 88
"Pawlie" Grilled Cheese and
 Pickle Sandwich 99
Parmesan Risotto 94
Pizza Dough 39
Spaghetti with Butter and Anchovies 91

FISH AND SEAFOOD

Afro-Asian Salmon with Lentil Salad and
Ginger-Soy Dressing 102

Codfish with Vegetable Marinère and
Aromatic Sauce 104

Ed's Lobster Roll 117

Fish Alla Talla with Cabbage Salad 106

Poached Halibut in Warm Herb
Vinaigrette 109

Poached Wild Striped Bass with Tomatoes,
Potatoes, and Bacon 110

Rosemary-Bacon Mussels 113

Seafood in Bouillabaisse 114

Seafood Gumbo 115

POULTRY

Chermoula-Rubbed Chicken with Couscous
Salad 120

Chicken Paillard 122

Homeschooled BBQ Chicken Wings with
Korean Glaze 126

Magret à la D'Artagnan 128

Squab with French Lentils and Cabbage 131

Whole Roasted Chicken with Fennel,
Potatoes, and Olives 125

MEAT

Barbecued Baby Back Ribs with
Asian Glaze 148

Big Marc Burgers 138

Calves' Liver with Bacon, Peas, and Maple 150

Ethiopian-Style Beef Stir-Fry 134

Frankie's Meatballs 140

Paella with Lamb 142

Pork Loin Roast with Apple-Cranberry Sauce
147

Seared Rack of Lamb with Pistachio
Tapenade 146

Skirt Steak Tortilla with Chimichurri Sauce 137

Spiced Lamb Skewers 145

SIDES

Broccoli and Cauliflower Goma-Ae 154

Cinnamon-Scented Tomato-Braised
Cauliflower 157

Latkes with Apple Puree and Sour Cream 162

Purple Potato Gratin 165

Smashed Potatoes with Rosemary
Vinaigrette 166

Spice-Roasted Carrots Marrakech Style 158

Whole Roasted Radishes with Anchovy
Butter 161

DESSERTS

Blackberry Crema Ice Cream 188

Citrus Cake 178

Chocolate Chili Ice Cream 191

Classic Apple Pie with Cheddar Lattice
Crust 182

Coconut Cake 174

Earl Grey Crème Brûlée 185

Panna Cotta with Blood Oranges 186

Peanut Financier 177

Pickled Strawberry Jam 192

Pineapple Carpaccio with Coconut Gratiné
and Lime 172

Red Wine–Poached Figs with Black
Pepper 170

Thai Fighter Ice Cream Sandwiches 190

Traditional French Madeleines 179

Warm Pistachio Moelleux 180

COCKTAILS

Forest Fix 198

Gold Rush Cocktail 201

Gurke (Cucumber Cocktail) 205

Harry Lime 202

Quebec Goes to Paris 206

Thai Basil Cocktail 197

APPETIZERS

GUACAMOLE

The reputation for guacamole that this restaurant chain treasures is the result of a finely tuned recipe prepared tableside. Echoing that procedure, it pays to make your guacamole at the last minute, if possible. Do you need to be reminded as to how versatile guacamole is? Use the buttery mixture in a taco or a sandwich, alongside grilled fish, and, as trend spotters know, spread on toast with a judicious sprinkle of crushed dried chili on top.

4 TO 6 SERVINGS

2 tablespoons chopped cilantro leaves

2 teaspoons minced onion

2 teaspoons seeded, minced jalapeño or serrano chili

Kosher salt

2 ripe Hass avocados, peeled and pitted

2 tablespoons cored, seeded, and finely chopped plum tomatoes

1 tablespoon lime juice

In a medium-size bowl, use the back of a spoon or a drink muddler to mash together half of the cilantro, onion, and chili with ½ teaspoon salt. Add the avocados and gently mash them into the bowl. The texture should be chunky. Fold in the remaining cilantro, onion, and chili. Fold in the tomatoes and lime juice, adjust the seasonings, and serve.

COOK'S NOTES In this recipe for guacamole, it's the avocado that shines. Other ingredients are used sparingly. The original recipe also calls for a trifle less lime juice; since the guacamole is prepared tableside in the restaurant, having the avocado discolor is not an issue. But for a home cook, who might be making it an hour or so in advance, a little more lime juice will help. Cover the guacamole with a film of plastic wrap placed directly on the surface.

SECOND HELPINGS
Any extra guacamole can be spread on a sandwich, spooned onto a baked potato, and even used on fresh corn on the cob instead of butter.

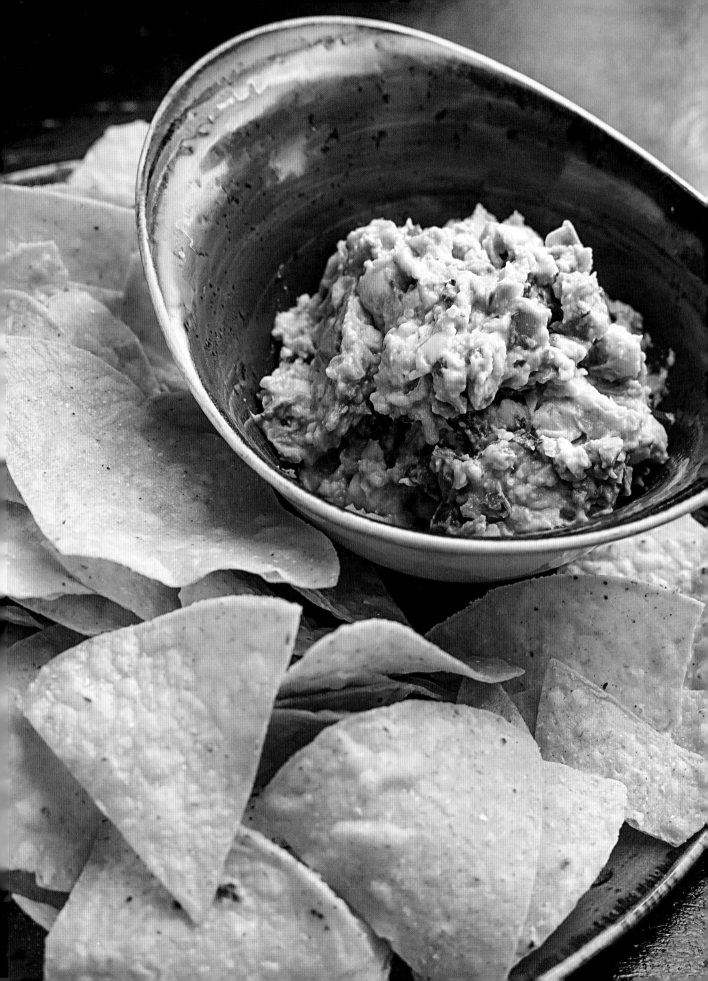

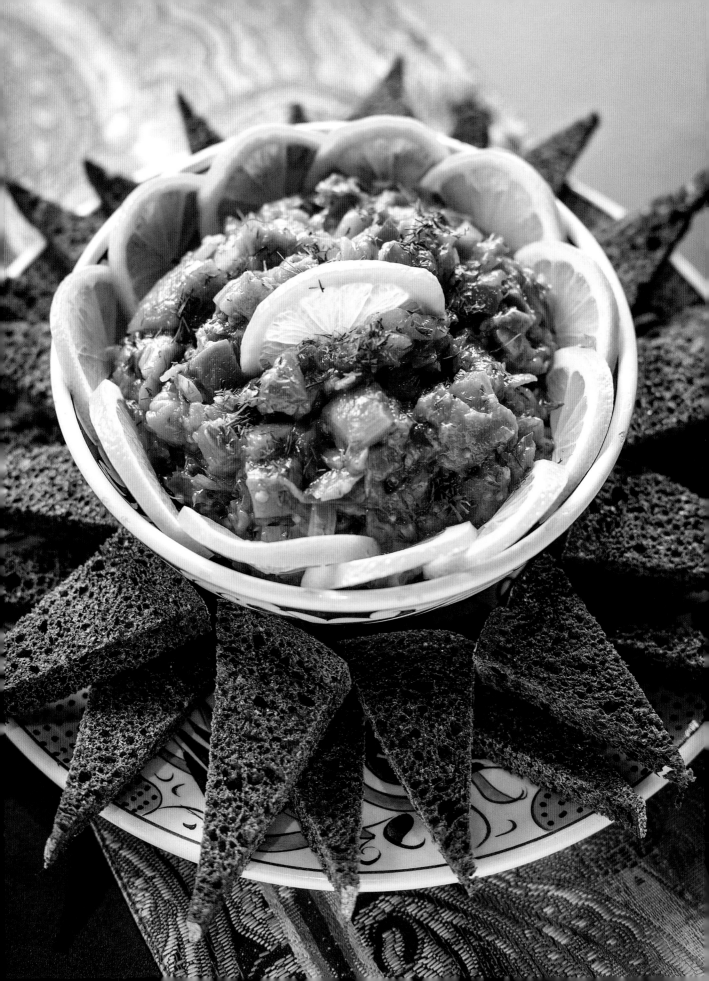

RUSSIAN EGGPLANT

This restaurant, in the shadow of the Williamsburg Bridge, is the rightful heir to the original Russian Tea Room on Fifty-seventh Street. Ellen Kaye's parents owned the restaurant, so she grew up there. Now she has her own little spot, not a copy of her parents' venue but a combination restaurant-cabaret, with some of the real Russian food that was washed down with vodka at the Tea Room. Her eggplant dip—or is it a salad?—is one of those classics on the restaurant's menu. It is rich and well seasoned without masking the distinctive allure of the eggplant.

1 medium-size eggplant

4 tablespoons extra virgin olive oil

½ cup finely chopped onion

½ cup finely chopped red bell pepper

1 clove garlic, minced

1 cup crushed canned tomatoes

1 tablespoon tomato paste

¼ teaspoon dried oregano

¼ cup minced flat-leaf parsley

2 tablespoons minced fresh dill

1 teaspoon minced basil leaves

¼ teaspoon ground coriander

Salt and freshly ground black pepper

1 teaspoon lemon juice

½ teaspoon Tabasco, or to taste

Black bread for serving

Trim the eggplant, peel it with a vegetable peeler, and cut it into a 1-inch dice. Heat 2 tablespoons of the oil in a sauté pan, add the eggplant, and cook on medium low, stirring, until the eggplant is tender, lightly browned, and glistening, about 20 minutes.

While the eggplant cooks, heat the remaining oil in a small skillet and cook the onion, bell pepper, and garlic on low until they are tender but not brown, 5 to 7 minutes.

When the eggplant is tender, add the onion mixture to it, along with the tomatoes, tomato paste, oregano, parsley, dill, basil, and coriander. Cook on low for 10 minutes. Season with salt and pepper, add the lemon juice and Tabasco, and transfer the mixture to a bowl. Cover and chill until it is quite cold, 3 to 4 hours.

Check the seasonings and serve with black bread.

COOK'S NOTES The eggplant undergoes a transformation in the pan. First, it sops up the oil and looks very dry, but as it slowly cooks, it shrinks and begins to release some of the oil, casting an alluring sheen.

SECOND HELPINGS
If you peel the eggplant in nice inch-wide strips, then cut the strips of peel into 3-inch lengths, you can fry them in olive oil, flesh-side down, until they are crisp. They will puff a bit. Drain them on paper towels, dust them with salt, and you have a snack to go along with the dish, or a topping for a pasta recipe.

KIMCHI DEVILED EGGS

The Momofuku group is multifaceted, informal, and trendsetting. *Momofuku* means "peach," the logo that unites all the elements. The Ssäm Bar specializes in small plates. Behind it all is David Chang, a chef who allows his Korean background to seep into his food, often in unexpected fashion, as in these otherwise basic deviled eggs seasoned with kimchi, the ubiquitous fermented vegetable pickle.

12 large eggs

1 cup napa cabbage kimchi, minced

3 tablespoons mayonnaise, homemade or store-bought

Cayenne

Salt

2 tablespoons minced chives

2 ounces wasabi tobiko, optional

Place the eggs in a saucepan and cover them with water. Bring them to a brisk simmer and cook for 2 minutes. Remove the pan from the heat, cover it, and let the eggs sit for 10 minutes. Drain and chill them in a bowl of ice water.

Peel the eggs, halve them lengthwise, and put the yolks into a bowl. Mash the yolks and mix in the kimchi and mayonnaise. Season with cayenne and salt to taste. Fill the white halves with the yolk mixture, mounding it up. Sprinkle some chives on top and garnish with a small dab of tobiko, if desired.

COOK'S NOTES Kimchi has become relatively easy to find in Asian shops, online, and even in some supermarkets. But if you don't have any, you might let your creative juices take hold and substitute some other spicy condiment with texture, like Thai red chili sauce or harissa.

SECOND HELPINGS
Leftovers are easily transformed into egg salad for sandwiches. And you may have leftover kimchi from preparing the eggs, which can be used as a condiment alongside seafood, tofu, meat, and poultry. Try it on a hot dog!

momofuku

ssäm bar

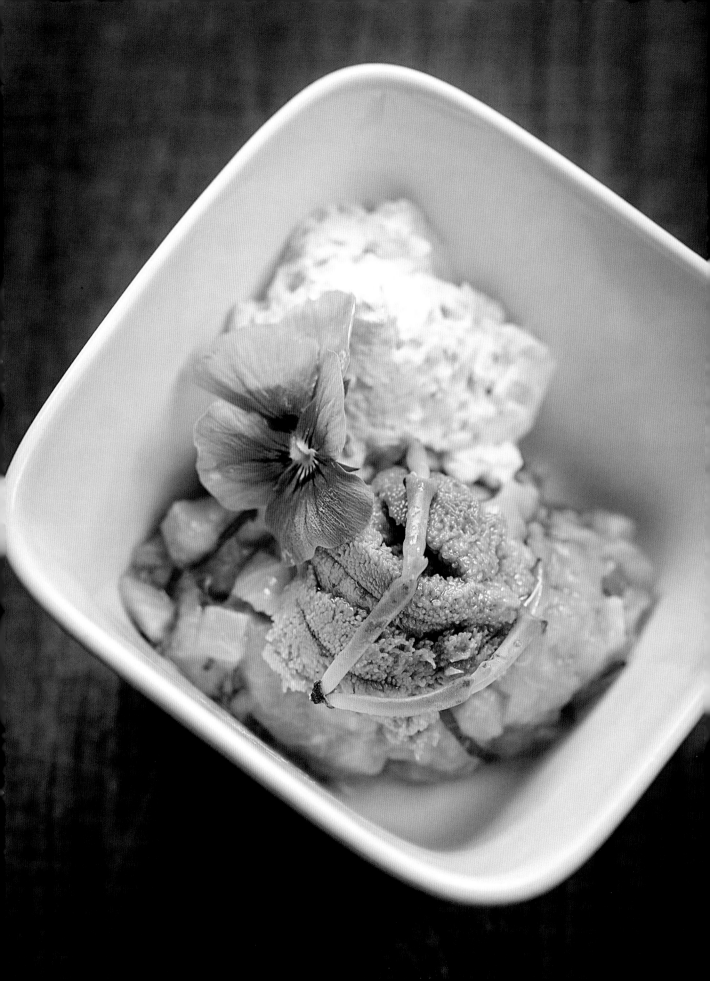

MARINATED HAMACHI WITH HARISSA AND UNI

As in the shrimp ceviche recipe on page 25, marinating the raw hamachi is a brief element of the preparation. In this dish, from a West Village restaurant that features inventive tasting menus, bold spice and citrus flavors are played off against the gentle canvas provided by the fish, including a garnish of creamy foam spiked with harissa. For the home cook, the harissa is incorporated into the marinade.

4 SERVINGS

1 juicing orange

12 ounces hamachi or yellowfin tuna, diced

1 teaspoon minced chives

2 tablespoons extra virgin olive oil

½ teaspoon grated shallot

1 teaspoon harissa or other thick hot sauce (see Cook's Note, page 158)

Salt

8 pieces uni (sea urchin roe), optional

8 slices baguette, toasted

Grate the zest from the orange. Place it in a bowl with the hamachi and chives. Mix. Remove the pith from the orange. Cut out eight orange segments and set them aside. Squeeze 2 tablespoons juice from the rest of the orange, and add it to a small bowl with the oil, shallot, harissa, and salt to taste. No more than 45 minutes before serving, fold this orange dressing into the hamachi mixture.

Divide the dressed hamachi among four salad plates. Top each portion with two pieces of uni and place two orange segments alongside the hamachi. Serve with toast.

COOK'S NOTES Hamachi, also called yellowtail, is a pale-fleshed tropical fish related to amberjack and, in the kitchen, is not unlike tuna. Most hamachi is farm-raised in Hawaii and Japan and goes to restaurants. Thus, yellowfin tuna, which is easier for home cooks to find, is a good substitute. As for the uni, high-end seafood markets and a few websites sell it. But the dish can be served without it. Caviar, which delivers umami like the uni, can be used.

SECOND HELPINGS
If you buy uni, you will wind up with more than you need for this recipe. It's a wonderful addition to pasta dishes like spaghetti with butter and anchovies (page 89) and is a requirement in Saul Bolton's bucatini ricci di mare (page 82).

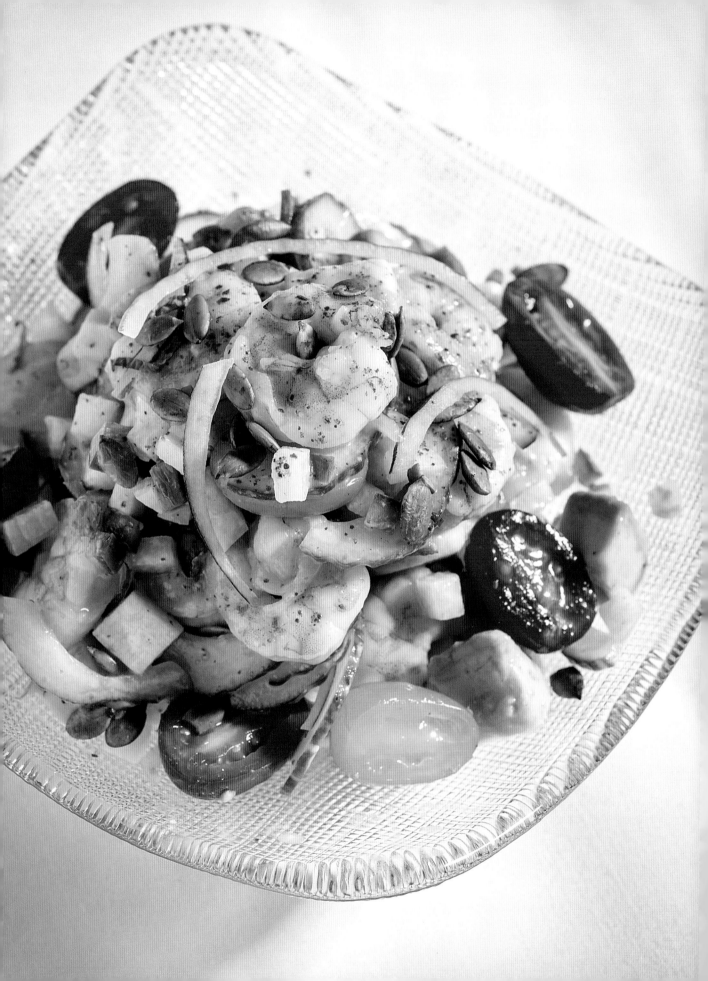

SHRIMP CEVICHE

Ceviche, the Mexican and South American fish dish, has changed in style. Once the product of long marination, enough to "cook" or pickle the seafood, it's now done quickly. In this version, the acid contributes flavor instead of a real textural change, keeping the ceviche fresher tasting than it might have been in the past.

3 tablespoons orange juice

3 tablespoons lime juice

2 tablespoons lemon juice

24 large shrimp (about 1½ pounds), quickly poached, then peeled and deveined

1 tablespoon minced jalapeño

1 chile de árbol, minced, or more to taste

6 to 8 mint leaves, cut into chiffonade

¼ cucumber, peeled, seeded, and sliced

24 grape tomatoes, preferably a mix of red and yellow, halved vertically

¼ cup thinly sliced red onion

Salt and freshly ground black pepper

1 small Hass avocado, peeled, pitted, and diced

1 tablespoon pepitas, toasted and crushed

Cayenne

Mix the citrus juices in a large bowl. Add the shrimp, jalapeño, árbol, and mint. Toss, then let the mixture marinate for about a minute. Add the cucumber, tomatoes, onion, and salt and pepper to taste. Toss. By this time, the impact of the árbol should become evident. Adjust the amount to taste. This dish should deliver some heat.

Gently fold in the avocado. Transfer the ceviche to a shallow serving bowl or to individual salad plates. Scatter pepitas on top. Sprinkle with salt and cayenne to taste.

COOK'S NOTES Chiles de árbol are similar to Thai bird chilis, small and slender. Their size makes it impossible to remove the seeds easily, so those intensify the spice. And if these particular chilis are not available, splash in a little Tabasco or other hot sauce instead.

To quickly poach the shrimp, bring a pot of salted water to a boil, add the shrimp, and as soon as the water starts to return to a boil, drain the shrimp and place them in a bowl with ice.

SECOND HELPINGS
Dice all the ingredients very small and pile small mounds of the ceviche on tortilla chips to serve as hors d'oeuvres the next day. This recipe will yield about 16 tidbits to serve with cocktails.

TUNA TARTARE

The quintessential neighborhood restaurant, T-Bar is all about comfort with class. The owner, Tony Fortuna, is a polished and accommodating host, and the food is always satisfying. Tuna tartare has become ubiquitous and it's always easy to like. Here it is given Asian seasonings and a touch of crunch with Chinese fried noodles, unsophisticated perhaps but certainly fun!

6 SERVINGS

1 pound sushi-quality tuna, diced

2 tablespoons minced shallot

2 tablespoons minced chives

2 teaspoons minced fresh ginger

3 tablespoons extra virgin olive oil

1 tablespoon soy sauce

2 teaspoons toasted sesame oil

½ teaspoon togarashi pepper

Pinch of cumin

Salt

Cayenne

¼ cup Chinese fried noodles

Place the tuna in a bowl. Add the remaining ingredients, except for the noodles, and toss gently to combine. Arrange the mixture on small plates. Garnish each portion with the noodles.

COOK'S NOTES Other fish, especially fluke, can be used in place of the tuna. Lump crabmeat, raw diced sea scallops, and crumbled smoked trout also work well.

SECOND HELPINGS
Togarashi pepper is a Japanese blend. Once you have bought some for this recipe, try using it in other dishes and to sprinkle on food, like eggs, at the table. It is complex, with slightly fruity heat.

CHIPOTLE GRILLED SHRIMP WITH TOMATILLO, ROASTED CORN, AND FETA SALSA

The vibe is so very downtown in this lounge-like Lower East Side spot. It was among the earliest non-tapas proponents of small-plate service in the city. Marinating the shrimp overnight might sound excessively long, but these are big shrimp and the marinade infuses them with great flavor and succulence, to be enhanced by notes of char during the cooking.

4 SERVINGS

1 tablespoon lime juice

½ teaspoon chipotle powder

½ teaspoon ancho or pasilla chili powder

3 tablespoons finely chopped cilantro

1 large clove garlic, forced through a press

3 tablespoons extra virgin olive oil

12 jumbo shrimp (about 1 pound), shelled and deveined

Salt

Tomatillo, Roasted Corn, and Feta Salsa (recipe follows)

Mix the lime juice, chipotle and ancho powders, cilantro, and garlic together in a medium-size bowl. Stir in the oil. Add the shrimp, turn to coat them with the marinade, then cover the bowl and refrigerate it overnight. Turn the shrimp once or twice as they marinate.

To serve, preheat a grill, grill pan, or cast iron skillet to very hot. Sear the shrimp on one side, 2 to 3 minutes. Turn them and sear the other side until they are just cooked through. Season them to taste with salt. Arrange all the shrimp on a platter or divide them among salad plates and serve, with salsa on the side.

COOK'S NOTES Shrimp are sold according to the number in a pound. Jumbo shrimp usually come about twelve to the pound, called U-12 in the trade. This recipe can be prepared with smaller shrimp, using more of them, but larger ones will take on nice color without overcooking.

TOMATILLO, ROASTED CORN, AND FETA SALSA
2 CUPS

1 ear fresh corn, shucked

2 tomatillos, finely diced

½ small red onion, finely diced

¼ cup finely diced, seeded red bell pepper

¼ cup chopped cilantro

2 tablespoons lime juice

3 tablespoons extra virgin olive oil

¼ cup crumbled feta cheese

½ teaspoon ancho or pasilla chili powder

½ teaspoon ground cumin

Sear the corn on a hot grill or in a skillet until lightly browned. Shave the kernels from the cob and place them in a bowl. Add the tomatillos, onion, bell pepper, and cilantro. Mix. Stir in the lime juice and oil, fold in the feta, and sprinkle in the chili powder and cumin. Mix, then transfer the salsa to a serving dish.

SECOND HELPINGS
You may have leftover salsa. It can be stretched with the addition of finely diced fresh pineapple or mango, chopped tomatoes, or even mayonnaise.

SQUID STUFFED WITH PORK IN LIME BROTH

At one of the city's better Thai restaurants, the kitchen is run by a couple who met while working in the refined precincts of Per Se. Ann Redding was born in Thailand, and she and Matt Danzer traveled throughout that country before opening their funky Thai pub. Their food has forceful personality, not the cookie-cutter routine of many of the city's Thai restaurants. Squid can be a blank canvas, more about texture than flavor. In this recipe it's roughed up with a mixture of ground pork and shrimp and distinctive Asian seasonings.

4 SERVINGS

6 ounces shrimp, shelled and deveined

6 ounces ground pork

2 tablespoons minced garlic

1 tablespoon minced cilantro stems

1 teaspoon freshly ground white pepper

½ teaspoon salt

2 tablespoons Chinese oyster sauce

1 tablespoon Asian fish sauce, preferably Thai nam pla

1½ pounds cleaned squid, the smaller the better, tentacles removed

1 tablespoon vegetable oil

Lime broth (recipe follows)

¼ cup cilantro leaves

Place the shrimp in a food processor. Pulse to chop coarsely. Add the pork, 1 tablespoon of the garlic, the cilantro stems, pepper, salt, oyster sauce, and fish sauce. Pulse until well combined but not too finely ground.

Place the filling in a pastry bag without a tip or in a plastic bag with a small corner cut off. (You can also use a small spoon.) Force the filling into each squid, leaving about ¾ inch headroom. Seal each with a toothpick.

In a small pan, fry the remaining garlic in the vegetable oil until it is lightly browned. Remove it to a paper towel to drain.

Use a very sharp, small knife or a razor blade to lightly slash the squid a few times without cutting through the flesh; this helps to keep the stuffed squid from bursting as they cook.

Place water in the bottom of a pot that can be fitted with a steamer basket and bring it to a simmer. Place the squid in a steamer basket over the water, cover, and steam until the filling is cooked through, about 10 minutes. If in doubt, remove one of the squids and test the inside with a thermometer; it should register 150° F.

Remove the squid from the pot. Heat the lime broth. Divide it among four soup plates. Place two or three stuffed squid in each, scatter them with cilantro and fried garlic, and serve.

SECOND HELPINGS
If you have leftover filling, form it into little meatballs, roll them in cornstarch, and sauté them. They can be added to the broth along with the stuffed squid or served on toothpicks as hors d'oeuvres.

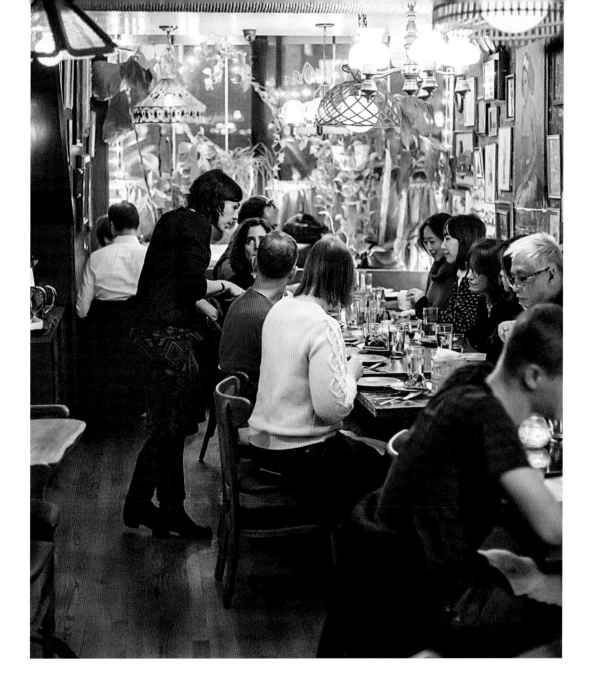

LIME BROTH
ABOUT 2 CUPS

2 cups chicken stock

1 tablespoon soy sauce

1 tablespoon Asian fish sauce, preferably Thai nam pla

1 tablespoon lime juice

1 clove garlic, sliced

Salt and freshly ground white pepper

Combine the stock, soy sauce, fish sauce, lime juice, and garlic in a small saucepan. Bring the mixture to a simmer. Season with salt and pepper to taste. Set the stock aside until you are ready to serve.

COOK'S NOTES When serving this dish, it's best to provide steak knives, which will allow diners to slice neatly through the squid and its filling.

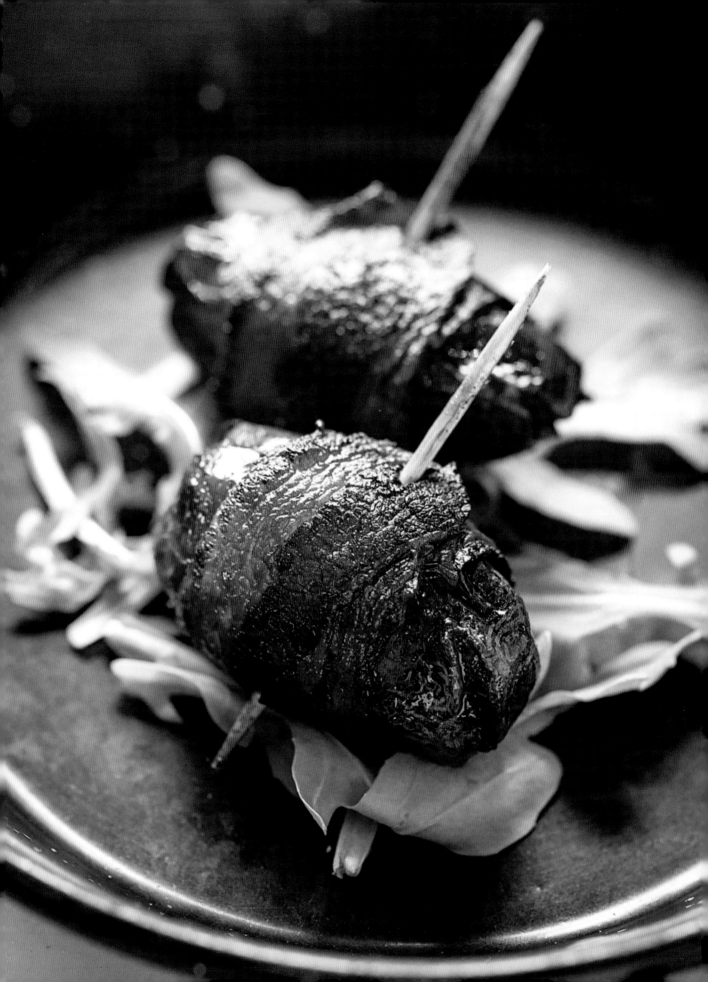

STUFFED DATES WRAPPED IN BACON

Seamus Mullen has a name that does not hint at his expertise when it comes to interpreting the food of Spain. But this Vermont chef with an Irish heritage has made Spanish food his specialty for nearly ten years, first at Boqueria, then Tertulia, and now El Colmado, a counter in a bustling market at the far west side of Midtown. These tapas pack sweet, salt, and fat into a mere bite.

4 SERVINGS

6 slices bacon, each cut in half

12 large Medjool dates

12 Marcona almonds

½ cup blue-veined cheese, preferably Spanish Valdeón

Preheat the oven to 475° F. Line a baking sheet with parchment.

Place the bacon slices on a work surface. Remove the pits from the dates. Insert an almond and a piece of the cheese in the center of each date. Close up the dates and place each at one end of a strip of bacon. Roll the date in the bacon.

Run a 6-inch bamboo skewer through the date horizontally, taking care to secure the bacon around the date. Place two more stuffed dates on each skewer.

Arrange the four skewers on the baking sheet and roast until the bacon is lightly browned, 8 to 10 minutes. Allow the dates to cool for a few minutes before serving.

COOK'S NOTES Three dates per person make for a tapa or appetizer portion. As a cocktail tidbit, use one date per skewer, to make a dozen, taking care to keep the date near the end of the skewer so it can easily be taken off as a quick bite. Other blue-veined cheeses, including Cabrales, Stilton, Roquefort, Fourme d'Ambert, and Maytag Blue can be used.

SECOND HELPINGS
Extra cheese is ripe for nibbling and can, of course, be crumbled over a salad.

FORAGER'S TREASURE OF WILD MUSHROOMS

In about four square blocks, David Bouley has established a tidy empire of restaurants and food venues. His flagship, Bouley, has the grand elegance of a French château. Across the street, Brushstroke transports the diner to Japan. Nearby is Bouley Botanical, where herbs and vegetables are grown indoors and there's space for catered events. As it is served at Bouley, this dish, an impressive array of exotic mushrooms spread on a plate and kissed with a delicate yet fragrant sauce, might appear to be impossible to reproduce at home. But the only difficult element is shopping. The elegant and succulent results are worth the effort.

4 SERVINGS

1 pound assorted mushrooms, at least four kinds: shiitake, royal trumpet, porcini, bluefoot, hon-shimeji, small maitake (hen-of-the-woods) clusters, small oyster mushroom clusters, chanterelles, small enoki clusters

3 tablespoons extra virgin olive oil

1 tablespoon finely chopped garlic

1 tablespoon finely chopped shallot

¼ cup unsweetened coconut milk

1½ tablespoons black truffle paste with porcini, or plain black truffle paste

Salt and freshly ground black pepper

½ teaspoon French quatre épices

2 tablespoons freshly grated Parmigiano Reggiano

Watercress or radish microgreens

Trim the mushrooms: separate the clusters; discard the shiitake stems; cut any large caps like shiitake, porcini, and royal trumpet in four; slice royal trumpet and porcini stems. Set them aside.

Place 1 tablespoon of the oil in a small saucepan. Add the garlic and shallot and sauté on medium until they are softened and starting to brown. Add the coconut milk and bring the mixture to a simmer, then remove the pan from the heat and stir in the truffle paste. Season with salt and pepper. Set the pan aside until you have cooked the mushrooms.

A few minutes before serving, heat the remaining oil in a very large skillet (or use two pans) over medium high. Add the mushrooms in a single layer—this is difficult at first, but they shrink as they cook—and sear until they start to wilt and look moist, a minute or so. Turn the mushrooms, reduce the heat to medium, and cook them for another couple of minutes. Season them with salt and pepper and dust them with quatre épices. Arrange the mushrooms on each of four salad plates. Briefly reheat the truffle sauce and drizzle it over the mushrooms.

Dust the mushrooms with the cheese and decorate with the microgreens. Serve.

COOK'S NOTES This dish can be made using supermarket mushrooms like cremini and shiitake. Quatre épices is a mixture of ground ginger, cloves, nutmeg, and white pepper.

SECOND HELPINGS
The more types of mushrooms you buy while "foraging" in a well-stocked market, the fewer you will need of each. Store them in a paper bag left open at the top in the refrigerator, but not sealed in a plastic bag, which will cause them to soften and rot.

DAVID BURKE GROUP

ROASTED HEN-OF-THE-WOODS MUSHROOMS

A restless, inventive chef, David Burke is not behind the stove in a restaurant but is, rather, involved with a company that runs restaurants and does catering. The clever idea of roasting a big, dramatic mushroom and serving it so guests can pull off earthy, lightly crisped pieces to dip in a garlic mayonnaise and enjoy with a drink is typical of Burke's flair.

1 head garlic

3 tablespoons extra virgin olive oil

1 pound hen-of-the-woods (maitake) mushrooms, in large clusters

Salt and freshly ground black pepper

5 sprigs fresh thyme

¾ cup mayonnaise

2 tablespoons lemon juice

Preheat the oven to 350° F. Break or cut the head of garlic in half. Slice off about ½ inch from the top of one of the halves. Brush it with a little of the oil. Wrap it in foil and bake until soft, around 40 minutes.

Finely chop three of the remaining garlic cloves (reserve the remainder for another use). Spread out the mushroom clusters on a baking sheet, brush them with the remaining oil, sprinkle them with the chopped garlic, season with salt and pepper, and scatter the thyme on top. When the half head of garlic has been in the oven for 30 minutes, put the mushrooms in the oven too.

Place the mayonnaise in a dish and stir in the lemon juice. When the garlic is soft, remove it from the oven and squeeze the soft garlic into the mayonnaise. Beat with a fork to combine. Transfer the sauce to a bowl for dipping.

When the mushrooms have started to crisp around the edges, after about 20 minutes, remove them from the oven and arrange them on a small platter with the bowl of garlic mayonnaise. Serve so guests can break off pieces of the mushroom clusters and dip them in the sauce.

COOK'S NOTES Maitake mushrooms are a cultivated variety. If they are not available, big clusters of oyster mushrooms can be substituted.

SECOND HELPINGS
Any leftover mushrooms can garnish a steak or be added to a salad.

TARTE MENTON

From the beginning, Andy D'Amico has stayed the course at this homage to the south of France. From Menton, a city that is almost on the Italian border, he offers this savory tart paved with olives, onions, and tomatoes, and showered with cheese. It's baked on a pizza dough, easily made and reliable, but is not a pizza. In fact, it's a close cousin to pissaladière, minus the anchovies.

6 TO 8 SERVINGS

¼ cup extra virgin olive oil

4 large onions (about 2½ pounds), diced

Salt and freshly ground black pepper

50 pitted Niçoise olives

2 tablespoons fresh thyme leaves

6 ounces fresh pizza dough (recipe follows)

½ cup freshly grated Parmigiano Reggiano

20 to 30 red and yellow cherry or grape tomatoes, halved

Use a little of the oil to grease a 9-inch pie pan. Heat a large skillet on medium low, and add the rest of the oil. Add the onions to the pan, season with salt and pepper, cover the pan, and let the onions cook for 30 minutes or so, stirring occasionally, until they are very soft but not brown. Increase the heat to medium, stir in the olives and thyme, and continue cooking, uncovered, until any liquid in the pan has evaporated. Remove from the heat.

Roll and stretch the dough to a very thin 12-inch circle. Fit it into the pie pan. Prick the dough. Refrigerate it for 15 minutes.

Preheat the oven to 400° F. Sprinkle 1 tablespoon of the cheese over the dough. Spread the onion mixture on top. Arrange the tomatoes closely together on the onions, cut side up. Bake the tarte for 20 to 25 minutes, until it is starting to brown. Scatter the remaining cheese over the tomatoes and continue baking until the tarte is golden, another 15 minutes or so.

Allow it to sit for a few minutes, then cut and serve.

COOK'S NOTES Though the recipe calls for baking the tarte in a pie pan, you could also fit the dough into an oblong baking pan to enable you to cut small squares to serve as hors d'oeuvres.

SECOND HELPINGS
Any leftovers can easily be reheated in a warm oven, but not in a microwave oven.

PIZZA DOUGH
3 SMALL OR 1 LARGE PIZZA OR OTHER TART

1 (¼ ounce) packet instant
dry yeast

Pinch of sugar

1 teaspoon salt

Freshly ground black pepper

3 tablespoons extra virgin olive oil

About 3 cups bread flour

Dissolve the yeast and sugar in ½ cup lukewarm water in a large mixing bowl. Let the mixture sit for 5 minutes; it should start to bubble. (If not, the yeast is not viable. Start again with new yeast.) Add another ½ cup warm water, the salt, about ½ teaspoon pepper, and the oil. Mix well. Stir in the flour ½ cup at a time, until the dough starts to leave the sides of the bowl. You should have added a little more than 2 cups flour at this point.

Knead the dough for about 5 minutes in the bowl, adding more flour as required to make it easy to handle. Brush a 3-quart bowl with oil, place the dough in the bowl, cover it, and let it rise until doubled.

Punch the dough down, divide it as needed for your recipe, and roll and stretch it on a lightly floured surface to fit your pan. Any unused dough can be refrigerated for a couple of days or frozen.

TWICE-BAKED UPSIDE-DOWN COMTÉ CHEESE SOUFFLÉS

The original Benoit, a classic in the Marais district of Paris, was founded in 1912. The mega-chef, Alain Ducasse, bought it in 2005 and subsequently opened branches in other cities. The New York Benoit now has Philippe Bertineau, who was at the bistro of François Payard, in the kitchen. These luxuriously creamy little soufflés are resilient enough to permit advance preparation.

8 SERVINGS

1 cup milk

1 large clove garlic, smashed

Salt and freshly ground white pepper

Pinch of nutmeg

6 tablespoons unsalted butter

6 tablespoons all-purpose flour

1¾ ounces Parmigiano Reggiano, grated

1 ounce Comté cheese, shredded

3 eggs, separated

Preheat the oven to 350° F. Lightly butter eight 4-ounce muffin cups, either individual foil ones or a muffin tin. If you use a nonstick pan, greasing is not necessary.

Combine the milk and garlic in a small saucepan. Bring the mixture just to a boil and turn off the heat. Season with salt, pepper, and nutmeg.

In a 3-quart saucepan, melt the butter. Stir in the flour and cook, whisking, for 2 to 3 minutes. Fish out and discard the garlic clove from the milk and pour the hot milk into the flour mixture, whisking constantly. Cook on low until the sauce—a béchamel—is thick and smooth. Remove it from the heat. Add the Parmigiano Reggiano and all but 1 tablespoon of the Comté. Mix until the sauce is smooth. Beat in the egg yolks, one at a time. Transfer this mixture to a large bowl. Check the seasonings and add more salt or pepper if needed.

Beat the egg whites until they hold peaks but are still creamy. Fold them into the cheese sauce. Spoon the mixture into the prepared muffin cups, filling them. Place the cups in a large pan, like a roasting pan. Add boiling water to the roasting pan to come halfway up the sides of the cups. Bake the soufflés for 15 to 20 minutes, until the tops are firm to the touch and barely starting to crack. They will not have browned and will have puffed up only a little.

Remove the soufflés from the oven. Preheat the broiler and line a baking sheet with foil. Run a knife around the edges of the cups to release the soufflés. Invert them onto the baking sheet. Top each with a smidgen of the reserved Comté. Place them under the broiler for a few minutes, until the tops are nicely browned. Transfer them to individual plates or to a platter and serve at once.

SECOND HELPINGS
These creamy little soufflés are surprisingly forgiving. Any that you do not use can be refrigerated and reheated. They can even be served alongside a main dish like grilled chicken or fillet of beef.

COOK'S NOTES The original recipe for this richly satisfying dish calls for the soufflés to be served with a creamy cheese sauce. But that complicates the recipe. Besides, they need no embellishment. That said, however, a drizzle of pesto or a tomato coulis alongside would not be a mistake. The recipe can be varied with other cheeses, including Gorgonzola or Cheddar, or, for a lighter touch, goat cheese. And it can be fancied up by using black truffle butter in place of regular unsalted, then garnished with fresh truffle shavings. There you have a celebratory starter for an occasion like New Year's Eve. Pop the cork!

SALADS

ARTICHOKE SALAD WITH SHAVED PARMESAN

The Serafina restaurants are crowd-pleasers serving straightforward Italian food in bright, cheerful settings. That the menu includes this brightly fresh salad of raw shaved artichokes played off against cheese and herbs is no surprise, since it's a typical Tuscan preparation.

4 SERVINGS

Juice of 2 lemons

16 baby artichokes

⅓ cup extra virgin olive oil

Salt and freshly ground black pepper

3 ounces Parmigiano Reggiano, shaved with a vegetable peeler

¼ cup flat-leaf parsley or mint leaves

Pour half of the lemon juice into a large bowl. Add 2 cups cold water. Trim the artichokes: first tear off a couple of layers of the heavier outer leaves, then use a serrated knife to trim the stems down to the base and slice ½ inch off the top. Using a sharp stainless steel knife or a mandoline, slice the artichokes vertically, as thin as possible and drop the slices into the lemon water as you go.

Whisk the rest of the lemon juice and the oil together. Season with salt and pepper.

Drain the artichokes and pat them dry. Dry the bowl. Return the artichokes to the bowl, add the dressing, and toss to coat. Distribute the artichokes among four salad plates. Top the salad with shavings of the cheese, then the herbs. Serve.

COOK'S NOTES If baby artichokes are not available, you can use large globe artichokes, well trimmed down to the heart and with the choke scooped out. Allow about 1 artichoke per person.

SECOND HELPINGS
Once trimmed and sliced, the artichokes must be used immediately.

ASIAN SLAW

At Leah Cohen's restaurant, this salad serves as a tangy refresher alongside the richly glazed barbecued baby back ribs (page 148), but it's also a stand-alone winner. Napa cabbage offers a less aggressive and more refreshing flavor than regular green cabbage in this slaw, which is showered with fresh herbs.

6 SERVINGS

½ cup mayonnaise, homemade or store-bought

1½ tablespoons Asian fish sauce

3 tablespoons rice vinegar

1 tablespoon lime juice

½ teaspoon sugar

4 cups shredded napa cabbage (about ½ small head)

3 tablespoons mint leaves in chiffonade

3 tablespoons cilantro leaves

2 tablespoons sliced scallions (green part only)

Pinch of chili powder, preferably Thai

Salt and freshly ground black pepper

Mix the mayonnaise, fish sauce, vinegar, lime juice, and sugar together.

Place the cabbage in a bowl and mix in the mint, cilantro, and scallions. Fold in the dressing. Season with chili powder, salt, and pepper. Set aside for about an hour before serving.

COOK'S NOTES Though crisp, slightly nutty-tasting napa cabbage works best in this recipe, green savoy cabbage or even romaine lettuce can be used instead. Like most slaws, this improves when allowed to rest for about an hour before serving to permit the cabbage to soften somewhat.

SECOND HELPINGS
Since you will not be using the white part of the scallions in the slaw, hang on to them and store them in a small plastic bag to use for other salads or as garnishes. Extra napa cabbage will keep for a number of days to use in other salads and in stir-fries.

BOULANGERIE

PATISSERIE

CAFÉ

MIGLIORELLI FARMS SNAP PEA SALAD

Though Andrew Carmellini's name has come to be associated with Italian and American food in recent years, his training was predominantly French and he rose to prominence cooking at Café Boulud. He has by no means abandoned Italy, but his latest venture, at this evocatively Parisian brasserie-style restaurant, is solidly French. This salad, a worthy contender on any menu, is not so very French after all. But it is simple to prepare, bright with the crunch of lightly cooked sugar snaps, and delicious to consume. It makes an excellent spring or summer first course. Migliorelli is the name of the farm in the greenmarket from which Carmellini buys his peas.

1 pound sugar snap peas, trimmed

1 ripe avocado, peeled, pitted, and chopped

1½ tablespoons lemon juice

1½ teaspoons dried fines herbes

Salt

6 tablespoons extra virgin olive oil

3 tablespoons chopped fresh mint leaves

3 tablespoons chopped fresh basil leaves

⅓ cup freshly grated Parmigiano Reggiano

⅓ cup pine nuts, toasted (see Cook's Notes, page 157)

¼ pound ricotta salata

Bring a large pot of water to a boil. Add the sugar snaps, boil them for about 3 minutes, until crisp-tender, then drain and transfer them to a large bowl of ice and water.

Combine the avocado, lemon juice, fines herbes, and about ½ teaspoon salt in a food processor. Turn on the machine and add 2 tablespoons of the oil in a thin stream. Transfer this avocado cream to a dish, cover it with plastic wrap laid directly on the surface, and refrigerate it until serving time.

Drain the sugar snaps well and toss them in a bowl with the mint, basil, Parmigiano Reggiano, pine nuts, and remaining oil. Season with salt and pepper.

Spread the avocado cream in a circle on each of four salad plates. Pile the snap pea salad on the avocado cream. Top each portion with shaved ricotta salata.

COOK'S NOTES The ingredient list calls for the leaves of herbs; take the time to pluck them from the stems before chopping them. And when it comes to basil, do not chop the leaves far in advance, because they will turn brown around the edges. Fines herbes usually combines parsley, chervil, tarragon, and chives, all dried.

SECOND HELPINGS
Any leftovers can be refrigerated and used the next day to garnish a cold pea soup or to top simply grilled fish.

SUSHI BAR WEDGE SALAD

An American who made his name in Tokyo with several innovative ramen bars, Ivan Orkin has come home to America and opened a noodle house here. His timing was impeccable, because New York has become obsessed with ramen. Usually, an iceberg wedge salad has a creamy blue cheese dressing. The carrot dressing provides a new direction.

6 SERVINGS

6 medium-size carrots, trimmed, peeled, and cut into chunks

1 (2-inch) piece fresh ginger, peeled and chopped

⅓ cup plus 2 tablespoons rice vinegar

2 tablespoons honey

½ cup grapeseed or canola oil

2 tablespoons strong mustard, preferably Japanese karashi

1 small red onion, peeled and thinly sliced

1 teaspoon sugar

Pinch of kosher salt

1 head iceberg lettuce, trimmed and cut into 6 wedges

Steam the carrots until they are tender, about 20 minutes. Turn on a food processor and drop the ginger in through the feed tube. Scrape the sides of the container. Add the carrots, ⅓ cup rice vinegar, the honey, oil, and mustard. Add 3 tablespoons water and process to make a puree. Set aside.

Mix the onion with the remaining 2 tablespoons vinegar, the sugar, and salt.

Put about 3 tablespoons of the carrot dressing on each of six salad plates. Place a wedge of lettuce on top, spoon the rest of the dressing onto the lettuce and top it with the onions. Serve.

COOK'S NOTES Ivan Orkin says that he often serves this salad garnished with cold poached shrimp.

SECOND HELPINGS
Any leftover dressing, mixed with a little olive oil, can be used for other salads. Extra iceberg lettuce can go into tacos.

ASPARAGUS AND PROSCIUTTO SALAD WITH BAKED EGGS

Bill Telepan marches at the forefront of the "eat local" movement. His menus feature Greenmarket vegetables, and his approach is seasonal. Here you have a layered salad built for spring, when asparagus emerge from the ground. It's not a dish for October. At other times of year, explore different options for this salad: mushrooms would be fine, as would broccoli florets, quartered brussels sprouts, or even carrots (blanch them before stir-frying).

7 tablespoons extra virgin olive oil

2 large shallots, each peeled and cut into 4 thick slices

Salt

4 large eggs

1 tablespoon lemon juice

1 teaspoon red wine vinegar

2 teaspoons whole grain mustard

1 tablespoon black mustard seeds

½ pound medium asparagus, ends snapped off, slant-cut into 2-inch pieces

2 tablespoons vegetable stock (or water)

2 heads frisée, cut into small pieces

8 thin slices prosciutto

Preheat the oven to 400° F. Heat 1 tablespoon of the oil in a small ovenproof pan over high, add the shallots, and dust with salt. Sauté until the shallots start to sizzle. Cover the pan with a lid or foil and place it in the oven to bake until the shallots are tender, about 10 minutes. Let them cool.

Place a medium-size ovenproof sauté pan on medium-high heat. Brush it with a tablespoon of the oil. Break the eggs into the pan and immediately place the pan in the oven for 3 to 4 minutes, until the whites are set. Remove the eggs from the oven.

Combine the lemon juice, vinegar, mustard, and a pinch of salt in a small bowl. Whisk to blend, then slowly whisk in 4 tablespoons of the oil. Check and adjust the seasoning. This is your vinaigrette.

Place a medium-size sauté pan over high heat and add the remaining tablespoon of oil.

Sauté the mustard seeds briefly. Add the asparagus and stir-fry until they are lightly browned, 3 to 5 minutes. Add the baked shallot slices, toss briefly, then remove the pan from the heat. Add the stock.

Place the frisée in a salad bowl and toss it with the vinaigrette. Divide it among four salad plates. Top each portion of the frisée with two slices prosciutto, then an egg and some of the asparagus. Serve.

COOK'S NOTES All asparagus should be trimmed by snapping the ends off where they break naturally. Usually any but the slenderest stalks call for peeling when served whole. But in this recipe, because the asparagus are cut in short pieces, peeling is not necessary.

SECOND HELPINGS
Double the vinaigrette recipe, and you have some lovely dressing to keep in the refrigerator for other salads.

BRUSSELS SPROUTS SALAD

Mexican and Latino foods do not often suggest salads beyond the shreds of lettuce or simple slaws to tuck into a taco. But Julian Medina's approach to his native cuisine is broader, and he welcomes other influences. Brussels sprouts turned mellow from roasting and tossed in a vinaigrette is a good example. Without the pickled onions and queso fresco, this salad does not reflect a particular ethnic identity.

1 tablespoon sherry vinegar

1 teaspoon minced shallot

1 teaspoon Dijon mustard

1 teaspoon minced garlic

½ cup extra virgin olive oil

Kosher salt and coarsely ground black pepper

4 cups brussels sprouts, ends trimmed, halved vertically

6 pickled cocktail onions, chopped

1 teaspoon minced cilantro leaves

2 tablespoons crumbled queso fresco

Preheat the oven to 400° F.

In a small bowl, mix the vinegar, shallot, mustard, and garlic together. Whisk in ¼ cup of the oil. Season with salt and pepper and set aside.

Combine the brussels sprouts and remaining oil in a bowl. Season them with pepper and transfer them to a roasting pan that will hold them comfortably. Roast the brussels sprouts for 20 to 30 minutes, until they are golden brown. Add the dressing and toss. Season with salt to taste. Place the salad in a shallow serving dish. Combine the pickled onions and cilantro and scatter them over the brussels sprouts. Top the salad with crumbled queso fresco and serve.

COOK'S NOTES Queso fresco, literally "fresh cheese," looks like feta or ricotta salata, but is much blander. But those other cheeses, or even crumbled goat cheese, can be used.

SECOND HELPINGS
Leftover brussels sprouts are suitable to use, even in small quantities, in other salads or vegetable dishes, and even in soups.

GRILLED ENDIVE SALAD WITH CITRUS DRESSING

Dell'anima is one of a collection of Italian restaurants, from wine bars to more formal dining rooms, centered in the East and West Village. The chef, Gabe Thompson, its creative engine, strives for simplicity in his well-focused dishes. This salad takes advantage of how attractive endives can be, and the addition of citrus provides fresh allure.

4 TO 6 SERVINGS

6 heads Belgian endive, trimmed and quartered lengthwise

6 tablespoons extra virgin olive oil

Kosher salt and freshly ground black pepper

Finely grated zest of 1 lemon

3 tablespoons orange juice

1 tablespoon lemon juice

2 tablespoons minced flat-leaf parsley

2 tablespoons minced mint leaves

1 ounce pecorino Romano, grated

Preheat a grill, grill pan, or cast iron skillet over high heat.

Place the endive quarters in a large bowl with the oil, a teaspoon or more of salt, and pepper to taste and toss to coat. Place the seasoned endives on the grill or in the pan, cut sides down. Cook them for about 2 minutes, until the cut sides are charred. Use tongs to turn the quarters to sear the other cut sides, another 2 minutes. Then turn to sear the uncut surfaces, about a minute. Do not crowd the wedges in the pan—sear them in several shifts if necessary. Transfer them to a large bowl.

Toss the endives with the lemon zest, orange juice, lemon juice, parsley, and mint. Check the seasonings, adding more salt and pepper if needed. Arrange the endives on a platter or distribute them among salad plates. Dust with grated pecorino and serve.

COOK'S NOTES Do not be stingy with the salt. The best antidote for bitter ingredients like endive is salt.

SECOND HELPINGS
Save any leftovers to incorporate into a regular green salad. The charred, dressed endives can be kept, refrigerated, for a full day.

dell'anima

QUINOA SALAD

The massive renovation of the dining room that was once notable only for breakfast has made the Regency an Upper East Side destination for lunch and dinner too. The nuttiness of quinoa is emphasized through the addition of pecans in this salad. It would be a good dish to include on the Thanksgiving table.

4 SERVINGS

1 cup quinoa, preferably red

Salt

1 medium-size red onion, peeled and cut into 12 wedges

5 tablespoons extra virgin olive oil

2 star anise

½ cup shelled pecans, broken into large pieces

1½ tablespoons lime juice

1 tablespoon pomegranate molasses

2 tablespoons sherry vinegar

Freshly ground black pepper

½ pound thick asparagus; zucchini or cucumber can be used instead

2 cups baby arugula

Bring 2 quarts of water to a boil in a saucepan. Add the quinoa and 1 tablespoon salt. Cook the quinoa until just tender, about 15 minutes. Drain it thoroughly and let it cool.

Preheat the oven to 350° F. Rub the onion wedges with 1 tablespoon of the oil, place them on a sheet of foil with the star anise and a sprinkling of salt, enclose the onion in the foil, and bake until the onion is tender, about 20 minutes. Meanwhile, toss the pecans with 2 teaspoons of the oil and a little salt, place them on a sheet of foil, and toast them in the oven alongside the onions for about 10 minutes.

Combine the lime juice, pomegranate molasses, sherry vinegar, and remaining oil in a small bowl. Beat to mix. Season with salt and pepper.

In a large bowl, mix the quinoa with the onions and pecans. Add about half of the vinaigrette. Set the mixture aside.

If you're using asparagus, snap off the ends; for zucchini, trim the top and bottom; for the cucumber, peel it. Then, using a mandoline or a vegetable peeler, cut thin vertical strips from whatever green vegetable you have chosen. Mix the strips with the arugula and toss the greens with as much of the remaining dressing as needed.

To serve, place a mound of the quinoa on each of four salad plates. Top it with the vegetable and arugula salad.

COOK'S NOTES You can tell when quinoa is done when you see little white "halos" appear on the seeds.

SECOND HELPINGS Double the dressing recipe, and you have a nice vinaigrette to keep on hand in the refrigerator for other salads or to use as a marinade for lamb or chicken.

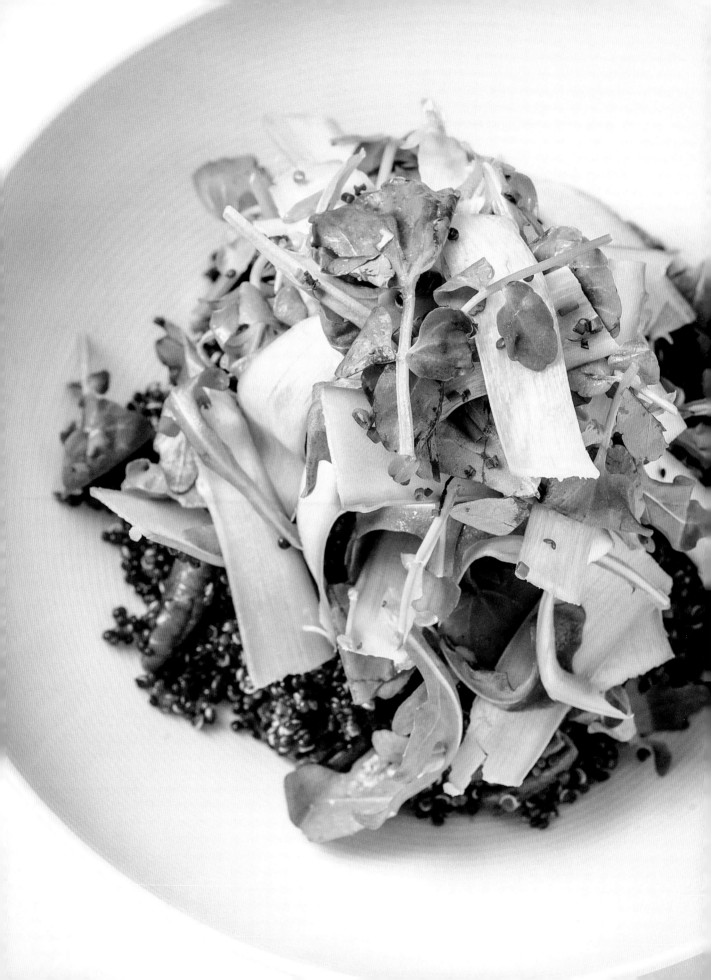

COLICCHIO & SONS AND CRAFT

ROASTED BEET SALAD WITH BEET VINAIGRETTE

A chain of sandwich shops, some serious restaurants, including Craft (pictured at right), and even a hotel or two are filling Tom Colicchio's résumé, to say nothing of his busy TV schedule. Much of his food has depended on vegetables, even before it was fashionable. The restaurant version of this bright, succulent salad, served at Colicchio & Sons, uses uniformly sized baby beets. To make the recipe convenient for home cooks, regular beets have been substituted here.

4 SERVINGS

9 medium-size beets, trimmed and scrubbed, or 24 baby beets

2 tablespoons grapeseed oil

Kosher salt and freshly ground black pepper

5 tablespoons extra virgin olive oil

¼ cup minced shallot

2 tablespoons red wine vinegar

½ teaspoon Dijon mustard

Sprigs of fresh tarragon for garnish

Preheat the oven to 400° F. Place the beets in a bowl, add the grapeseed oil, season with salt and pepper, and rub the beets to coat with the oil and seasonings. Place the beets on a large sheet of foil and fold the foil over the beets. Place this packet on a baking sheet and roast until the beets are tender, about 40 minutes, or about 20 minutes if you are using baby beets. Open the foil and let the beets cool to room temperature.

Peel the beets. Coarsely chop one of the medium beets (or 4 baby beets) and set the others aside.

Heat 1 tablespoon of the olive oil in a small skillet on low. Add the shallots and sauté until they are tender and translucent. Transfer them to a bowl and whisk in the vinegar and mustard. Whisk in the remaining olive oil. Season with salt and pepper. Stir in the chopped beet.

Slice the whole beets about ½ inch thick and divide the slices among four salad plates. (Cut baby beets in half.) Spoon the dressing over the beets, garnish them with tarragon, and serve.

COOK'S NOTES Though peeling beets once they are cooked will not stain your skin as much as peeling them raw, you still might consider protecting your hands with plastic gloves or sandwich bags when you tackle them.

SECOND HELPINGS
Golden beets would work as well as red ones here. The important thing is that the beets you use be uniform in size. But in trying to use beets of uniform size, you may need to buy more than one bunch and wind up with extra beets. You can roast the extras and use them as a side dish or, dressed with a sharp vinaigrette, in a salad or as a condiment.

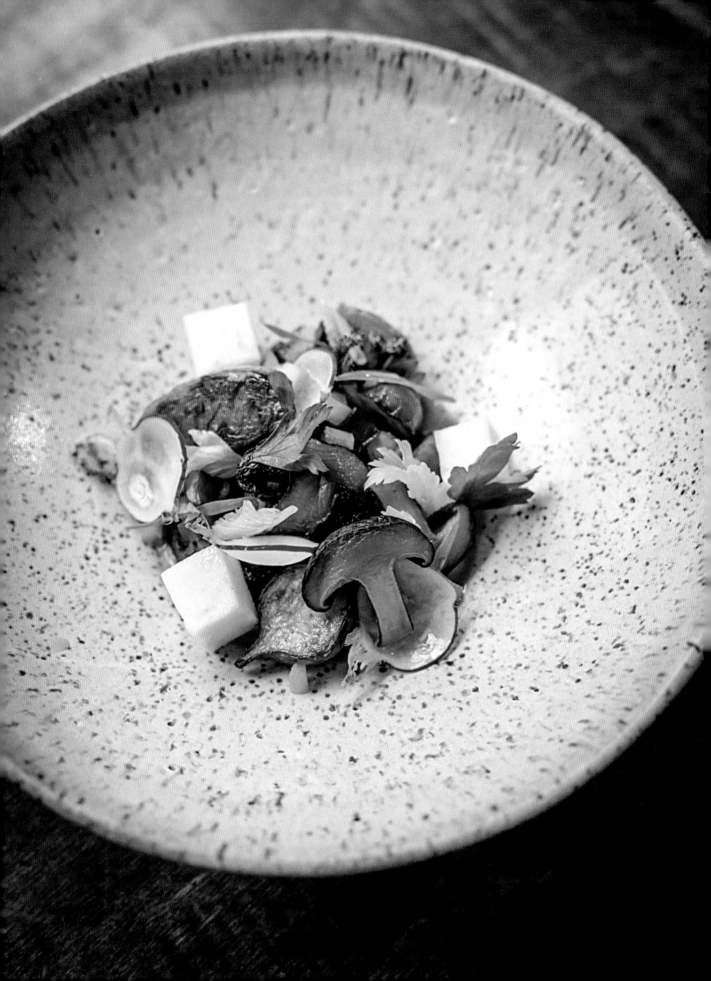

WARM MUSHROOM SALAD WITH APPLES AND CELERY

Adding an apple to a salad composed of mushrooms and celery almost sounds as though the dish is on track to be a Waldorf salad. But Mike Anthony, the chef at Gramercy Tavern, is too sophisticated for that. The apple draws the other ingredients into its orbit and adds sweet crunch to a combination of ingredients that offers deep complexity.

4 SERVINGS

½ pound medium-size shiitake mushrooms, wiped clean

4 ounces small cremini mushrooms, wiped clean

1 tart apple, peeled, cored, and diced

1 tablespoon lemon juice

3 tablespoons extra virgin olive oil

1 stalk celery, cut into small dice

1 tablespoon minced shallot

3½ tablespoons sherry vinegar

Salt and freshly ground white pepper

2 tablespoons soy sauce, mushroom soy if available

1 teaspoon sugar

1 teaspoon Dijon mustard

1 clove garlic, minced

½ cup grapeseed oil

1 tablespoon fresh tarragon leaves

Remove the stems from the shiitake mushrooms and place them in a small saucepan; add ½ cup water and simmer them for 10 minutes. Strain the liquid, discarding the stems, and set it aside. Quarter the shiitake caps and cut the cremini mushrooms in half. Toss the apple with the lemon juice.

Heat 2 tablespoons of the olive oil in a large nonreactive skillet on medium. Add the mushrooms, 1 tablespoon of the celery, and the shallot. Sauté for about 3 minutes, until the mushrooms are golden and no longer look raw. Add 1½ teaspoons of the vinegar and 2 tablespoons of the mushroom stock to briefly deglaze the pan. Season the mixture with salt and white pepper and transfer it to a bowl.

Combine the soy sauce, sugar, 1 tablespoon of the vinegar, and 2 tablespoons of the mushroom stock in a small saucepan. Simmer the mixture for 4 to 5 minutes, until it is syrupy. Transfer it to a jar or container with a cover and add the remaining vinegar, 1 tablespoon mushroom stock, the mustard, garlic, and grapeseed oil. Cover the jar tightly and shake it vigorously to emulsify the dressing. Season with salt and pepper.

Return the skillet to the stove, set the heat on low, and add the remaining tablespoon of olive oil. Return the mushrooms to the pan, toss them to heat through, then remove the pan from the heat and add the soy dressing. Mix and divide the mushrooms among four salad plates. Top each with diced apple, the remaining celery, and the tarragon.

SECOND HELPINGS

This soy dressing is a keeper. Consider preparing extra to have on hand. Use it warm to dress a mixed mushroom sauté or even soba noodles tossed with shiitake mushrooms.

COOK'S NOTES There are times when it would be terrific to have a team of sous-chefs in the home kitchen to do all the demanding prep—such as dicing a number of ingredients for a recipe like this. But the combination of ingredients in this salad is so well married that it's worth the effort.

SOUPS

COLD CORN SOUP

This iconic restaurant in a somewhat quirky space just off Union Square is a favorite of the publishing world. Its location made it an early supporter of the Union Square Greenmarket, and recipes like this one, featuring local corn made creamy, are typical. Danny Meyer, who opened the restaurant thirty years ago, is faced with a rent hike and plans to relocate it, preferably nearby.

4 SERVINGS

6 ears fresh local corn, preferably yellow or bicolor, shucked

2 tablespoons unsalted butter

1 small shallot, sliced

½ cup heavy cream

Salt and freshly ground white pepper

Shave the corn kernels off the cobs and set them aside; break the cobs in half and place them in a 4-quart saucepan. Add 4 cups water and simmer gently for 40 minutes to make corn stock. Remove the cobs, reserve them, and let the stock cool.

In a medium-size sauté pan, melt the butter and add the shallot, sautéing it on low until translucent. Add the corn kernels and ½ cup corn stock. Cover and cook over medium heat for about 5 minutes, then uncover, stir, and cook for about 2 minutes more. Do not let the corn or shallot brown.

Scrape the cobs with the back of a knife into the corn mixture, to release the juices and pulp. Add 1½ cups of the reserved corn stock to the pan. Puree the corn mixture in a blender until very smooth. Stir in the cream and thin the soup with additional corn stock, if desired. Season with salt and pepper. Chill before serving.

COOK'S NOTES Cold soups are as much about texture as about flavor. They can be unpleasant when too thick. The rule of thumb is not much thicker than tomato juice. Some mixtures thicken as they chill, so check before serving the soup. Check the seasoning too. Chilling mutes some flavors, so tasting and adding more salt is usually necessary.

SECOND HELPINGS
The smooth corn puree—before you thin it with cream to make the soup—can be used in many ways. The chef, Carmen Quagliata, suggests trying it as a pasta sauce with black pepper and pecorino, as an addition to pancake batter, or for coating French toast. It's also superb as an ingredient in vegetable gratins.

STRAWBERRY GAZPACHO

At first, the thought of strawberry gazpacho might be off-putting: will it be too sweet? But trust Daniel Humm to make the unusual succeed. After trying his version of gazpacho, you may consider making strawberries an essential ingredient going forward. The strawberries enhance the fruitiness—and the color—of the soup, without adding sweetness.

3 tablespoons plus ½ cup extra virgin olive oil

3 cloves garlic, crushed

3 cups crustless whole grain bread cut into ½-inch cubes

5 sprigs thyme

Salt

6 cups strawberries, hulled and quartered

1 medium-size English cucumber, peeled and diced

1¼ cups diced red bell pepper

¾ cup diced green bell pepper

6 tablespoons tomato juice, or to taste

3 tablespoons red wine vinegar, or to taste

Tabasco

Freshly ground black pepper

8 small basil sprigs

Heat a medium-size sauté pan on medium. Add 3 tablespoons oil and 2 garlic cloves. When the garlic starts to sizzle, add the bread cubes. Toss until the bread starts to color, add the thyme, and continue to cook until the bread turns brown. Remove the bread, discard the garlic and thyme, season the bread lightly with salt, and set aside 1 cup of the cubes. Place the rest in a large bowl.

Reserve 24 pieces of strawberry for garnish. Add the rest to the large bowl with the bread, along with the cucumber, bell peppers, tomato juice, and vinegar, as well as the remaining garlic and oil. Cover the bowl tightly and set it aside to marinate at room temperature for 3 to 6 hours.

Puree the contents of the bowl in a blender, in several batches. Pass the soup through a sieve. Refrigerate it for at least 4 hours, until it is very cold. Check the seasoning and add Tabasco, salt, and, if needed, more vinegar or tomato juice. Chill the soup bowls.

Divide the soup among the bowls, top each portion with a grind of black pepper, some croutons, a few strawberry pieces, and a basil sprig.

COOK'S NOTES Strawberries are sold all year, but out-of-season strawberries lack flavor. This is a recipe to consider in early summer, when you want cold soup and the strawberries are at their peak.

SECOND HELPINGS
Leftover soup can be served in shot glasses or espresso cups as an hors d'oeuvre with cocktails. The soup can be frozen.

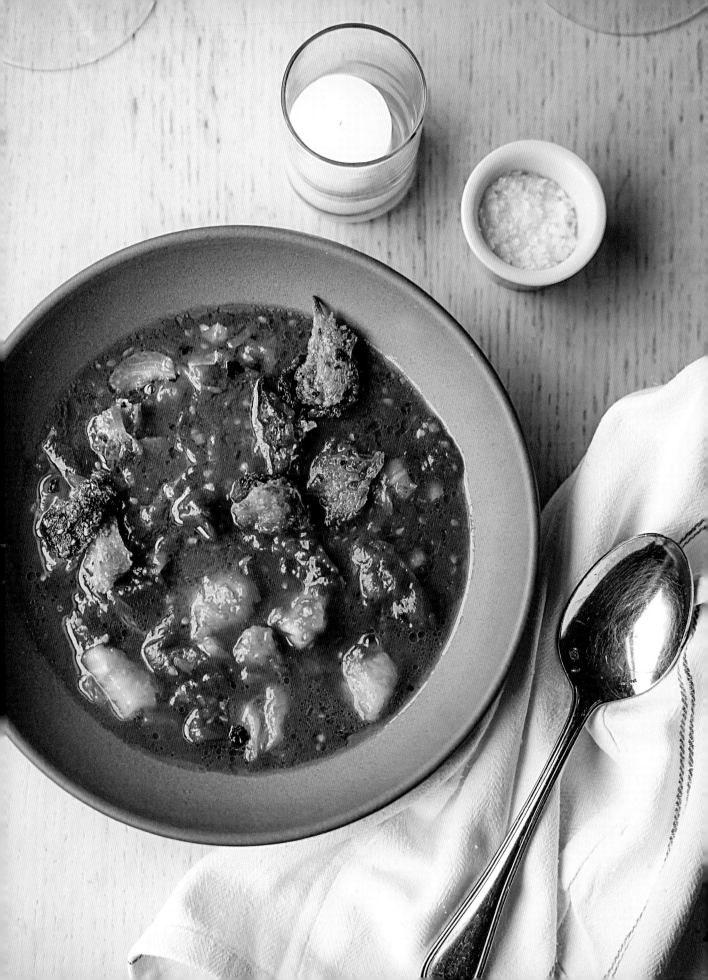

WARM TOMATO SOUP

The restaurant, named for the jazz musician Charlie Parker, is a lively Greenwich Village spot, with a vibrant wine program. This soup was an impromptu creation by the chef, Ryan Hardy, one summer, when the kitchen was overwhelmed with gorgeous heirloom tomatoes. This dish captures the essence of ripe tomatoes by just warming them. The addition of sweet vermouth deepens the flavor. Spooning it at a table near the open windows on a gentle evening was summertime perfection.

4 tablespoons extra virgin olive oil

1 cup cubed ciabatta

Sea salt

2 cloves garlic, sliced

Pinch of crushed red chili flakes

¼ cup sweet vermouth

4 pounds ripe heirloom tomatoes, cut in rough dice, with their juices

4 small sprigs basil for garnish

4 SERVINGS

Heat 2 tablespoons of the oil in a 3-quart saucepan on medium. Add the ciabatta and lightly brown the cubes, then remove them to a paper towel to drain. Season them with sea salt to taste.

Add the remaining oil to the pan, add the garlic and sauté on low until lightly browned. Add the chili flakes and vermouth. Simmer until the vermouth is reduced by half. Add the tomatoes, season with sea salt, and simmer the soup for about 5 minutes, until the tomatoes have given up their juices but still hold their shape.

Divide the soup among four bowls, garnish with some croutons and a sprig of basil, and serve.

COOK'S NOTES The ripe richness of tomatoes in season takes center stage in this soup; do not attempt it with out-of-season tomatoes. As for the basil, pluck off the topmost, small sprigs from the branches. It's a delicate garnish. The soup does extremely well when served warm, not piping hot.

SECOND HELPINGS
Send any leftovers to the freezer—and, if you are savvy, make extra. That way you can recapture the flavor of midsummer in the off-season.

CAULIFLOWER SOUP WITH CAPERS AND BLACK OLIVES

Cesare Casella is the Tuscan chef known for always sporting a sprig of herbs in his jacket pocket. His food, served at the tiny restaurant he runs on the Upper West Side is simple and fragrant, like this velvety soup. The addition of tapenade and capers gives it personality. Omit the dairy and vegans will love it.

6 SERVINGS

1 tablespoon extra virgin olive oil, plus more for garnish

1½ cups diced red onion

2 cloves garlic, minced

2 cups peeled, diced russet potatoes (about 2 medium)

2½ cups cauliflower, cut into small florets

3 cups vegetable stock

2 bay leaves

Pinch of nutmeg

Salt

¾ cup whole milk, heavy cream, or crème fraîche

Freshly ground black pepper

2 tablespoons black olive tapenade

1 tablespoon tiny capers

Heat the oil in a large soup pot or saucepan. Add the onion and garlic and sauté on medium until they are translucent. Do not allow them to brown. Add the potatoes and cauliflower, stir briefly, then add the stock, bay leaves, and nutmeg. Bring the soup to a simmer, cover it, and cook until the vegetables are tender, about 30 minutes.

Remove the bay leaves and puree the soup in a blender. You will probably have to do this in two or three batches. Return the soup to the pot and season it to taste with salt. Add the milk and bring it to a simmer. If not serving right away, remove the pot from the heat, cover it, and set it aside until serving time.

To serve, reheat the soup if necessary, season with pepper, and ladle it into warm soup plates. Garnish each serving with a drizzle of oil, 1 teaspoon of tapenade, and a few capers.

COOK'S NOTES You can use a food processor instead of a blender, but the results will not be as silky. Whether to use milk, heavy cream, or crème fraîche depends on how rich you'd like the soup. The soup can be made in advance and refrigerated overnight.

SECOND HELPINGS
This soup is excellent served cold, like a vichyssoise. It also welcomes the addition of a seafood garnish such as poached mussels or oysters.

FALL SQUASH SOUP

In the international portfolio of restaurants owned by Daniel Boulud, DBGB is the least French and the least refined. It's a beer hall on the Bowery, known for sausages and suds. This smooth squash soup is subtly spiced.

6 SERVINGS

1 inch orange peel

1 crushed cardamom pod

1 tablespoon crushed coriander seed

1 bay leaf

2 pounds winter squash, preferably an assortment: butternut, delicata, kabocha

1 tablespoon extra virgin olive oil

Salt and freshly ground white pepper

2 tablespoons unsalted butter

1 small onion, chopped

1 small carrot, chopped

1 celery stalk, chopped

2 cloves garlic, chopped

1½ teaspoons seeded, minced jalapeño

1 tablespoon minced fresh ginger

½ teaspoon ground mace

¾ cup orange juice

¾ cup crème fraîche

Goat cheese garnish (recipe follows)

⅓ cup pumpkin seeds, toasted

2 tablespoons pumpkin seed oil

Preheat the oven to 350° F. Tie the orange peel, cardamom, coriander, and bay leaf into a small bundle, using cheesecloth.

Slice each squash in half lengthwise and scoop out the seeds. Rub olive oil on the flesh. Season it with salt and pepper. Wrap each piece in foil and place it on a baking sheet cut side down. Roast for 1½ hours, until the squash is tender. Let it cool.

Place a 4-quart casserole or heavy pot on medium heat. Add the butter and let it become nut-brown. Add the onion, carrot, celery, garlic, jalapeño, ginger, prepared spice bundle, and mace. Sprinkle the mixture with salt and pepper. Cook for 6 to 8 minutes, until the vegetables are lightly browned. Unwrap the squash and scoop the flesh into the pot. Add the orange juice and 4 cups water and bring the soup to a simmer. Cook, stirring occasionally, for 30 minutes.

Remove the spice bundle. Transfer the contents of the pot to a blender along with the crème fraîche and puree until the soup is smooth. You may have to do this in several batches. Strain the soup through a sieve into a clean saucepan. Bring it to a simmer, add salt and pepper to taste. If necessary, adjust the texture of the soup with a little more water; it should not be too thick.

When you are ready to serve, reheat the soup. Ladle it into soup plates and garnish each serving with the goat cheese mixture. Scatter on the pumpkin seeds and drizzle with pumpkin seed oil. Serve at once.

COOK'S NOTES The soup can be prepared in advance, as can its garnish, and refrigerated overnight. When reheating it, you may need to adjust the consistency, as it may have thickened.

SECOND HELPINGS
A small amount of leftover soup can be pooled on plates and used as an underpinning for roast pork or game.

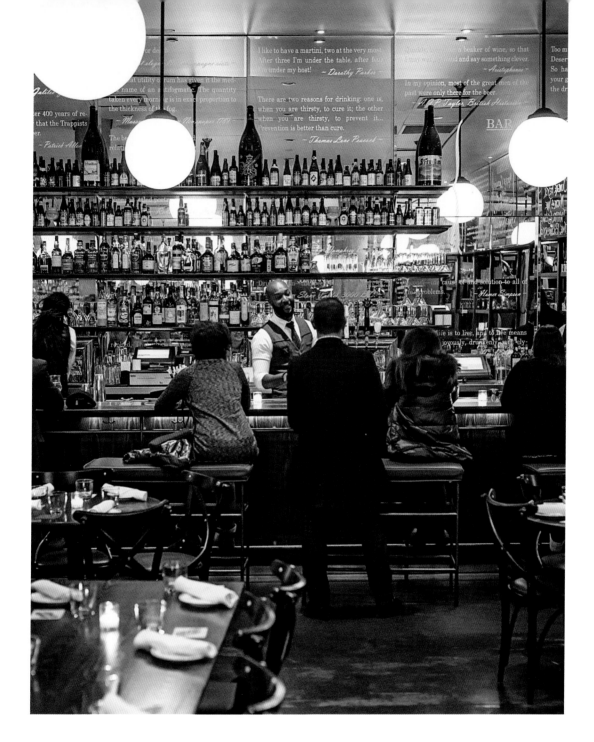

GOAT CHEESE GARNISH
ABOUT ½ CUP

½ cup plain soft goat cheese

1½ tablespoons crème fraîche

Pinch of salt

Pinch of nutmeg

Pinch of cayenne

In a bowl, mix together the goat cheese with the crème fraîche, salt, nutmeg, and cayenne until smooth.

LENTIL SOUP WITH PANCETTA

This restaurant was a sibling to Franny's (see page 84) and was installed in the original Franny's space in Brooklyn. It has closed. But it was best known for deeply flavored, rustic Italian fare like this soup, which takes no prisoners. It is hearty enough to anchor a meal when the weather blusters.

6 TO 8 SERVINGS

1⅓ cups lentils

Salt

⅓ cup extra virgin olive oil

½ cup finely diced pancetta (about 3 ounces)

¼ cup sliced garlic

1½ teaspoons minced fresh rosemary

1½ teaspoons minced fresh sage leaves

½ teaspoon minced chile de árbol

1 cup finely diced onion

½ cup finely diced celery

½ cup finely diced carrot

½ cup finely chopped parsley

⅓ cup dry red wine

1 tablespoon red wine vinegar

Place the lentils and 6 cups water in a saucepan. Bring the water to a boil, reduce the heat to low, and simmer until the lentils are tender, about 20 minutes. Season with salt. Set aside.

Heat the oil in a 4-quart saucepan. Add the pancetta and cook on medium low until the pancetta starts to brown. Add the garlic, rosemary, sage, and árbol and cook until the garlic softens and barely starts to brown. Add the onion, celery, and carrot and cook until they are soft. Add the parsley and wine, stir, then add the lentils, along with any liquid. Cook for about 10 minutes, until the lentils are very soft. Remove the pan from the heat and add the vinegar.

Scoop out and set aside about 1½ cups of the lentils and vegetables, but no liquid. Puree the remaining soup, adding enough water to make 5 cups. Stir the reserved lentils and vegetables back into the mixture. Reheat the soup to serve at once or cover and let cool. Refrigerate until ready to serve.

Reheat the soup and check the seasoning.

COOK'S NOTES If your preference is for a smoother soup, do not set any lentils and vegetables aside. Puree it all. Using a blender instead of a food processor will result in a finer texture. If desired, the pancetta can be omitted, and the soup will be vegan.

SECOND HELPINGS
This soup freezes extremely well.

MUSHROOM BOUCHE

The collection of restaurants that belongs to Michael White and his partners covers various regions of Italy and several dining styles, including a rustic trattoria, a pizzeria, a country inn, a steak house, and more formal venues. This recipe is from a place in the latter category, on the Upper East Side. It is deeply mushroom flavored, silken, and sumptuous enough for an elegant dinner.

1 pound white mushrooms

Salt

3 tablespoons extra virgin olive oil

1 large onion, sliced

½ cup sliced shallots

1 clove garlic, sliced

1 cup dry Marsala

2 cups mushroom stock or vegetable stock

1 cup milk

3 sprigs thyme

½ cup heavy cream, optional

1 tablespoon lemon juice

Freshly ground black pepper

Quarter the mushrooms. Place them in a food processor and process until very finely minced. Transfer the mushrooms to a clean towel, dust them with salt, and squeeze the mushrooms in the towel over a bowl to extract as much liquid as possible. Reserve the liquid.

Heat the oil in a 3-quart saucepan on medium. Add the mushrooms and sauté them until they look dry and have started to brown, about 10 minutes. Add the onion, shallots, and garlic and cook, stirring, until the onion and shallots are soft but not brown. Add the Marsala and let it reduce by half.

Add the reserved mushroom liquid, the stock, and milk. Bring the soup to a simmer. Add the thyme. Simmer for about 30 minutes. Remove the thyme.

Transfer the mixture to a blender and puree until it is smooth. Return the soup to the saucepan. Stir in the cream, if desired, and the lemon juice. Season with salt and pepper. Serve hot.

COOK'S NOTES This soup is also delicious cold, especially if served with a dollop of sour cream topped with some sturgeon caviar.

SECOND HELPINGS
Extra soup can live in the refrigerator to be served another day. It can be stretched with other vegetable purees or even with black beans.

CRAB SOUP SERENA

Serena Bass, a caterer and style-setter based in the Meatpacking District, headed north to the heart of Harlem for her restaurant. And her fans have followed her there. Lido is Italian, but the menu gathers influences from afar—like this crab soup, which has a definite Low Country accent with its crabmeat and bell peppers. It's light yet richly textured. And it would welcome other seafood, including lobster, shrimp, mussels, or chunks of fish.

6 tablespoons unsalted butter

¼ cup finely diced green bell pepper

¼ cup finely diced red bell pepper

⅓ cup finely diced celery

¼ cup finely diced carrot

1 tablespoon minced garlic

Salt

⅓ cup all-purpose flour

4 ripe plum tomatoes, peeled and diced

⅓ cup dry white wine, preferably sauvignon blanc

5 cups chicken stock

2 bay leaves

Freshly ground black pepper

¾ cup heavy cream

12 ounces lump crabmeat, preferably jumbo

¼ cup minced fresh dill

1 tablespoon lemon juice

1½ teaspoons Tabasco, or to taste

Melt the butter over medium heat in a 3-quart saucepan. Add the bell peppers, celery, carrot, garlic, and 1 teaspoon salt. Cook until the vegetables have softened. Stir in the flour and cook for a few minutes, not letting the flour brown.

Add half of the tomatoes, the wine, stock, bay leaves, and ½ teaspoon black pepper. Simmer gently for 30 minutes. Set aside until ready to serve.

Bring the soup to a simmer and add the cream, crabmeat, dill, and lemon juice. Season with additional salt and pepper to taste. Stir in the Tabasco. Top each portion with a small spoonful of the remaining tomatoes. Serve.

COOK'S NOTES Despite its long ingredient list, this crab soup, actually a creamy but not overly rich bisque, is very easy to prepare. The base of this soup, without the crabmeat and cream, can be readied well in advance of serving time, even refrigerated overnight.

SECOND HELPINGS
Leftovers, pureed in a blender until smooth, can easily be used as a sauce for fish or seafood; it works especially well brushed on top of fish fillets or even split lobsters before they are broiled. Consider trying it as a sauce for fettuccine too.

PASTA
AND
GRAINS

BROCCOLINI FETTUCCINE

Now installed in a space on the Lower East Side about four times the size of the original East Village vegetarian spot, Dirt Candy has become more comfortable and better known. The name? An expression of Amanda Cohen's approach to vegetarian cooking, which has certainly caught on. You'll find that broccolini is sweeter than broccoli rabe, which is often used with pasta in southern Italy, making for a pleasingly mellow dish.

4 SERVINGS

2 bunches broccolini
(about 1 pound)

3 tablespoons unsalted butter

2 cups sliced porcini mushrooms
or shiitake mushroom caps
(about ½ pound)

Salt and freshly ground black
pepper

12 ounces fresh spinach fettuccine

¼ cup finely chopped basil or
flat-leaf parsley

1 tablespoon extra virgin olive oil

¼ cup freshly grated Parmigiano
Reggiano

4 poached eggs, kept warm,
optional

SECOND HELPINGS
If you wind up with more than a cup of the puree, hang on to it to use in soups.

Cut the tops off the broccolini and set them aside. You should have about 2 cups of tops. Trim off and discard the bottoms of the stems, chop the stems, and place them in a food processor. Puree, adding a couple of tablespoons of water to make the mixture fairly smooth. You should have about 1 cup.

Heat a pot of water for the pasta. Meanwhile, place the butter in a large sauté pan over medium heat. When it melts, add the mushrooms and sauté until they wilt, a couple of minutes. Add the broccolini puree and the reserved broccolini tops and sauté another minute or so, until the broccolini softens. Season the mixture with salt and pepper and remove the pan from the heat.

Add the fettuccine and a tablespoon of salt to the boiling water and cook the pasta until it's al dente, following the instructions on the package for the cooking time. Add a couple of spoonfuls of the pasta water to the mushroom and broccolini mixture. Drain the pasta and add it to the sauté pan. Add the basil and oil. Place the pan over low heat and cook for a few minutes, tossing everything together to combine. Check the seasoning.

Divide the pasta among four shallow soup plates, dust it with cheese, and, if desired, top each portion with a poached egg.

COOK'S NOTES Broccolini, bunches of stalks topped with broccoli-like florets, is fairly new to the market. It's a mild-tasting vegetable. If it's not available, regular broccoli can be substituted. Originally, the recipe called for a little of the puree to be used in making fresh broccolini fettuccine and if you're up for making your own, do incorporate the puree. It would also be good added to gnocchi dough or, well seasoned, as a ravioli filling.

FIDEOS WITH MUSSELS, CHORIZO, AND ALMONDS

Though Dos Caminos is a chain of Mexican restaurants, there is a selection of Spanish dishes on the menu, including this one, a classic preparation similar to paella that uses extra-fine noodles in place of rice. It's a delicious change of pace for the typical seasonings of saffron, tomatoes, and paprika bolstered with seafood and chorizo.

4 SERVINGS

About 3 cups chicken stock

½ cup dry white wine

½ teaspoon crumbled saffron threads

2 tablespoons extra virgin olive oil, plus more for garnish

6 cloves garlic, sliced

8 ounces Spanish chorizo, cut into ½-inch dice

2 tablespoons unsalted butter

1 medium-size onion, finely chopped

12 ounces fideos or angel hair pasta

1 pound mussels, scrubbed

1 cup diced ripe tomatoes

1 teaspoon hot smoked Spanish paprika

½ teaspoon crumbled dried chili, preferably chile de árbol

2 cups cooked chickpeas (a 15-ounce can), rinsed and drained

½ cup chopped flat-leaf parsley leaves

Salt and freshly ground black pepper

½ cup sliced almonds with skin, toasted (see Cook's Notes, page 157)

Place the stock and wine in a saucepan, bring it to a simmer, add the saffron, and keep the liquid at a bare simmer. Heat the oil in a 5- or 6-quart sauté pan on medium high, add the garlic, sauté until it is golden, then transfer it to a paper towel to drain. Add the chorizo to the pan, sauté until it is golden brown, and transfer it to a paper towel. Add the butter and onion, reduce the heat to medium, and sauté the onion until it is golden, about 5 minutes.

Add the fideos, breaking them up as you put them in the pan, and continue breaking them as they sauté; cook them for 4 to 5 minutes, until they turn golden. Add the stock mixture. Add the mussels, tomatoes, paprika, and chili; cover and cook until the mussels have opened, most of the liquid has been absorbed, and the fideos are tender.

Fold in the chickpeas, garlic, chorizo, and parsley. Season to taste with salt and pepper. Sprinkle the fideos with almonds and drizzle with a little more oil and serve.

COOK'S NOTES In Spain this dish would be cooked in a paella pan and served from the pan. If you have a 14-inch paella pan, you might consider using it for this recipe. But then, what to do for a cover? A sheet of heavy-duty foil is all you need.

SECOND HELPINGS
You can transform this dish into something even grander by adding shrimp, lobster, or clams along with the mussels, and cooking the recipe in a larger pan to serve at least eight. Either way, any leftovers are delicious stirred into a simple tomato soup.

BUCATINI RICCI DI MARE

Having been named to run the new restaurant in the Brooklyn Museum, Saul Bolton closed his popular flagship on Smith Street in Cobble Hill. He now gives museumgoers and others a taste of serious food in a cultural setting, a trend that is playing out all over the city. This recipe for "riches of the sea," featuring sea urchins and butter, yields a dish that's as rich as can be—and a shot of chili muscles in too. Consider this a special-occasion dish, serving a small portion for each guest to start an intimate dinner party. It takes no more than 20 minutes, start to finish, so it's important to have all your ingredients ready.

4 TO 6 SERVINGS

Salt

12 ounces bucatini

3 tablespoons extra virgin olive oil

3 large cloves garlic, sliced paper-thin

Pinch of red chili flakes

2 cups dry white wine

1 tray (about 9 ounces) uni (sea urchin)

3 tablespoons unsalted butter, softened

1 tablespoon lemon juice

20 basil leaves, torn

5 pickled Italian hot peppers, preferably long red ones, cut in julienne

Place a pot of salted water over high heat for the pasta. Add the pasta when it comes to a boil.

Meanwhile, heat the oil on medium in a large sauté pan. Add the garlic and chili flakes and cook until the garlic starts to brown. Add the wine, increase the heat to medium high, and cook until it's reduced by half. Lower the heat.

Mash all but 2 tablespoons of the uni in a dish and add it to the pan along with the butter. Keep mashing the uni and butter with a fork so they become creamy. Stir in ½ cup of the pasta water. By this time, the pasta should be al dente. Drain it, reserving a little more of the water, and add it to the pan with the uni. Add the lemon juice, basil, and hot peppers. Season to taste with salt. Add the reserved pasta water if needed.

Divide the mixture among soup plates and top each with a few pieces of the reserved uni. Serve at once.

COOK'S NOTES Japanese markets and some specialty fish markets sell uni, bright orange and usually called the roe of the sea urchin. Actually, it's the gonads. It is also available online. Bucatini is thick, hollow spaghetti. Linguine can be substituted.

SECOND HELPINGS
Any leftover uni can be saved to serve on toast as an hors d'oeuvre.

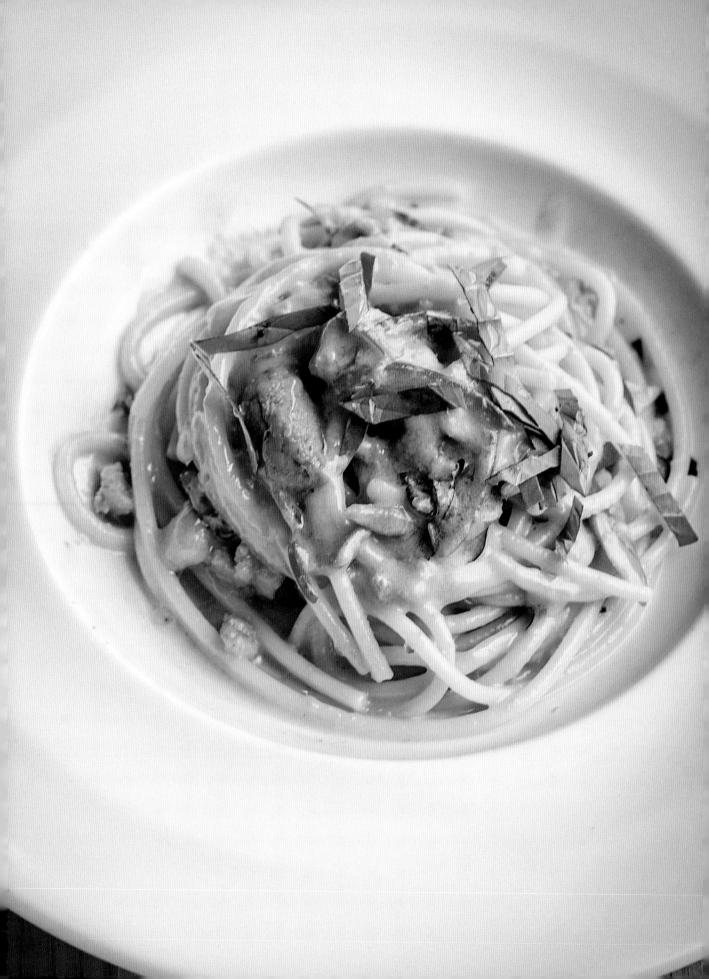

CLASSIC MACARONI AND CHEESE

Murray's, the premier cheese store in New York, opened a cheese-oriented café a couple of years ago, and mac and cheese is one of the specialties. The complexity of this dish results from the mixture of cheeses used in it.

4 SERVINGS

½ small onion

1 bay leaf

2 whole cloves

2 cups whole milk

6 tablespoons unsalted butter

1 small clove garlic, minced

¼ cup all-purpose flour

¼ teaspoon nutmeg

Cayenne

Freshly ground black pepper

4 ounces raclette, shredded

3 ounces Comté, grated

Salt

8 ounces elbow macaroni

5 ounces farmhouse Cheddar, grated

½ cup panko (coarse bread crumbs)

1 teaspoon fresh thyme leaves

Grated zest of ½ lemon

SECOND HELPINGS

Any leftovers can be refrigerated, then cut in slices and sautéed to serve alongside meat dishes or eggs. Fried mac and cheese is particularly suited to accompany barbecue.

Cut a slit in the onion half and poke a bay leaf in; stick the cloves in the onion. Place the milk in a small saucepan and add the onion. Bring the milk just to a simmer and turn off the heat.

Place 4 tablespoons of the butter in a 3-quart saucepan over medium heat. When the butter melts, add the garlic, let it sizzle briefly, then whisk in the flour until smooth. Cook briefly. Remove the onion from the milk, then gradually pour the milk into the pan, whisking all the while. Continue cooking until the sauce thickens. Add the nutmeg, cayenne to taste, and black pepper. Stir in the raclette and Comté, cooking until smooth. Remove the sauce from the heat.

Bring a pot of salted water to a boil for the macaroni and cook until it is al dente. Drain the pasta and place it in a large bowl. Fold all but 1 ounce of the Cheddar into the macaroni, toss to distribute it, then stir in the cheese sauce. Season the mixture with salt and more pepper if desired.

Preheat the oven to 350° F. Use a dab of the butter to grease a 2½-quart baking dish. Melt the remaining butter in a small skillet. Add the panko and cook on medium low until it begins to color. Fold in the remaining cheddar, the thyme, and the lemon zest. Remove the pan from the heat.

Pour the macaroni mixture into the baking dish. Smooth the top and scatter the panko mixture on the surface. Bake the casserole for about 20 minutes, until it starts to bubble and the panko is golden brown. Serve.

COOK'S NOTES There are variations galore to be attempted here; penne in place of macaroni for one. As for the variety of cheeses, the options include Parmigiano Reggiano, Gouda, Beaufort, Manchego, Gruyère, Pleasant Ridge Reserve, and even some blue-veined varieties, to name a few.

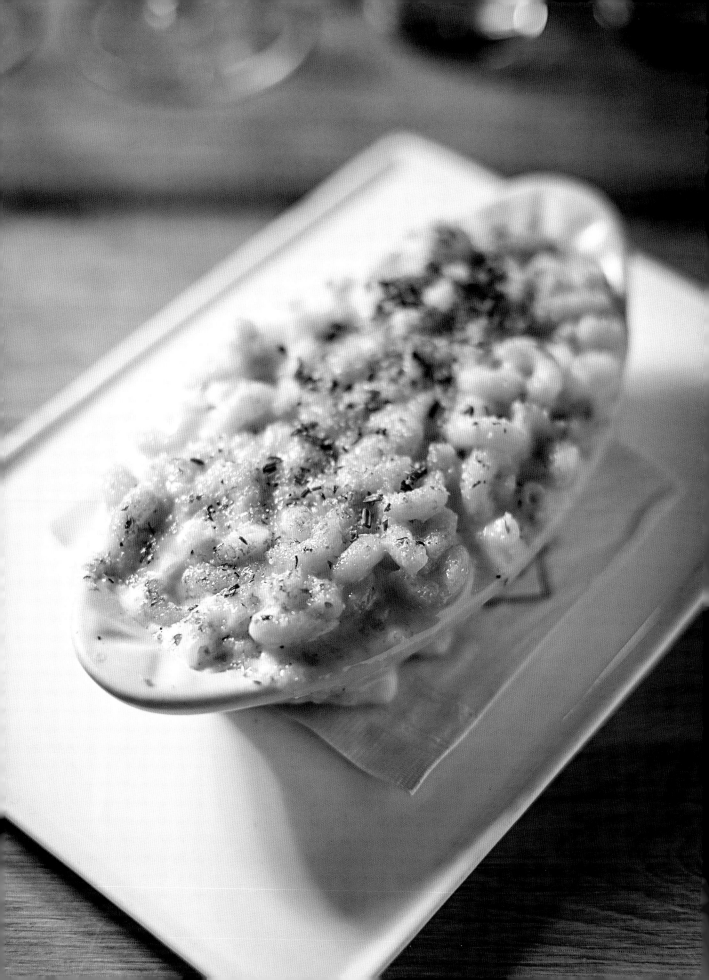

FUSILLI WITH SAUSAGE, CANNELLINI BEANS, AND CHILIS

This popular restaurant, the work of Francine Stephens and Andrew Feinberg in Park Slope, Brooklyn, is best known for its pizzas. But their pasta dishes are worthy of note, like this one that involves a few offbeat, personal touches. Scallions and lemon bring bright freshness to the dish, which otherwise might be a heavy challenge with its sausage and beans.

4 SERVINGS

4 tablespoons extra virgin olive oil

12 ounces sweet Italian sausage, casings removed

8 cloves garlic, sliced

2 cups cooked cannellini beans (a 15-ounce can), drained and rinsed

1 teaspoon crushed red chili flakes

Salt

12 ounces fusilli

¼ cup sliced scallions

Juice of 1 lemon

Heat a large sauté pan on medium. Add 3 tablespoons of the oil. Add the sausage and cook, stirring and breaking it up with a large fork until it is uniformly crumbly and golden brown. Stir in the garlic and cook it for about a minute; don't let it brown. Fold in the cannellini beans, cook for a couple of minutes, then stir in the chili flakes.

Add ¾ cup water and bring the mixture to a simmer. Remove it from the heat.

Bring a large pot of salted water to a boil for the pasta. Cook the fusilli until it is al dente, and reserve ½ cup of the pasta water. Drain the pasta and add it to the sauté pan; place it over medium heat. Add the scallions. Cook for a few minutes, until the pasta becomes glazed with the sauce. Add some pasta water if needed to keep everything moist. Check the seasoning. Stir in the lemon juice.

Divide the pasta among four plates or bowls and drizzle it with the remaining oil.

COOK'S NOTES You could ramp up the chili factor by using half sweet, half hot Italian sausage, or even all hot sausage.

SECOND HELPINGS
Don't you love cold pasta straight from the fridge as a late-night snack?

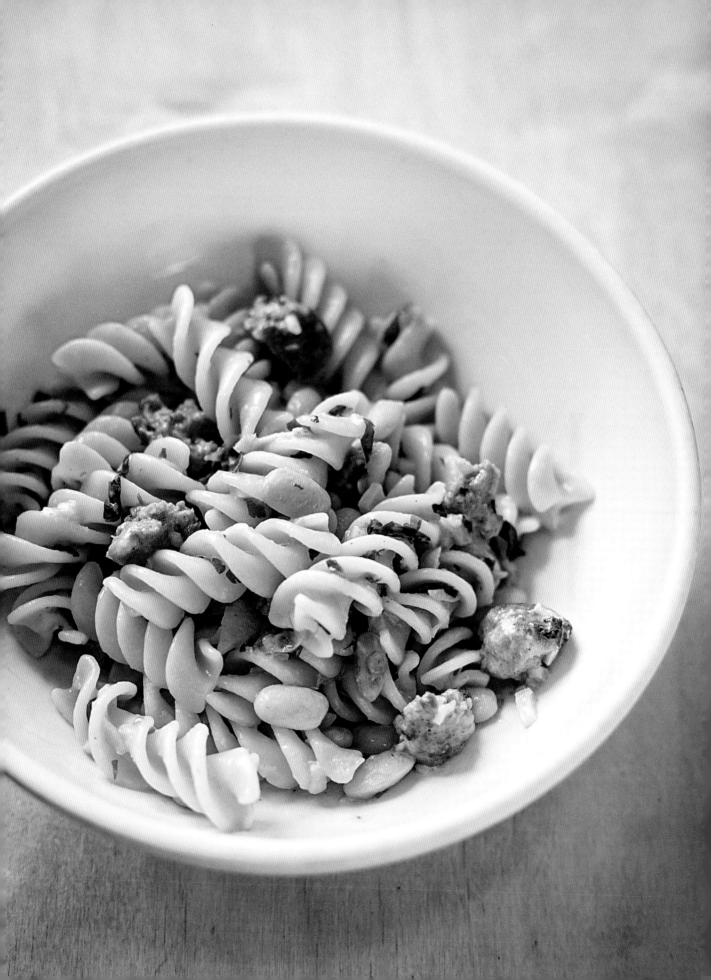

LINGUINE WITH CLAMS

In an urban seafood shack, lobster is king. But in addition, Ed McFarland offers chowders, stews, and his take on Italian linguine with clams. What sets his recipe apart is the knob of butter, making a suave enrichment for the briny sauce.

4 SERVINGS

3 tablespoons extra virgin olive oil

3 cloves garlic, chopped

¼ cup panko (coarse bread crumbs)

2 teaspoons mayonnaise

3 tablespoons minced flat-leaf parsley

1 tablespoon freshly grated Parmigiano Reggiano

Salt and freshly ground black pepper

1 cup clam juice

3 dozen littleneck clams, scrubbed

12 ounces linguine

½ teaspoon crushed red chili flakes, or to taste

2 tablespoons unsalted butter

Heat 2 tablespoons of the oil in a skillet on medium. Add one-third of the garlic and cook until it is barely starting to color. Add the panko and cook, stirring, until the crumbs are golden brown. Stir in the mayonnaise and 1 tablespoon of the parsley. Remove the mixture from the heat. Fold in the cheese. Season the mixture with salt and pepper and set it aside.

Bring a large pot of salted water to a boil for the pasta. Meanwhile, heat the remaining oil in a large sauté pan. Add the remaining garlic. When it barely starts to color, add the clam juice. Add the clams to the pan, cover it, and cook on medium until they open, 7 minutes or so, discarding any clams that have not opened. Meanwhile boil the linguine until it is al dente, about 7 minutes.

Use a slotted spoon to fish the clams from the pan and transfer them to a bowl. Cover it. Add the red chili to the pan, adjusting the amount as desired. Add the butter and cook on low until it melts. Add the remaining parsley.

When the linguine is done, reserve 1 cup of the pasta water. Drain the linguine and transfer it to the pan. Toss it with the other ingredients to amalgamate everything. Use tongs to divide the linguine among four shallow soup plates. Place the clams in their shells on top, dividing them equally among the bowls. Pour the broth over each portion, adding some pasta water if needed so there is some liquid in the bowls without making the dish soupy. Scatter the bread crumbs on top and serve.

COOK'S NOTES Manila clams can be used in place of the littlenecks. Try to buy fresh or frozen clam juice from a fish market instead of using the bottled kind, which can be too salty.

SECOND HELPINGS
Keep any extra bread crumbs on hand, refrigerated, for other uses.

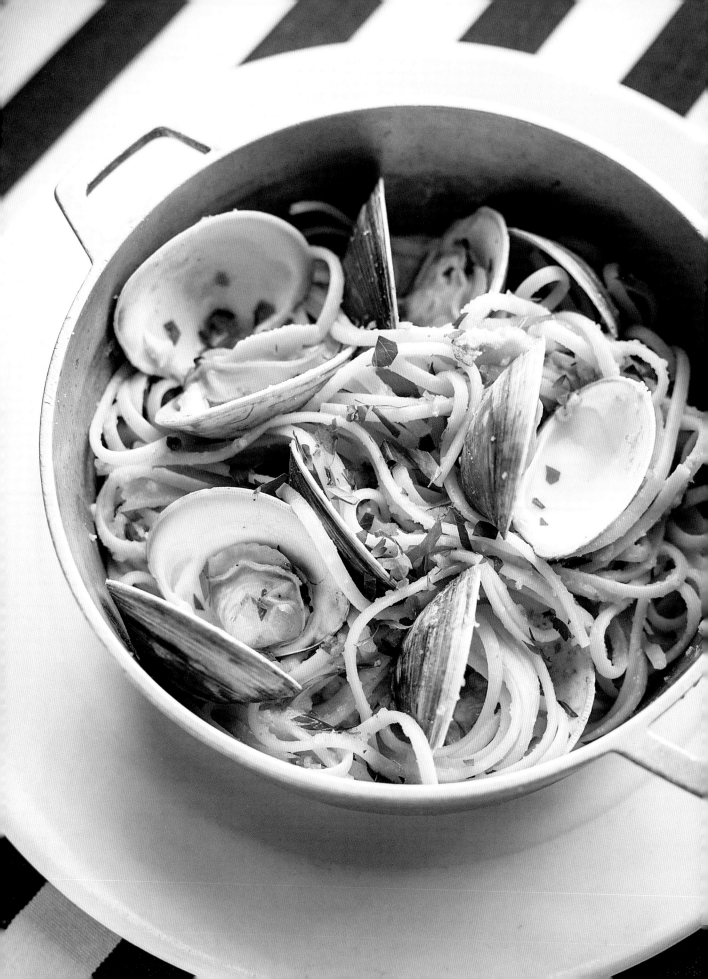

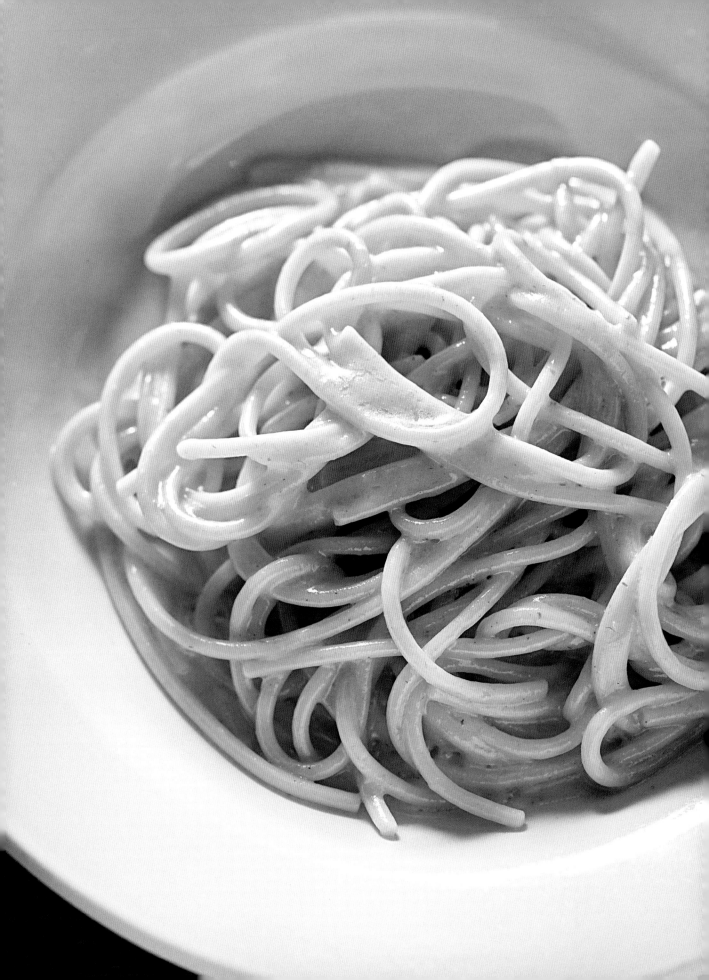

SPAGHETTI WITH BUTTER AND ANCHOVIES

This is not a classic Roman dish like much of what's on Maialino's menu, but its simplicity is typical of the food of Rome. It packs rich flavor, delivering the sort of slightly funky, intriguing element that the Japanese call umami, the "fifth taste."

1 pound spaghetti

Salt

2 tablespoons extra virgin olive oil

12 fillets cured anchovies in oil

4 ounces (1 stick) unsalted butter, in pieces

2 tablespoons colatura (Italian anchovy extract) or Vietnamese fish sauce (nuoc mam)

Freshly ground black pepper

2 tablespoons freshly grated Grana Padano or Parmigiano Reggiano

4 TO 6 SERVINGS

Bring a large pot of water to a boil for the spaghetti. Salt it lightly. Add the spaghetti and cook until it is al dente, about 6 minutes.

Meanwhile, heat the oil in a 12-inch skillet on medium. Add the anchovies and stir them in the oil as they start to break up. Scoop out 1 cup of the pasta water and add half to the skillet. Stir.

When the pasta is al dente, drain it, but not too thoroughly, and add it to the skillet. Add the butter and colatura. Using tongs, stir the pasta in the skillet with the other ingredients until the strands are well coated. Add a little more pasta water if needed so there is creamy moisture clinging to the pasta. Season with salt and pepper.

Add the cheese, stir, and serve at once, while hot.

COOK'S NOTES Because this recipe is so quick to assemble, it pays to be well organized and to have all the ingredients ready before you turn on the stove.

SECOND HELPINGS
Though this dish needs no further embellishment, it can also be the base for variations. A light dusting of toasted bread crumbs along with the cheese would not be a mistake. Also, try tossing in some diced sautéed zucchini, blanched English peas, or finely chopped ripe tomatoes and slivered basil or mint.

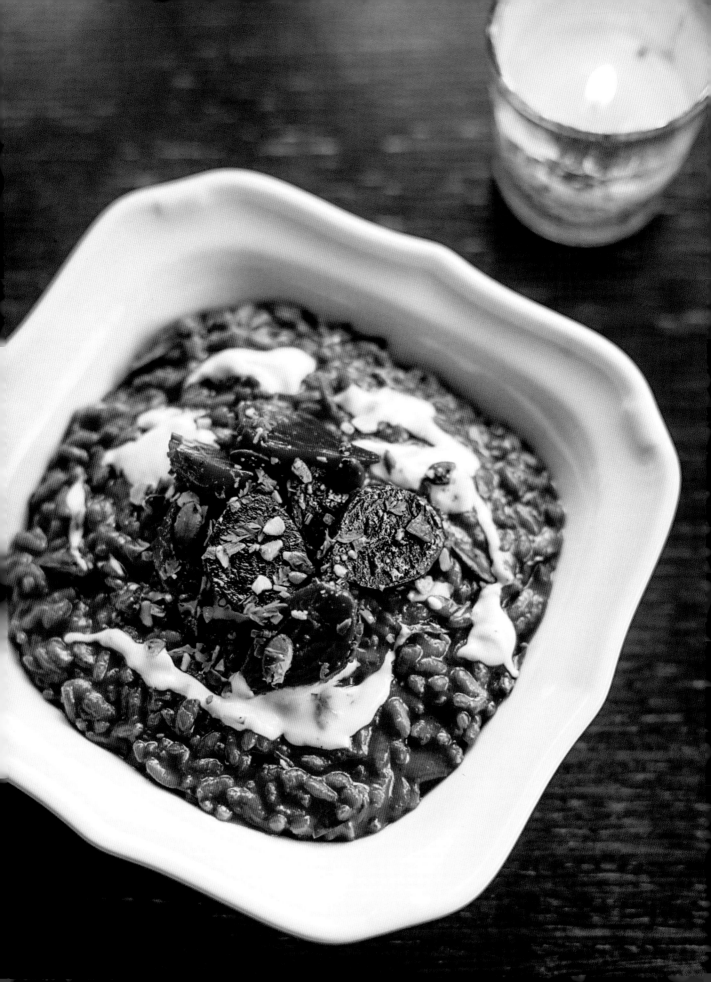

BEET AND GOAT CHEESE RISOTTO

Bryan Calvert, the chef and co-owner of this elegant restaurant in Prospect Heights, Brooklyn, has cleverly and successfully reinterpreted that perennial favorite, the beet salad with goat cheese, as a risotto. Beet juice tints the rice while the tangy goat cheese plays off against the sweetness of the beets that garnish it.

1 bunch baby beets, or two medium-large beets, preferably golden, with greens

3 tablespoons extra virgin olive oil

Salt and freshly ground black pepper

4 ounces plain soft goat cheese, at room temperature

1 teaspoon lemon zest

3 cups vegetable stock

1 tablespoon unsalted butter

2 small cloves garlic, minced

1 tablespoon minced shallot

1½ cups Arborio rice

2 sprigs fresh thyme

¼ cup dry white wine

1 cup beet juice

2 tablespoons freshly grated Parmigiano Reggiano

Scrub the beets. Trim off the tops and choose five or six of the nicest leaves; rinse, dry, and chop them. Peel the baby beets and slice them ¼ inch thick. If you're using larger beets, peel and quarter them, then slice them.

Heat 1 tablespoon of the oil in a sauté pan on medium low, add the beet slices, and sauté, stirring from time to time, until the beets are lightly seared and tender, about 10 minutes. Season with salt and pepper, remove the beets from the pan, and keep them warm in a covered dish. Add another tablespoon of the oil and sauté the greens just until they wilt. Remove them to a bowl.

Mash the goat cheese with the remaining olive oil, the lemon zest, and ½ teaspoon black pepper. Set it aside.

Place the stock in a small saucepan on low heat to keep warm.

Heat the butter in a shallow saucepan or sauté pan. Add the garlic and shallot and sauté on low until they turn translucent, about 5 minutes. Add the rice. Cook, stirring, until the grains whiten and start to toast. Add the thyme sprigs and the wine; stir and cook until the wine is absorbed by the rice. Add the stock, ½ cup at a time, waiting each time until the liquid is absorbed before adding more. When all the stock is used, the rice should be almost done. Add the beet juice. Continue cooking another minute or so, until the rice is al dente. Stir in the beet greens, half of the goat cheese mixture, and the Parmigiano Reggiano. Remove the pan from the heat. Check the seasoning. Remove the thyme sprigs.

Divide the risotto among four dinner plates or shallow soup plates and top each portion with some of the remaining goat cheese. Scatter the sautéed beet slices on top. Serve.

COOK'S NOTES So of course you will wonder how to obtain beet juice. The easiest method is to own a vegetable juicer or pick some beet juice up at your neighborhood juice bar. But strain the juice because you do not want any pulp. You could also buy canned beets and drain them for their juice.

SECOND HELPINGS
You may wind up with extra beet juice. Add it to smoothies.

PARMESAN RISOTTO

This restaurant takes a great deal of explaining. Originally the space was occupied by Montrachet, a pioneer in the TriBeCa neighborhood. It enjoyed a good run but closed after 9/11. The owner, Drew Nieporent, took quite a few years to reopen it, due to all sorts of partnership and chef complications. It finally reemerged as Corton, with the avant-garde English chef, Paul Liebrandt, in charge. The subtext for all of this is the fact that both Montrachet and Corton are the names of highly esteemed Burgundy wines. Liebrandt left after five years, in 2013. So much for Corton. Rather than simply hire a new chef, Nieporent redid the space somewhat, giving it a less formal ambiance. Now it is called Bâtard, which is a subcategory of the Montrachet canon. The chef, Markus Glocker, is Austrian.

½ cup English peas

About 6 cups vegetable stock

3 tablespoons extra virgin olive oil

2 shallots, minced

1 clove garlic, minced

1½ cups Arborio rice

½ cup dry white wine

Salt and freshly ground black pepper

½ cup mascarpone cheese

1 ounce Parmigiano Reggiano, grated

A few sprigs of watercress

Bring 1 quart of water to a boil and add the peas; cook them for 5 minutes, then drain and place them in a small bowl of ice water. Drain and set them aside. Place the stock in a saucepan and keep it warm on low heat.

In a shallow saucepan, heat the oil on medium. Add the shallots and sauté them briefly, until they are softened but not brown. Add the garlic, cook it for about half a minute, then add the rice. Stir for a few minutes until the rice starts to whiten. Add the wine and cook until it has nearly evaporated. Stir in the stock ½ cup at a time, adding more only after the previous addition has been absorbed. Cooking the rice in the stock should take no more than 18 minutes.

Remove the risotto from the heat, season it with salt and pepper, and fold in the mascarpone. Fold in the Parmigiano Reggiano, divide the risotto among shallow soup plates, and top each portion with peas and watercress. Serve at once.

COOK'S NOTES Making a proper risotto does not require constant stirring. Every few minutes is enough. This chef's addition of mascarpone gives the dish a seductive creaminess. It's a trick that can be applied to all sorts of risottos. To serve, the chef dusts the risotto with powdered dried herbs (chervil, chives, parsley), easily done in a mortar.

SECOND HELPINGS
Any leftover risotto is excellent chilled, then shaped into little pancakes and fried. It can also be added to omelets or scrambled eggs.

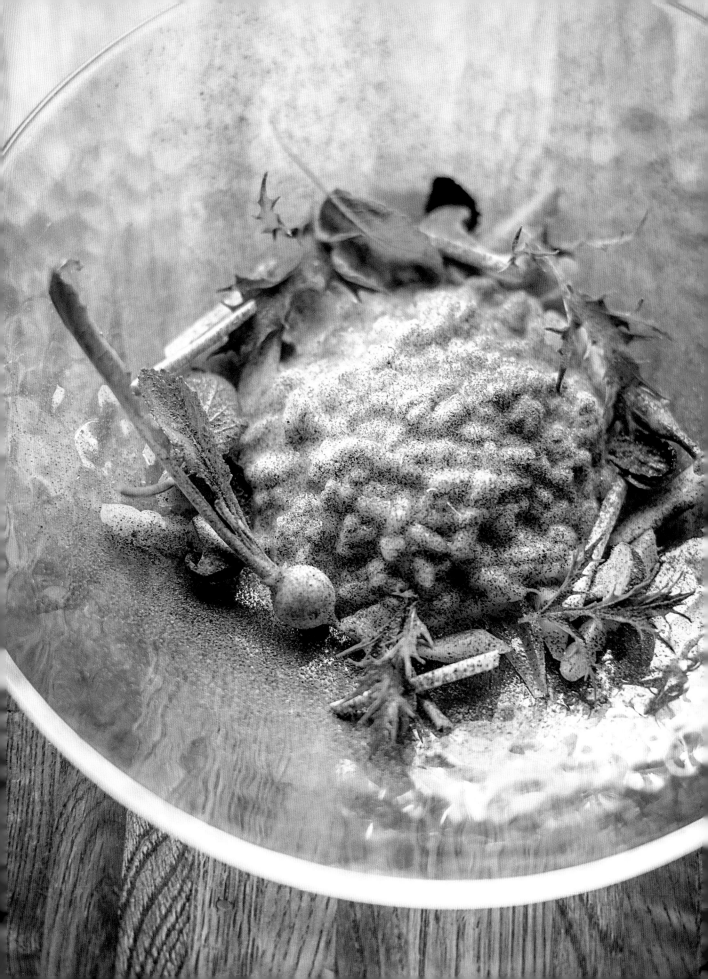

BLUE HILL AND BLUE HILL AT STONE BARNS

GRAIN RISOTTO WITH CORN PUREE AND GRILLED CORN

Blue Hill at Stone Barns is about as locavore as it gets. The property, a Rockefeller estate in a northern suburb of New York City, is also a working farm, complete with livestock. Dan Barber's Blue Hill restaurant in Greenwich Village opened prior to establishing Stone Barns, and now it, too, profits from the produce, meats, chicken, eggs, and so forth that the sibling property provides. This earthy, nutty-tasting dish brightened with fresh corn is a risotto by virtue of the texture of the grains and corn.

6 TO 8 SERVINGS

6 tablespoons vegetable oil, preferably grapeseed

2 carrots, peeled

1 medium-large onion, halved

1 stalk celery

2 cups ancient wheat: farro, spelt, or a mixture

1 bay leaf

Salt and freshly ground black pepper

1 clove garlic, minced

6 ears fresh corn, shucked, kernels removed from 4 of them

2 sprigs fresh thyme

1 cup vegetable stock

1 tablespoon minced flat-leaf parsley leaves

1 tablespoon minced chives

2 teaspoons sherry vinegar

Freshly grated Parmigiano Reggiano, optional

SECOND HELPINGS
Any leftover grains are excellent to add to soup or even breakfast pancakes.

Heat 2 tablespoons of the oil in a 4-quart sauté pan. Add one of the carrots, an onion half, and the celery. Cook on low for 5 minutes. Stir in the grains and toast for a few minutes on low. Add 5 cups water and the bay leaf, and season with salt and pepper. Cover and cook the mixture on low for about 40 minutes, until the grains are tender but not mushy.

Meanwhile, finely chop the remaining carrot and onion half. Heat 2 tablespoons of the oil in a heavy sauté pan on medium low. Add the chopped carrot and onion and the garlic. Season with salt and pepper. Cook until the vegetables are lightly browned. Add the corn kernels, increase the heat to high, and sauté for 5 minutes. Add the thyme and vegetable stock. Simmer for 5 minutes. Check the seasonings.

Remove the thyme. Let the mixture cool somewhat, then transfer to a blender and puree. Strain it through a sieve. You should have about 2 cups.

Heat a grill, grill pan, or cast iron skillet to hot. Brush each of the remaining 2 ears of corn with 1 tablespoon of the oil. Sear the corn on the grill until it is lightly charred. As soon as the corn is cool enough to handle, shave the kernels from the cobs. Set them aside.

When the grains are done, remove and discard the onion, carrot, celery, and bay leaf. Strain the grains through a sieve, reserving the liquid. Return the grains to the sauté pan. Stir in the corn puree, about ½ cup of the grain cooking liquid (if there is less, make up the difference with water), and the grilled corn kernels. Season with salt and pepper. Cook on low to reheat the grains. Fold in the parsley, chives, and vinegar. Adjust the seasonings. Serve with grated cheese on the side.

COOK'S NOTES This dish has some flexibility in its construction. Though it's best made in summer or early fall, when fresh corn is at its peak, it can be made with frozen corn kernels. Other vegetables, like diced bell peppers, Jerusalem artichokes, or mushrooms, especially chanterelles, can be added.

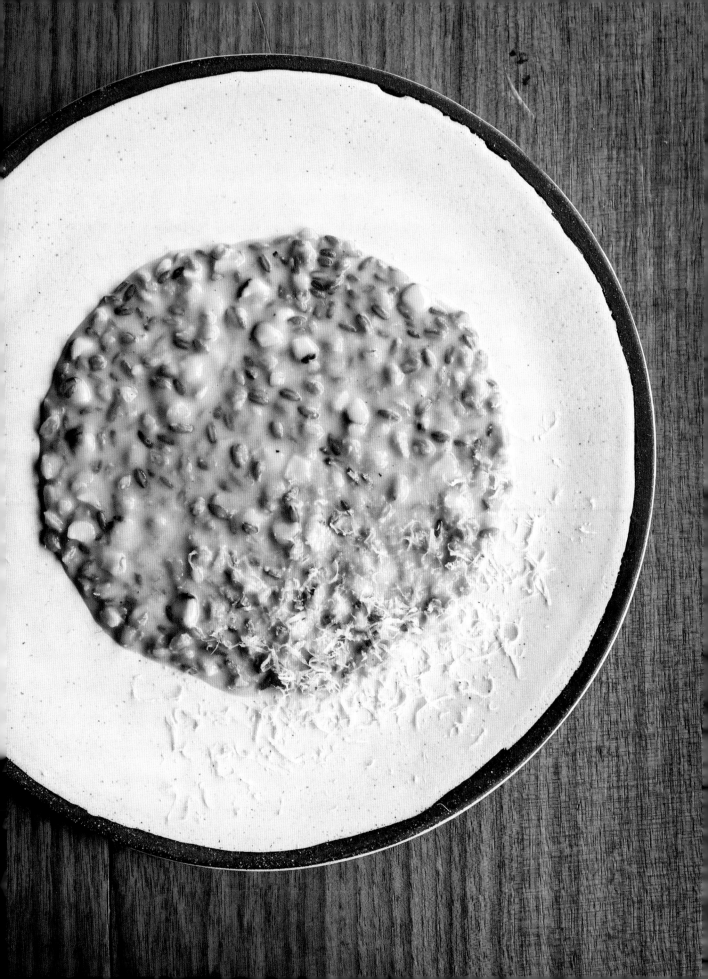

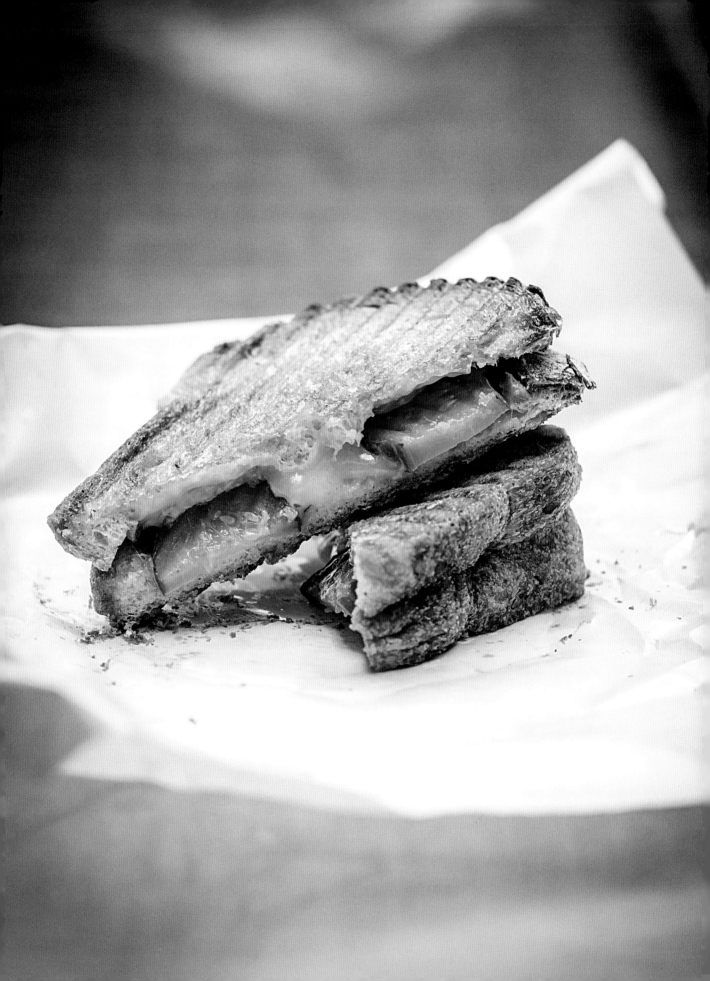

"PAWLIE" GRILLED CHEESE AND PICKLE SANDWICH

The small shop in the Essex Street Market on the Lower East Side is the tip of the iceberg. Anne Saxelby has a warehouse in Brooklyn from which she runs a thriving wholesale business, selling only American-made artisanal cheeses and other dairy. This sandwich calls for Pawlet, a Fontina-style cheese from Vermont. It is not your typical grilled cheese sandwich choice, but it produces beautifully gooey results between slices of buttery toast.

4 slices, each ¾ inch thick, firm white bread, preferably from a Pullman loaf

3 tablespoons unsalted butter, softened

6 ounces Consider Bardwell Pawlet cheese, or other smooth and nutty cheese such as Italian Fontina or Swiss Appenzeller

¼ cup chopped spicy pickles

Spread the bread slices with the butter on one side. Remove the rinds from the cheese, slice the cheese ¼ inch thick, and trim it to fit the bread.

Place a large cast iron skillet or a griddle on high heat. Place two slices of the bread, buttered side down, on a work surface. Spread pickles on each one, then top them with the cheese. Cover each sandwich with a second slice of bread, placed buttered side up.

Arrange the sandwiches in the skillet, lower the heat to medium, and toast until they are golden brown, pressing them with a spatula. When the bottom sides have browned, turn the sandwiches and cook until the other sides brown.

Cut each into two or four pieces on the bias and serve.

COOK'S NOTES Be sure your butter is very soft so it can be spread in a nice slick without tearing the bread. Butter straight out of the fridge can be cut into pats and softened in a microwave oven for about 10 seconds. But watch carefully; you do not want melted butter.

2 SERVINGS

SECOND HELPINGS
If you cut each sandwich into eight pieces, you have tasty hors d'oeuvres to serve with cocktails.

MARC HAEBERLIN

EMERIL LAGASSE

PAUL BOCUSE

ANDRÉ SOLTNER

GORDON RAMSAY

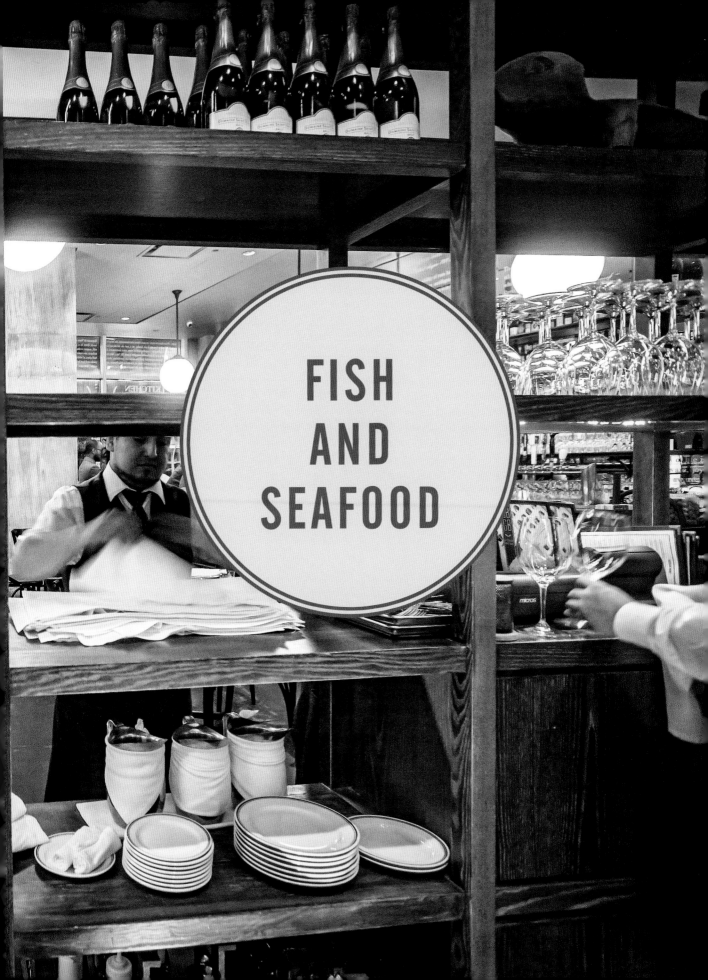

AFRO-ASIAN SALMON WITH LENTIL SALAD AND GINGER-SOY DRESSING

For this dish, the chef, Alexander Smalls, who works with the Cecil, a new Harlem restaurant, gives a nod to Africa, with the sweet potatoes, and to Asia, with ginger, soy sauce, and sesame. A fish as robust as salmon is not daunted by all these elements. Many of the dishes on his menu are similarly crosscultural and boldly flavored.

4 SERVINGS

2 medium-size sweet potatoes

¾ cup black lentils

Salt

2 tablespoons rice vinegar

2 tablespoons lime juice

3 tablespoons soy sauce

4 tablespoons toasted sesame oil

4 tablespoons grapeseed oil

⅓ cup minced shallots

1 teaspoon grated fresh ginger

1 clove garlic, minced

½ teaspoon crushed red chili flakes

1 teaspoon Dijon mustard

1 tablespoon molasses

Cinnamon

Coarsely ground black pepper

¼ cup thinly sliced red onion

⅓ cup dried currants

4 (6-ounce) pieces wild Pacific salmon fillet, skinned

4 cups baby spinach

Preheat the oven to 400° F. Roast the potatoes for about 40 minutes, until they are tender when pierced with the tip of a knife. Set them aside to cool. Meanwhile, bring 3 cups of water to a boil in a 2-quart saucepan, add the lentils, and simmer until they are just tender, about 40 minutes. Drain and transfer them to a large bowl; season with salt.

In a separate bowl, combine the rice vinegar, lime juice, soy sauce, half of the sesame oil, 4 tablespoons of the grapeseed oil, the shallots, ginger, garlic, chili flakes, mustard, molasses, and a pinch of cinnamon. Season the mixture with pepper and beat until smooth.

Remove and discard the skin from the potatoes and dice the flesh; add to the lentils along with the red onion and currants. Gently fold these ingredients together. Fold in half of the dressing.

Brush the salmon with the remaining sesame oil, a pinch or two of cinnamon, and salt and black pepper to taste. Heat a cast iron skillet or grill pan to very hot. Add the salmon and sear the pieces for 2 to 3 minutes on each side for medium rare to medium. Transfer them to a platter and brush them with some of the remaining dressing. Fold the spinach into the lentil salad and add the remaining dressing.

Pile the salad in the center of a platter, surround it with the portions of salmon, and serve.

COOK'S NOTES Wild Pacific salmon—king or sockeye—not farm-raised Atlantic salmon, is the best fish for this recipe. Cook salmon no more than medium to retain its moist richness. Other fish, including arctic char, black sea bass, red snapper, or wild striped bass would be good choices for this preparation too; they should be cooked longer than salmon.

SECOND HELPINGS
Leftover salad can see another day, especially if bolstered with chunks of sautéed zucchini, fresh corn off the cob, diced tomato, or roasted peppers. Grilled or poached chicken can be folded in too.

CODFISH WITH VEGETABLE MARINÈRE AND AROMATIC SAUCE

In a restaurant, this dish would involve painstakingly cooking each vegetable separately, then arranging the pieces in a carefully designed mosaic on the top of each portion of fish. Since home cooks do not have a team of line cooks to create such artistic magnificence, this version is simpler to prepare while still keeping the spirit of the original. An array of condiments provide a bold counterpoint for the delicate fish and mild vegetables.

4 SERVINGS

5 tablespoons extra virgin olive oil

¼ cup onion, cut into ½-inch dice

1 clove garlic, minced

¼ cup fennel, cut into ½-inch dice

¼ cup celery, cut into ½-inch dice

¼ cup red bell pepper, cut into ½-inch dice

¼ cup green bell pepper, cut into ½-inch dice

¼ cup zucchini, cut into ½-inch dice

1 fresh Thai bird chili or chile de árbol, minced, or ½ teaspoon crushed red chili flakes

Pinch of saffron

10 pitted black or Kalamata olives, chopped

10 pitted small green olives, chopped

1 tablespoon capers

1 ripe plum tomato, cut into ½-inch dice

1 teaspoon fresh thyme leaves plus 4 branches thyme for garnish

Place 1 tablespoon oil in a medium-size skillet over low heat. Add the onion and garlic and sauté slowly until they are translucent. Add the fennel, celery, and red and green bell peppers. Continue sautéing until the vegetables have softened. Add the zucchini, sauté until it softens, then add the chili, saffron, black and green olives, capers, tomato, and thyme leaves. Continue cooking until the tomato is soft. Remove the pan from the heat. Stir in 2 tablespoons of the oil.

Prepare the sauce. Mix the vinegar, soy sauce, and ketchup together in a small saucepan. Add the Tabasco. Bring to a simmer and cook for a few minutes, until smooth. Stir in the butter and cook just until the butter melts. Set the pan aside.

Just before serving, pat the fish dry. Season the fillets with salt and pepper. Heat the remaining 2 tablespoons oil in a heavy skillet large enough to hold the fish in a single layer. Over medium-high heat, sauté the fish until it is cooked through and lightly browned, turning it once, 8 to 10 minutes.

Transfer the fish to a serving platter or individual dinner plates. Reheat the vegetable mixture until it is just warm and fold in the basil. Spoon vegetables on top of each portion of fish. Reheat the sauce and spoon it around the fish. Drizzle the basil oil around the outside of the sauce. Serve.

COOK'S NOTES Ketchup in a Jean-Georges Vongerichten three-star sauce? Yes, the sauce does call for ketchup.

3 tablespoons sherry vinegar

¼ cup soy sauce

3 tablespoons ketchup

1 teaspoon Tabasco

2 tablespoons unsalted butter

4 (6-ounce) fillets cod or hake

Salt and freshly ground black pepper

2 basil leaves, preferably Thai, cut into chiffonade

1 tablespoon basil-flavored olive oil

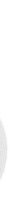

SECOND HELPINGS
Any leftover fish can be turned into fish cakes, vegetables and all.

FISH ALLA TALLA WITH CABBAGE SALAD

This restaurant started as a small, popular Mexican spot in Dumbo, the part of Brooklyn under the approaches to the Manhattan and Brooklyn bridges. But after about a year, it had developed enough of a following that it began looking to relocate to larger quarters. It finally moved to the Bowery in Manhattan, just north of Houston Street, or NoHo. But it kept its Brooklyn name. A verdant cilantro seasoning, then a strong sear on the grill contribute great flavor to this fish. The slaw alongside is pure refreshment.

1 cup cilantro

½ medium onion, quartered

2 cloves garlic

1 jalapeño, seeded and halved

Juice of 1 lime, more to taste

Salt and freshly ground black pepper

3 tablespoons extra virgin olive oil

4 (6-ounce) fillets black sea bass or other white-fleshed fish, with skin

Cabbage salad (recipe follows)

Combine the cilantro, onion, garlic, jalapeño, lime juice, and salt and pepper to taste in the bowl of a food processor. Process until the mixture is finely ground. With the machine running, slowly drizzle in the oil to make an emulsion. Adjust the seasoning.

Rub the fish generously with the cilantro mixture. Let it stand for 25 minutes.

Heat a grill, a grill pan, or cast iron skillet to hot. Brush the grill racks or pans with olive oil. Remove the fish, reserving the marinade. Add the fish, skin side down, and sear, cooking for 2 to 3 minutes. Turn the fish and continue cooking until just cooked through, 5 to 8 minutes, depending on the thickness of the pieces. Warm any left-over marinade.

Arrange the fish on a platter or place each piece on a dinner plate with some of the cabbage salad alongside. Pour the warmed marinade into a small bowl and serve it with the fish.

COOK'S NOTES It's more important that the fish be fresh than it be black sea bass. Wild striped bass or red snapper fillets could be used instead. Even bluefish would be fine. Just about any fillets would work in this recipe.

SECOND HELPINGS
You are likely to have some of the salad, a slaw, really, left over. It would be fine alongside a sandwich for lunch or even in a sandwich or a taco. Shredded carrots, chopped scallions, slivered snap peas, or diced bell peppers can be added to it.

CABBAGE SALAD
ABOUT 6 CUPS

¼ green cabbage, cored and very thinly shredded

½ medium-size red onion, thinly sliced

½ English cucumber, peeled and thinly sliced

Juice of 1 lime

3 tablespoons cider vinegar

Salt and freshly ground black pepper

1 ripe avocado, peeled, pitted, and diced

4 ounces queso fresco or 2 ounces feta cheese

Combine the cabbage, onion, and cucumber in a bowl. Add the lime juice and vinegar, season with salt and pepper, and let the mixture stand 30 minutes. Mix well and reseason.

Fold in the avocado and the cheese. Cover and set the salad aside until you are ready to use it, but not more than an hour.

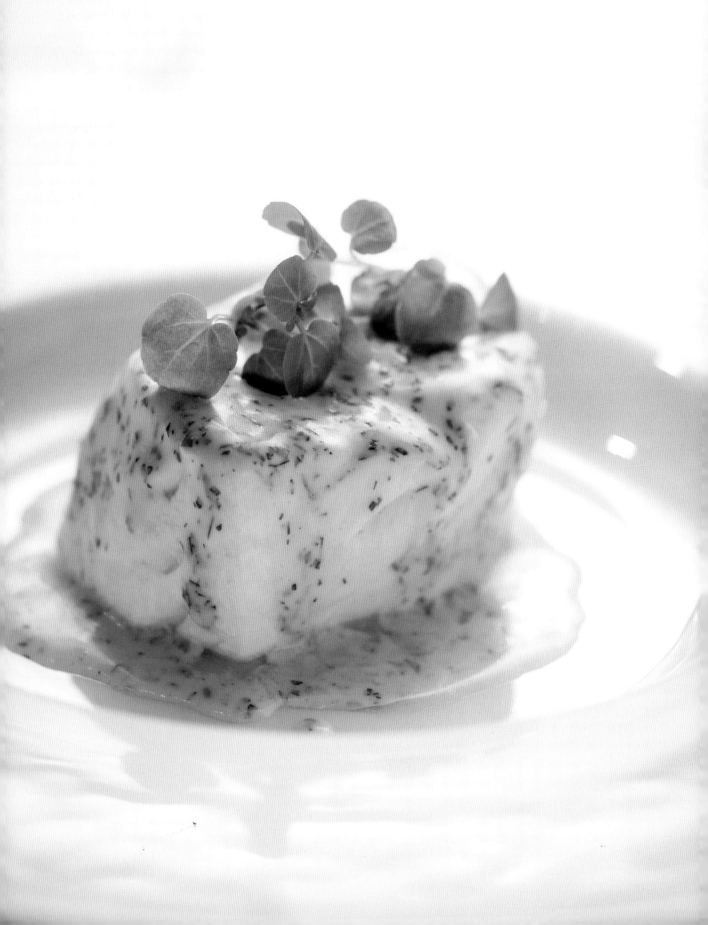

POACHED HALIBUT IN WARM HERB VINAIGRETTE

At the helm of Le Bernardin, the premier seafood restaurant in New York, probably in the United States, and perhaps on the planet, is Eric Ripert, who, in partnership with Maguy Le Coze, has maintained the restaurant's high standing for decades. This recipe is not a Ripert addition to the restaurant's repertory, however. It dates back to the early years of Le Bernardin, in Paris, not yet in New York, when Gilbert Le Coze, the co-founder, was in the kitchen. He brought the dish with him to New York, and it has been a staple on the restaurant's menu ever since. This is Ripert's version. The warm, well-balanced herbal vinaigrette is all that's needed to enliven the meaty dish.

2 tablespoons Dijon mustard

Sea salt and freshly ground white pepper

3 tablespoons red wine vinegar

1 tablespoon sherry vinegar

⅔ cup extra virgin olive oil

1 small shallot, finely diced

3 cups court bouillon or fish stock

2 pounds halibut steaks, with skin

1½ teaspoons minced flat-leaf parsley leaves

2 tablespoons minced chives

2 tablespoons minced chervil

1 teaspoon minced fresh tarragon leaves

4 SERVINGS

Place the mustard in a bowl; whisk in the salt and pepper and the vinegars. Slowly drizzle in the oil. Add the shallot. Transfer this dressing to a small saucepan.

Bring the court bouillon to a boil in a 10- or 12-inch saucepan. Reduce the heat to a bare simmer. Season the halibut with salt and pepper. Poach it at a very slow simmer for 5 to 6 minutes, until a metal skewer inserted in the center of the fish feels barely warm when touched to your lower lip. Gently lift the fish out of the pan, drain it well, and transfer it to a platter. Cover the platter loosely with foil.

Add the parsley, chives, chervil, and tarragon to the dressing. Heat it until it is just warm.

Remove the skin from the halibut and transfer each steak to a dinner plate or a serving platter. Spoon the warm vinaigrette over and around the fish and serve.

COOK'S NOTES This method of testing fish for doneness—by inserting a metal skewer in the center, then gauging the heat—is foolproof. When the skewer is warm, the fish is cooked through. If you wait until the fish "flakes," as many recipes suggest, it is likely to be overcooked.

SECOND HELPINGS
Another way to present this dish is to divide each cooked halibut steak in two, removing the center bone, to yield eight fillets. Arrange them on a platter to serve. You may wind up with surplus fish, which is excellent broken into chunks for a salad. The court bouillon used for poaching the fish can work as fish stock for another dish; strain it through cheesecloth and freeze it.

POACHED WILD STRIPED BASS WITH TOMATOES, POTATOES, AND BACON

This is a simple fish stew that has the DNA of kakavia, a Greek fisherman's dish often made right on the boat. Kakavia is the name of the rounded pot in which it simmers, as well as the dish itself. The main difference is that the fishermen would not have used bacon. Is it similar to bouillabaisse? Indeed, though less complicated, not seasoned with saffron, and much quicker to prepare. But it requires the ripest midsummer tomatoes.

4 SERVINGS

2 tablespoons extra virgin olive oil

3 strips thick-cut bacon, cut into ¼-inch slivers

1 small onion, quartered and thinly sliced

5 cloves garlic, thinly sliced

1 small head fennel, diced

¼ teaspoon crushed red chili flakes

2 large beefsteak tomatoes, cored and chopped, with their juices

Sea salt

½ cup dry white wine

½ pound Yukon gold potatoes, peeled and diced

Freshly ground black pepper

1 teaspoon sherry vinegar

1½ pounds wild striped bass fillets, skinned, cut into 8 pieces

6 basil leaves, torn

1 cup, packed, baby spinach

⅔ cup mayonnaise seasoned with 1 teaspoon sriracha or other hot sauce, optional

Warm the oil in a 4-quart saucepan or casserole over medium heat. Add the bacon and let it sizzle for about 5 minutes, until it is golden. Stir in the onion and garlic and cook until they are soft but not brown. Add the fennel and cook for a few minutes, until softened. Stir in the chili flakes. Add the tomatoes and 1 teaspoon salt, cover the pot, and cook the mixture on medium for about 10 minutes.

Stir in the wine and 2 cups water; bring the soup to a simmer, add the potatoes, and cook for another 6 minutes or so, until the potatoes are tender. Check the seasonings, adding salt and pepper to taste. Add the vinegar. Season the fish pieces with salt and pepper, place them in the soup, and simmer it on low, covered, until the fish is just cooked through, about 5 minutes. Meanwhile, warm four large soup plates.

When the fish is done, transfer it to the warm soup plates. Remove the pot from the heat, stir in the basil and spinach, just to wilt it, and divide the soup among the plates. Serve spiced mayonnaise alongside, if desired.

COOK'S NOTES If you own a large wok with a cover, it's a great vessel for cooking this stew. In fact, its shape resembles the pot that Greek fishermen would use. As for the fish, wild striped bass is the first choice, but other fish, including sea bass, grouper, halibut, and red snapper, would also be good.

SECOND HELPINGS
Any leftover soup—and fish—can be pureed in a food processor, then thinned with water or tomato juice with additional chili flakes added to make a lusty Mediterranean-style fish soup.

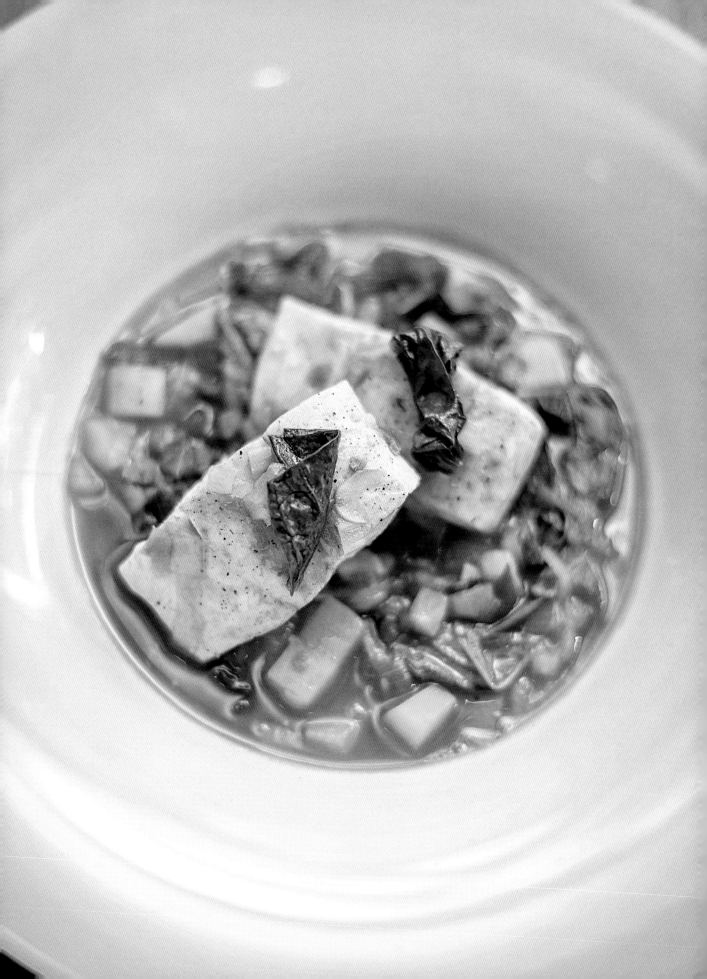

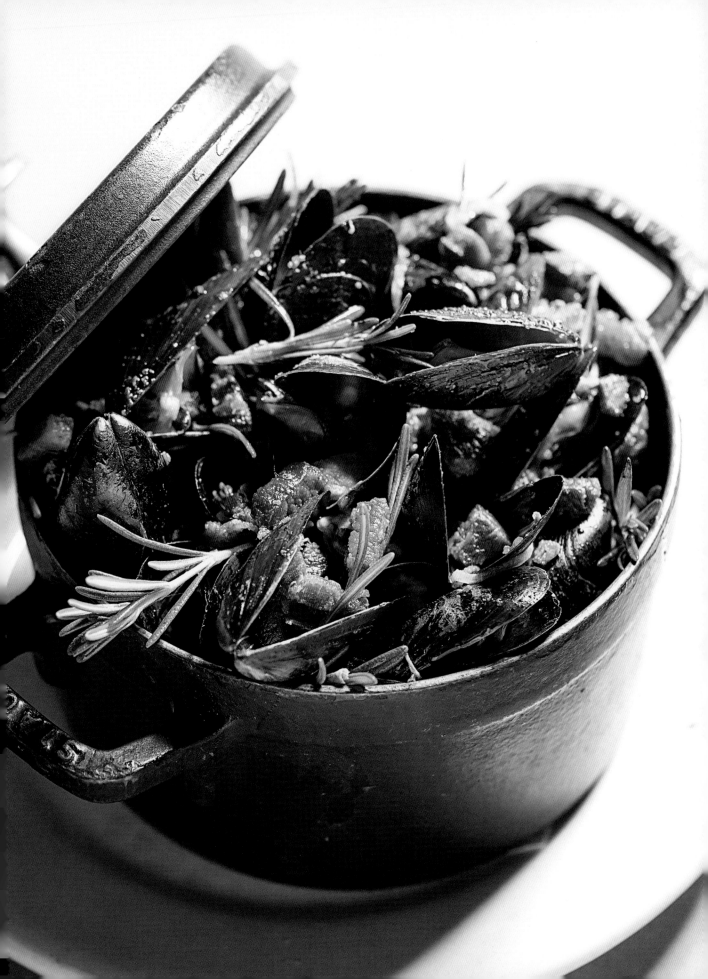

DITCH PLAINS AND LANDMARC

ROSEMARY-BACON MUSSELS

As chef and restaurateur, Marc Murphy has carved out a niche for hearty American food. Included in his collection is Ditch Plains, a casual seafood spot named for an area in Montauk, at the tip of Long Island, where surfers, Murphy among them, gather to ride the waves. Here, a classic pot of steamed mussels is given new personality with smoky bacon and piney rosemary. Murphy serves this dish at both his Ditch Plains and Landmarc restaurants.

¼ pound thick-cut bacon, cut into ½-inch pieces

2 shallots, thinly sliced

2 cloves garlic, thinly sliced

8 sprigs fresh rosemary

3 pounds mussels, scrubbed and debearded

Salt and freshly ground black pepper

3 cups dry white wine

¼ cup chopped flat-leaf parsley

3 tablespoons unsalted butter

Sourdough baguette

Place a 4-quart pot over medium-high heat. Add the bacon and cook until it is crispy, 5 to 6 minutes. Add the shallots and garlic, lower the heat to medium, and cook until they are translucent. Add the rosemary. Add the mussels and stir for about a minute. Season with salt and pepper.

Add the wine. Cover the pot and steam the mussels for 6 to 8 minutes, until they have opened. Transfer the mussels (discarding any that have not opened) with a slotted spoon to deep soup bowls. Add the parsley and butter to the broth, bring it to a simmer, and ladle the broth over the mussels. Serve with sourdough bread alongside.

COOK'S NOTES These days, mussels are invariably cultivated, not gathered in the wild. The result is that they are quite clean and need very little of the tedious scrubbing that was once necessary.

SECOND HELPINGS
Shuck any leftover mussels, reserving one of the shells from each. Mix the mussels with mayonnaise seasoned with hot sauce, herbs, or capers and put each back in a shell to serve as a nibble with cocktails.

SEAFOOD IN BOUILLABAISSE

The original Eleven Madison Park was where Kerry Heffernan attracted attention. Subsequently he was at South Gate. Now he is consulting. Throughout, he has been a supporter of City Harvest. The bouillabaisse basics, including tomatoes, fennel, saffron, and garlic, are all on display in this stew's aroma and flavor.

4 SERVINGS

4 tablespoons extra virgin olive oil

4 cooked blue crabs, halved

1½ cups dry white wine

1 bulb fennel, trimmed and cut into eighths

2 slender leeks, white part only, trimmed and chopped

Salt and freshly ground black pepper

4 cloves garlic, minced

1 teaspoon saffron threads

1 (14-ounce) can Italian plum tomatoes, crushed

6 sprigs fresh thyme

1 bay leaf

Espelette pepper to taste

8 slices monkfish (each ½ inch thick; about 1 pound total)

16 littleneck clams

Toasted baguette slices brushed with olive oil and rubbed with garlic

SECOND HELPINGS
Any leftover soup and seafood can be pureed, then thinned and reseasoned to make a classic soupe de poisson.

Heat 3 tablespoons of the oil in a large skillet. Add the crabs and sear them on all sides. Add ¼ cup of the wine, then transfer the contents of the pan to a 4-quart pot.

Heat the remaining 1 tablespoon oil in a skillet. Add the fennel and leeks, season with salt and pepper, and sauté on low until soft. Add the garlic, saffron, and the rest of the wine. Cook on medium high to reduce the wine to about ½ cup. Add the tomatoes. Transfer these ingredients to the pot with the crabs and add just enough water to barely cover the crabs. Add the thyme and bay leaf, bring the soup to a simmer, season it with Espelette pepper, and cook 15 minutes. Turn off the heat and transfer the crabs to a bowl.

When the crabs are cool enough to handle, pick the meat out. Set it aside.

Return the mixture in the pot to a simmer and cook for another 15 minutes. Check the seasoning. Place the monkfish slices in the pot, add the clams, cover, and simmer for 7 to 10 minutes, until the clams open and the fish is cooked.

Divide the crabmeat among four deep soup plates. Add the fish and clams, discarding any clams that have not opened. Pour the simmering soup over the seafood and serve with baguette slices.

COOK'S NOTES If blue crabs are not available, tiger shrimp or other large shrimp can be used instead. Mussels can be added in addition to or even in place of the clams. Originally the recipe called for sea robins, a trash fish similar to the rascasse, an essential ingredient of authentic bouillabaisse. Since sea robins are very hard to come by—I occasionally find them in Chinatown—I substituted monkfish, a similar but much larger denizen of the deep. Espelette is a chili from the Pyrénées region of southwest France. It's a terrific seasoning to keep on hand.

SEAFOOD GUMBO

Southern and soul are the cuisines served at this jazz cabaret, a branch of Jazz at Lincoln Center. This gumbo is classic, a mixture of onion, bell peppers, okra, and seafood in a thick, nutty roux-based soup, prepared with few improvisational riffs. Yes, you could add chopped fresh tomatoes or other seafood like clams or lobster, but you have here the basic. Play it as you wish.

½ cup vegetable oil

½ cup all-purpose flour

1 cup chopped Spanish onion

1 cup chopped celery

1 cup chopped green bell pepper

½ cup chopped red bell pepper

½ pound andouille sausage, casings removed, halved lengthwise and sliced ½ inch thick

3 cups seafood stock: lobster, fish, oyster, or a mixture

2 tablespoons extra virgin olive oil

6 ounces okra, trimmed and sliced

1 tablespoon tomato paste

2 bay leaves

Salt and freshly ground black pepper

½ pound medium shrimp, peeled and deveined

½ pound lump crabmeat

12 shucked oysters, with their juice

Salt and freshly ground black pepper

4 cups cooked long-grain rice

Tabasco for serving

4 SERVINGS

In a large, heavy-bottomed sauté pan, heat the vegetable oil, stir in the flour, and cook on low heat, stirring constantly until the mixture, the roux, turns deep amber and smells nutty, 10 minutes or so. Add the onion, celery, and both bell peppers. Sauté, stirring occasionally, until the vegetables are soft. Stir in the sausage and sauté for about 10 minutes. Add the stock and simmer for about 10 minutes.

In a separate pan, heat 1 tablespoon of the olive oil and sauté the okra on medium until it starts to brown. Add the okra to the mixture in the sauté pan along with the tomato paste and bay leaves. Partly cover the pan and simmer the gumbo for 30 minutes. Season to taste with salt and pepper.

In the pan you used for the okra, heat the rest of the olive oil. Sear the shrimp for 1 minute. Add them to the gumbo. Stir the crabmeat and oysters into the gumbo and cook it for 2 minutes, just until the oysters firm up. Turn off the heat until you're ready to serve. The gumbo can sit off the heat up to 1 hour.

Adjust the seasonings and gently reheat the gumbo. Serve it with steamed rice on the side and Tabasco for the table.

COOK'S NOTES Mastering the roux, the combination of flour and fat, is critical in Cajun cooking, a cuisine that demands that roux be dark, browned but not burned. Bear in mind that once it's removed from the heat, the roux will continue to cook in the pan, so it's best to stop the cooking before it turns very dark.

SECOND HELPINGS
Leftover gumbo can be stretched with more stock and seafood. Chopped tomatoes can also be added.

ED'S LOBSTER ROLL

The lobster roll is more popular than ever—and not just at summertime seafood shacks. Miniature ones are served at cocktail parties as hors d'oeuvres. There are actually two approaches to the lobster roll: one made with mayonnaise and often celery, which seems to hold sway in New York, and another, made with melted butter, which is sometimes called Connecticut-style, though it's also popular in Maine. This version is squarely in the mayo camp.

3 lobsters (about 1½ pounds each), cooked, shucked, meat cut into bite-size chunks

½ cup mayonnaise

Grated zest and juice of ½ lemon

⅔ cup minced celery

Salt and freshly ground black pepper

Tabasco to taste

4 hot dog rolls, preferably the top-loading style, or brioche buns

3 tablespoons melted butter

Place the lobster meat in a bowl. Stir in the mayonnaise, lemon, and celery. Season to taste with salt, pepper, and Tabasco.

Lightly toast the hot dog rolls. Brush the inside of each roll with butter, fill it with lobster salad, and serve.

COOK'S NOTES You can purchase cooked lobster meat, though it's more economical to cook your own lobsters, or even buy whole cooked lobsters and shuck them yourself. You will need about 2 cups of lobster meat. As for the buns, you can make your own using the recipe for cheddar and black pepper buns (page 139), though you may want to omit the cheese.

SECOND HELPINGS
There will be no leftovers.

POULTRY

CHERMOULA-RUBBED CHICKEN WITH COUSCOUS SALAD

Smoked meats and bagels via Montreal was where Mile End began. There is now a separate sandwich shop, and Noah Bernamoff, one of the partners, has opened a satellite bagel store. The menu, once strictly deli, has also expanded, as affirmed by recipes like this, with its North African approach. The well-seasoned chicken and couscous salad can be served at room temperature; consider it for a summer buffet.

1 cup Israeli couscous

6 tablespoons extra virgin olive oil

1 cup halved grape tomatoes

6 scallions, trimmed and chopped

½ cup pine nuts, toasted
(see Cook's Notes, page 157)

½ cup sliced roasted red pepper

½ cup minced red onion

½ cup chopped flat-leaf parsley

½ cup mint leaves in chiffonade

4 tablespoons lemon juice

Salt and freshly ground black pepper

8 ounces canned, jarred, or frozen and thawed artichoke hearts

Grated zest of 1 lemon

6 skinless and boneless chicken thighs, each cut in half

Chermoula spice mixture
(recipe follows)

Bring 2 quarts of water to a boil, add the couscous, and cook until it is just tender, about 10 minutes. Drain it well, place it in a large bowl, and toss it with 2 tablespoons of the oil. When the couscous has cooled to room temperature, fold in the tomatoes, scallions, pine nuts, red pepper, onion, parsley, and mint. Add 3 tablespoons of the lemon juice. Season the salad with salt and pepper and set it aside.

Drain the artichokes and pat them dry. Heat 2 tablespoons of the oil to very hot in a small, heavy skillet. Add the artichokes and fry, turning them frequently, until they are lightly browned. Drain them on paper towels, season them with salt and pepper, dust them with lemon zest, and fold them into the couscous. Spread the couscous on a serving platter.

Pat the chicken dry. Season it with salt and pepper. Place a large, heavy skillet, preferably cast iron, over high heat. Add the remaining 2 tablespoons of oil. Cook the chicken until the underside is lightly browned, about 5 minutes. Lightly dust the chicken with some of the chermoula spice and turn it. Brown the other side, dust again with chermoula, and turn the pieces again. When the chicken is just cooked through, about 15 minutes total cooking time, dust it with the remaining chermoula.

Place the chicken on the bed of couscous. Drizzle the remaining lemon juice over the chicken and serve.

COOK'S NOTES Israeli couscous is larger than regular couscous. Italian fregola, from Sardinia, is a suitable substitute. Chermoula is a Moroccan seasoning. It can be a dry blend, as here, but it is often fresh, with parsley, onion, and lemon, all of which are incorporated elsewhere in this recipe instead.

SECOND HELPINGS
Having the premixed chermoula spice on hand is useful. You can call on it as a rub for fish on the grill and even vegetables. Prepare extra.

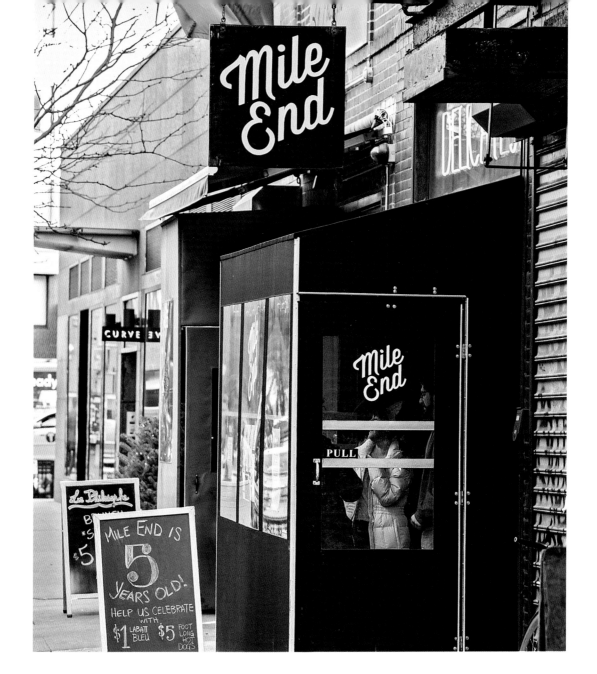

CHERMOULA SPICE
ABOUT 2 TABLESPOONS

2 teaspoons ground cumin

1 teaspoon smoked paprika

1 teaspoon ground coriander

¼ teaspoon ground allspice

¼ teaspoon ground turmeric

¼ teaspoon ground ginger

¼ teaspoon cayenne, or to taste

Pinch of mace

Mix all the spices together.

CHICKEN PAILLARD

Seafood, the raison d'être of Le Bernardin, is not served at the restaurant's wine bar across the courtyard. Here the food consists of wine-friendly small plates. The chicken paillards come with their own salad component. The bar is named for Le Bernardin's award-winning sommelier, Aldo Sohm, and run by him.

2 SERVINGS

1 whole skinless, boneless chicken breast

1 shallot, sliced

1 clove garlic, sliced

2 sprigs thyme

Zest of 1 lemon

1 tablespoon herbes de Provence

6 tablespoons extra virgin olive oil

1 tablespoon Dijon mustard

2 tablespoons red wine vinegar

2 tablespoons sherry vinegar

Salt and freshly ground black pepper

1 cup cherry tomatoes, halved

¼ cup pitted, sliced green olives

2 cups salad: baby arugula, frisée, mâche, or a mixture

Separate the halves of the chicken breast. Butterfly each half and lightly pound it. In a dish that will hold the chicken in a single layer, mix the shallot, garlic, thyme, lemon zest, herbes de Provence, and 2 tablespoons of the oil. Add the chicken, turn it to coat both sides, and cover it. Let it marinate overnight in the refrigerator.

Beat together the remaining olive oil with the mustard and vinegars. Season the vinaigrette with salt and pepper.

Mix the tomatoes, olives, and greens in a bowl. Dress it with some of the vinaigrette.

Heat a grill or a grill pan to very hot. Remove the chicken from the marinade and season it with salt and pepper. Grill the chicken on high heat for just a minute or two per side, enough to get grill marks, if possible. Do not overcook.

Put each portion of chicken on a dinner plate. Top it with the salad. Drizzle any remaining dressing around the chicken and serve.

COOK'S NOTES Try to find high-quality free-range or organic chicken for this and for any other chicken dishes you prepare. It will deliver better flavor. The lengthy marinating process for this recipe also adds complexity and juiciness. It can be shortened to a few hours.

SECOND HELPINGS
Extra salad, once dressed, will not last for another day. But plain and undressed, it can be held. Surplus dressing has a long shelf life.

WHOLE ROASTED CHICKEN WITH FENNEL, POTATOES, AND OLIVES

This method of roasting a chicken has its distinctive elements. First there is the spice rub, which Gabe Thompson, the chef, suggests can also be applied to fish, pork loin, or leg of lamb. The bed of vegetables, which essentially cook in the roasting juices, make for an easy accompaniment.

2 tablespoons fennel seeds

1 tablespoon black peppercorns

2 fennel bulbs

1½ pounds baby Yukon gold potatoes, halved

¾ cup pitted olives, preferably Kalamata

4 tablespoons extra virgin olive oil

Kosher salt

1 (3½-pound) chicken

1 cup well-seasoned chicken stock

1 tablespoon minced flat-leaf parsley leaves

1 tablespoon lemon juice

Preheat the oven to 400° F. In a spice grinder, finely grind the fennel seeds and peppercorns.

Trim the fennel bulbs. Slice each in half lengthwise. Cut each half lengthwise into ¼-inch-thick slices, discarding the cores. Place the sliced fennel in a large bowl with the potatoes and olives. Toss them with 3 tablespoons of the oil, 2 teaspoons salt, and 1 teaspoon of the ground spices. Spread this mixture over the bottom of a roasting pan. Place a rack in the roasting pan.

Season the chicken with 2 teaspoons salt and 2 tablespoons of the ground spices. Place the bird on the rack, breast side up, and roast it for 50 minutes to 1 hour, until the breast registers 155° F on an instant-read thermometer and the juices run clear. Remove the chicken from the roasting pan, still on the rack, and place it on a cutting board.

Stir the vegetables in the roasting pan, then return the pan to the oven and roast them for another 20 minutes or so, until the potatoes are tender and can be easily pierced with a paring knife.

Transfer the vegetables to a warm serving platter. Carve the chicken and place the meat on the bed of vegetables. Place the roasting pan on top of the stove over medium-high heat. Add the chicken stock and cook, scraping the pan with a large spoon, to loosen darkened bits. Add the remaining oil, the parsley, and the lemon juice. Cook another minute or so. Adjust the seasonings to taste.

Spoon some of the sauce over the chicken and vegetables and pour the rest into a bowl to serve alongside.

COOK'S NOTES You can consider varying the peppercorns in the spice rub; try Sichuan or red ones. If fresh fennel is not available, celery would work, and other types of potatoes and olives can be used.

SECOND HELPINGS
Extra chicken? Let me count the ways! As for the vegetables, chopped small, they are excellent in a soup or an omelet.

HOMESCHOOLED BBQ CHICKEN WINGS WITH KOREAN GLAZE

These are crowd-pleasers. And they can be made simply with the restaurant's regular barbecue sauce or, as this alluring option indicates, with a Korean-accented sauce and glaze.

6 SERVINGS

1½ teaspoons smoked paprika

1 teaspoon kosher salt

1½ teaspoons light brown sugar

1½ tablespoons chipotle chili powder

½ teaspoon granulated garlic

½ teaspoon granulated onion

1 teaspoon freshly ground black pepper

¼ teaspoon ground cumin

¼ teaspoon celery salt

¼ teaspoon cayenne

3½ to 4 pounds chicken wings (12 to 16)

½ cup soy sauce

½ cup hoisin sauce

⅓ cup barbecue sauce, preferably Dinosaur

2½ tablespoons rice wine vinegar

¼ cup honey

⅓ cup dark brown sugar

1 tablespoon sriracha sauce

1½ teaspoons toasted sesame oil

Juice of ½ lime

1 tablespoon canola oil

1 tablespoon sesame seeds

Combine the paprika, salt, light brown sugar, chili powder, garlic, onion, pepper, cumin, celery salt, and cayenne in a bowl. Rub the chicken wings with this mixture and set them aside.

To make the glaze, combine the soy sauce, hoisin, barbecue sauce, vinegar, honey, dark brown sugar, and sriracha in a saucepan. Bring the mixture to a simmer and cook until it is reduced by half, 20 to 25 minutes. Remove it from the heat, stir in the sesame oil and lime juice, and set it aside.

Preheat the oven to 350° F. Line a baking pan with heavy-duty foil or a silicone mat. Oil the foil with the canola. Place the chicken wings in the pan; do not crowd them. Bake until the wings are cooked through, about 30 minutes. Remove them from the oven.

Turn on the broiler. Brush the wings on both sides with the glaze. Broil them, skin side up, for about 5 minutes, until the wings start to caramelize. Turn the wings, brush them with more sauce, and broil them for another 4 to 5 minutes, until they start to caramelize. Turn them once more and broil them briefly until they begin to char. Transfer them to a platter. Dust with sesame seeds and serve hot or at room temperature with any extra sauce on the side.

COOK'S NOTES The wings can also be grilled, but they require close and careful watching, moving, and turning on the grill so they do not burn before they are cooked through. They're more work that way.

SECOND HELPINGS
Leftover wings are always welcome with a drink. Leftover sauce, kept on hand, will enhance whatever you grill.

MAGRET À LA D'ARTAGNAN

André Daguin—the father of Ariane Daguin, who founded the food company D'Artagnan—had a restaurant in his hometown of Auch, in southwest France. He is said to have been the first chef to serve a duck breast prepared like steak. The duck must be cooked to no more than medium, and medium rare is best.

4 SERVINGS

2 magret duck breasts (about 1 pound each)

Salt and freshly ground black pepper

1 shallot, finely chopped

1 cup full-bodied red wine, preferably Madiran

2 tablespoons duck or veal demi-glace or soft unsalted butter

With a sharp knife, score the skin of the magret in a crosshatch pattern, not cutting into the flesh. Season the duck on both sides with salt and pepper.

Heat a heavy skillet, preferably cast iron, until it is very hot. Place the magrets in the skillet, skin side down, lower the heat to medium, and sear them for about 8 minutes, until they are well-browned. Spoon off the rendered fat in the pan as it accumulates. Turn the magrets and continue cooking for about 4 minutes. Check their doneness by cutting into the flesh near one end with a sharp knife; the flesh should be medium rare. If it's too rare, continue cooking for another few minutes.

When the magrets are done, transfer them to a cutting board and tent them with foil to keep them warm.

Drain all but a thin film of fat from the pan. Add the shallot and sauté on medium low until the pieces are translucent. Add the wine and simmer to reduce it by half. Swirl in the demi-glace and cook briefly. If you're using butter, swirl it in bit by bit to thicken the sauce. Season with salt and pepper.

Carve the magrets into slices about ¼ inch thick, cutting crosswise on a slant. Arrange them on a platter or on four dinner plates and spoon the sauce over the slices.

COOK'S NOTES Cooking magret couldn't be simpler. It can be grilled or broiled instead of pan-roasted, though the amount of fat makes flare-ups a hazard. Do not cook it too close to your source of heat. Another method is to sear the magret on a grill or in a pan for about a minute on each side, then put it in a 175° F oven for an hour and a half. It will come out perfectly medium rare.

SECOND HELPINGS
Thin slices of leftover magret, with the fat trimmed off, are delicious in a salad or sandwich.

OUEST

Ouest

Ouest

SQUAB WITH FRENCH LENTILS AND CABBAGE

"A French background put to use in the service of American cooking" is the way Tom Valenti describes his approach during his decades-long career. Ouest is French for "west," an apt name for his fine-dining yet friendly pioneer restaurant on the Upper West Side. Squabs are meaty little birds with dark flesh, best served medium rare. Their gaminess plays off nicely against the earthy, mellow lentils.

4 SERVINGS

1 tablespoon extra virgin olive oil

1 cup finely diced onion

1 celery stalk, finely diced

½ cup diced carrot

4 cloves garlic, minced

¾ cup lentils, preferably French Le Puy

2 teaspoons thyme leaves

1 bay leaf

Salt and freshly ground black pepper

About 3½ cups chicken stock

5 tablespoons unsalted butter

½ head savoy cabbage, chopped (about 6 cups)

¼ cup heavy cream

1½ teaspoons Dijon mustard

4 squabs, butterflied

Heat the oil in a 3-quart saucepan on medium. Add the onion, celery, carrot, and three of the garlic cloves and sauté until the vegetables are tender but not brown, about 8 minutes. Stir in the lentils. Add the thyme, bay leaf, and a dusting of salt and pepper, then 2½ cups of the stock. Bring the mixture to a simmer and cook it, partly covered, for about 1 hour, until the lentils are al dente. Add a little more stock during cooking if needed. Set the lentils aside, covered.

Heat 4 tablespoons of the butter in a large sauté pan. Add the remaining clove of garlic and 1 cup chicken stock, then add the cabbage. Season with salt and pepper. Cook, covered, until the cabbage has wilted and is tender, about 30 minutes. Set it aside, covered.

Shortly before serving time, gently reheat the lentils, stir in the cream and mustard, and check the seasoning. Gently reheat the cabbage.

Season the squabs with salt and pepper. Heat a large, heavy skillet, preferably cast iron, to very hot. Add the squabs, skin side down and sear for about 3 minutes. Turn them and cook the other side for about 2 minutes. For medium rare, the total cooking time should be around 5 minutes. If you cannot fit all the squabs in your pan (or pans) at once, cook them in shifts, putting those that are finished on a baking sheet in a 150° F oven to keep warm.

Spoon some of the lentils onto each of four dinner plates. Top them with cabbage, then a squab.

COOK'S NOTES Perhaps squabs are not your idea of what to cook for dinner. In that case, you can bed other birds like quails or baby chickens on the lentils and cabbage. Sausages and even meats like lamb shanks, slices of steak, or pork tenderloin are other choices.

SECOND HELPINGS
Fold extra lentils and cabbage into a soup.

MEAT

ETHIOPIAN-STYLE BEEF STIR-FRY

Though he was raised in Sweden by adoptive parents and began his career in New York at Aquavit, a Scandinavian restaurant, Marcus Samuelsson's Ethiopian roots show through in some of his cooking. His Harlem restaurant offers tastes of Africa, Sweden, and the southern United States, and this dish is a billboard for Ethiopia, well spiced and bolstered with tomatoes and peanuts.

6 SERVINGS

1 tablespoon mild chili powder

½ teaspoon ground cardamom

½ teaspoon ground ginger

¼ teaspoon freshly ground black pepper

1½ pounds hanger steak or beef tenderloin, cut into ½-inch cubes

¼ cup peanut oil

2 red onions, sliced

3 cloves garlic, quartered

Salt

3 medium-size ripe tomatoes, chopped, or 1½ cups drained, roughly chopped canned tomatoes

1 bunch broccolini, in 2-inch pieces

2 jalapeños, seeded and thinly sliced

½ cup unsalted dry-roasted peanuts, coarsely chopped

½ cup dry red wine

6 thin slices navel orange, quartered

Mix the chili powder, cardamom, ginger, and pepper in a bowl. Add the beef and toss to coat.

Heat the oil in a large skillet on high. Add the onions and garlic and sauté, stirring constantly, until they begin to brown on the edges. Add the meat, sprinkle it with 1 teaspoon salt, and stir-fry until it is browned on all sides.

Reduce the heat and add the tomatoes, broccolini, jalapeños, peanuts, and wine. Simmer for about a minute, then season with salt if needed. Cook for about 2 minutes more, then serve, garnished with orange pieces.

COOK'S NOTES For surefire tenderness, use the tenderloin. Consider serving rice alongside this dish.

SECOND HELPINGS
Add more tomatoes to any leftovers, and you have a fine pasta sauce.

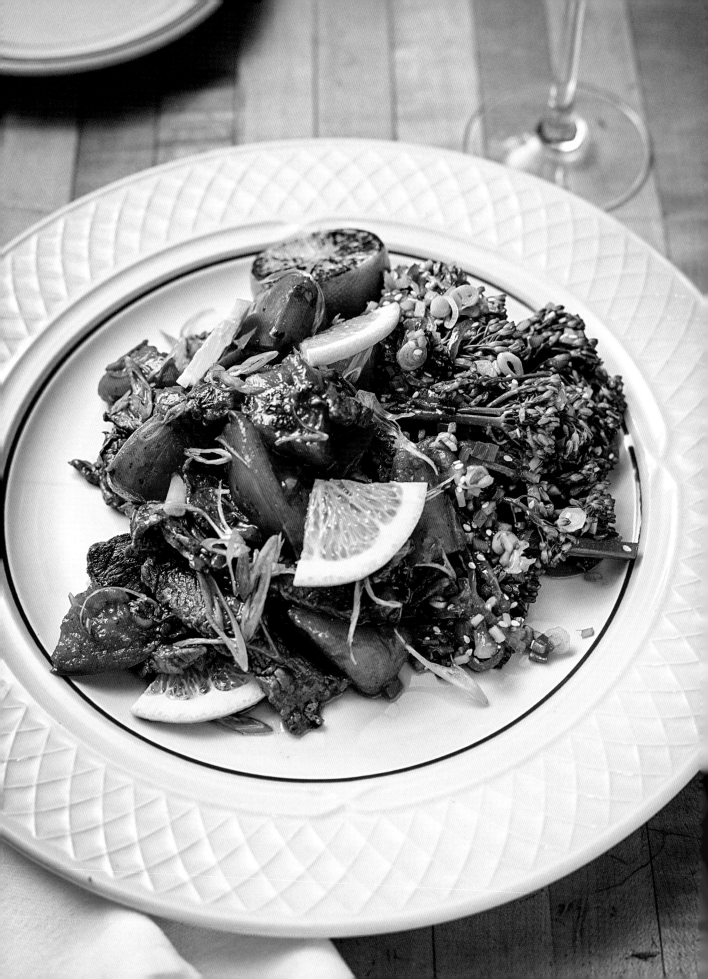

SKIRT STEAK TORTILLA WITH CHIMICHURRI SAUCE

Along with the traditional steaks like rib-eye, filet mignon, and New York strip, Michael Lomonaco also offers some lesser yet tasty cuts, including hanger steak, flank steak, and here, skirt steak. What these cuts lack in buttery tenderness, they more than make up in flavor. They're best done medium rare. Cooking more than that toughens them.

4 TO 6 SERVINGS

1 package 6-inch soft flour tortillas

1 tablespoon extra virgin olive oil

2 pounds skirt steak

Salt and freshly ground black pepper

Chimichurri sauce (recipe follows)

1 large tomato, thinly sliced

1 small sweet onion, thinly sliced

1 bunch watercress, heavy stems removed, rinsed, dried, and coarsely chopped

Preheat the oven to 200° F. Wrap the tortillas in foil and place them in the oven to keep warm.

Preheat a grill or heat a cast iron or grill pan for a few minutes on medium. Brush the grill grates or pan with the oil.

Season the steak with salt and pepper. Sear for 2 to 3 minutes on one side, then turn and cook to the desired degree of doneness, another 2 to 3 minutes for medium rare. Set the steak on a cutting board to rest for about 10 minutes.

Thinly slice the steak, cutting at an angle across the grain. Pile the meat on a platter and drizzle it with a little of the chimichurri sauce. Serve the rest of the sauce alongside. Pile the tortillas, tomato, onion, and watercress on another platter and serve them with the steak, for guests to assemble at the table.

CHIMICHURRI SAUCE
ABOUT 1 CUP

1 clove garlic

½ cup extra virgin olive oil

3 tablespoons white wine vinegar

2 jalapeños, seeded and minced

½ cup, packed, flat-leaf parsley leaves

3 tablespoons minced cilantro leaves

1 fresh bay leaf

Sea salt and freshly ground black pepper

Using a food processor, with the machine running, drop the garlic through the feed tube to mince it. Scrape the sides of the container. Add the oil, vinegar, jalapeños, parsley, cilantro, and bay leaf. Process until the mixture is well-blended. Season the sauce to taste with salt and pepper.

Refrigerate the chimichurri until you're ready to use it, up to 1 week.

COOK'S NOTES These steak slices in tortillas would be excellent served more Mexican-style, with guacamole (page 16) and pico de gallo or some other salsa. Or make the dish French, using baguettes as the foundation for sandwiches, with mustard and sautéed onions.

SECOND HELPINGS
Chimichurri, the vibrant Argentine steak sauce, is as wonderful as pesto to keep on hand as a condiment.

THE BIG MARC

A longtime supporter of City Harvest, Marc Murphy's restaurant style is informal, with big flavor. His burgers wink at McDonald's with the name, the pickles, and his own brand of "secret" sauce. But his buns are infinitely better, incorporating cheese in the dough. And yes, you can sprinkle sesame seeds on top after you brush them with egg if you so desire.

BIG MARC BURGERS

3 pounds ground sirloin, 20 percent fat

Salt and freshly ground black pepper

8 to 12 Cheddar and black pepper buns (recipe follows)

4 tablespoons unsalted butter, melted

48 slices bread-and-butter pickles

1 cup spiked ketchup (recipe follows)

Form the beef into eight to twelve patties, depending on the size you prefer. Season them with salt and pepper. Cover them with a sheet of parchment and refrigerate them until you're ready to cook.

Split the buns, brush the cut sides with melted butter, and toast them. Divide the pickle slices among the bottom halves of the buns. Spread ketchup on the top halves.

Heat a cast iron skillet, grill pan, or grill to very hot. Sear the burgers for about 2 minutes, turn them, and sear them a bit shy of 2 minutes on the second side for medium rare, or longer if you want them more well-cooked. Place them on the prepared bottom halves of the buns, put the top halves in place, and serve.

SECOND HELPINGS
This recipe can easily be divided for fewer portions. Even if you make less of the burger mixture, though, it's still worth baking the entire recipe for the buns. Any you do not use can be wrapped and frozen.

CHEDDAR AND BLACK PEPPER BUNS
8 TO 12 BUNS

1 (¼-ounce) packet instant
dry yeast

¼ cup sugar

4 large eggs

4 ounces (1 stick) unsalted butter,
melted and cooled, plus soft butter
for bowl and baking sheet

1½ teaspoons salt

About 4 cups all-purpose flour

1 cup shredded sharp yellow
Cheddar (about 3 ounces)

1 tablespoon coarsely ground
black pepper

Mix the yeast with the sugar in a large bowl. Add 1 cup warm water
and mix well. Set the mixture aside until it starts to bubble up, a few
minutes. Add three of the eggs, the melted butter, and the salt. Mix.
Add 4 cups of the flour, ½ cup at a time, mixing slowly by machine
or by hand until the dough is smooth and elastic. It will still be a bit
sticky but easy to handle.

Transfer the dough to a large bowl that has been lightly greased with
butter. Cover it loosely with a towel and set it aside to rise for 1 hour
or a little longer until about doubled.

Turn the dough out onto a work surface. Gradually knead in the
cheese and pepper until they are evenly distributed. Try to work the
dough as little as possible. Divide the dough into eight equal pieces
for large buns or twelve for medium-size. Form each piece into a
ball. Line a large baking sheet with foil and coat it with butter. Place
the balls of dough on the baking sheet, allowing a couple of inches
between each one. Flatten them lightly with your hand. Set them
aside to rise until doubled, about 40 minutes.

Preheat the oven to 350° F. Beat the remaining egg and brush it
onto the tops of the buns. Bake until the buns are richly browned,
about 30 minutes. Transfer them to a rack and let them cool for at
least 20 minutes before cutting them.

SPIKED KETCHUP
ABOUT 1 CUP

⅓ cup mayonnaise

1 tablespoon Dijon mustard

½ cup ketchup

1 teaspoon roasted garlic puree,
optional

1½ ounces vodka, optional

Mix all the ingredients and set the sauce aside until you're ready to
use it.

COOK'S NOTES The beef recommended for this recipe is 20
percent fat. You can use chuck, sirloin, round, or a mixture. When
forming the patties, do not compress them too much. They will be
juicier. For roasted garlic puree, see the recipe for roasted hen-of-
the-woods mushrooms (page 37).

FRANKIE'S MEATBALLS

It's not at all fancy, but Rao's in East Harlem is as exclusive a restaurant as there is. It has a list of regular customers who have tables booked on a weekly or monthly basis. And those who are not invited by a regular or who are unable to obtain some other sort of inside favor have no chance of securing a reservation. That said, those who do go find simple, old-fashioned red-sauce Italian fare in copious portions. These tender meatballs are classic Rao's. And they are also served at the Rao's branches in Las Vegas and Los Angeles, where you need no special connections to dine.

8 SERVINGS

1 pound lean ground beef

1 pound ground pork

1 pound ground veal

2 large eggs, beaten

1 cup freshly grated pecorino Romano cheese

1½ tablespoons finely chopped flat-leaf parsley

1 clove garlic, minced

2 cups plain bread crumbs

Salt and freshly ground black pepper

Extra virgin olive oil for frying

Place the beef, pork, and veal in a large bowl. Add the eggs, cheese, parsley, and garlic. Mix well—the best way is with your hands. Add the bread crumbs, salt, and pepper, and mix again. Add up to 1 cup cold water, gradually working it in, to make the mixture moist and easy to shape.

Shape the mixture into balls 2 to 3 inches in diameter, as desired.

Heat ½ cup oil over medium in a large skillet. Fry the meatballs in batches without crowding, turning them to cook all sides. Add more oil to the skillet if needed. Drain the meatballs on paper towels as they are done.

COOK'S NOTES If it's more convenient, you can shape the meatballs and refrigerate them for several hours before frying them.

SECOND HELPING
This recipe makes plenty
meatballs, so store extra
the freezer in zipper-clo
plastic bags. Once they
frozen, shake the bag or
to separate the meatballs,
making it easy to retrieve
them as needed.

PAELLA WITH LAMB

In a cavernous space at the edge of the Meatpacking District, Ken Oringer and Jamie Bissonnette have replicated their successful Boston restaurant, Toro. It's headquarters for lusty Spanish fare, from tapas to paellas, to specialties grilled on a plancha. This recipe is not for one of those kitchen-sink paellas, but a dish that shows how paella can be crafted with various ingredients, even some that are unexpected, like lamb and snails.

6 SERVINGS

5 tablespoons extra virgin olive oil

2 lamb shanks

4 medium-size onions, chopped

4 cloves garlic, sliced

2 stalks celery, diced

½ head fennel, diced

2 sprigs fresh rosemary

4 sprigs fresh thyme

1 bay leaf

1 cup dry white wine

Salt and freshly ground black pepper

About 4 cups chicken stock

2 carrots, finely chopped

1 bunch scallions, thinly sliced on an angle, whites and greens kept separate

1½ cups Spanish short-grain rice (Bomba or Calasparra)

2 tablespoons tomato paste

24 canned Burgundy snails, strained and soaked in water for 1 hour, optional

½ cup pitted Niçoise olives, optional

A small handful of arugula leaves

Preheat the oven to 350° F. Heat 2 tablespoons of the oil in a 4-quart casserole. Add the lamb shanks and brown them on all sides on medium-high heat. Remove them from the pan. Reduce the heat to medium low and add half of the onions, half of the garlic, the celery, and the fennel. Sauté until the vegetables are soft. Add the rosemary, thyme, bay leaf, and wine. Cook, scraping the pan, for about 3 minutes. Season with salt and pepper and stir in 4 cups of the chicken stock. Return the lamb shanks to the pan, cover it, and bake them, covered, for 90 minutes, turning the lamb once.

Remove the lamb from the casserole. Strain the liquid and discard the vegetables and herbs. You should have 5 cups of liquid. If not, add a enough additional stock to make up the difference. Pour the liquid into a saucepan. When the lamb is cool enough to handle, pull the meat off the bones, discarding the fat and gristle. Warm the stock on low.

Heat the remaining oil in a 14-inch paella pan on medium. Add the remaining onions and garlic, the carrots, and the whites of the scallions. Sauté until the vegetables are soft but not brown. Season them with salt and pepper. Stir in the rice and cook on medium until the grains whiten. Stir in the tomato paste. Add the reserved stock, stir, and taste for seasoning. Cook the paella on medium high for about 10 minutes, until the rice starts to plump up but is not yet tender. Scatter the pieces of lamb over the paella—no need to mix them; they will fall into the rice mixture. Scatter on the snails, if using, or the olives in place of the snails. Lower the heat to medium and let the paella cook for another 5 to 10 minutes, until the liquid has been absorbed and the rice is al dente.

Increase the heat to high for a minute or two, to crisp the rice on the bottom. Remove the pan from the heat, scatter the greens of the scallions and the arugula on top, cover the paella with a sheet of parchment paper, and let it sit for 10 minutes before serving.

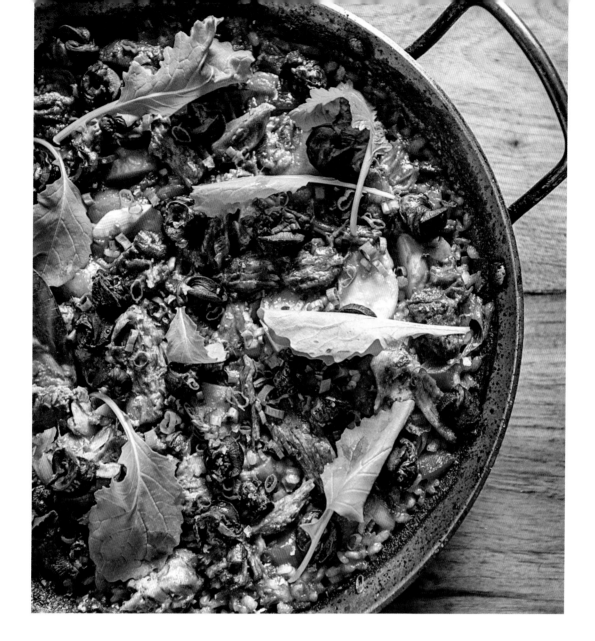

SECOND HELPINGS

Any leftovers make for a delicious snack but can also be folded into an omelet or be used to bolster a quiche.

COOK'S NOTES The notion that a paella has to be a mix of seafood, sausage, and chicken is off base, especially in Spain. You will find such paellas, but you will also find them with other ingredients, even entirely vegetarian ones. This paella is made with lamb and snails, fairly typical in parts of Valencia away from the coast. Instead of snails, pitted olives make for a nice addition. Cooked chickpeas or English peas can be used, and pair nicely with the lamb. You'll note that there is no saffron in this paella either. It does not need it. But a pinch of chili—Espelette or Aleppo pepper—can be added. However you decide to flavor your paella, it's important to use short-grain rice, ideally a Spanish variety. If that's not available, Italian Arborio, a close cousin, can replace it. As for the pan, an authentic paella pan, made of steel with shallow sloping sides, is best. It's a fairly lightweight utensil that allows for the rapid transfer of heat.

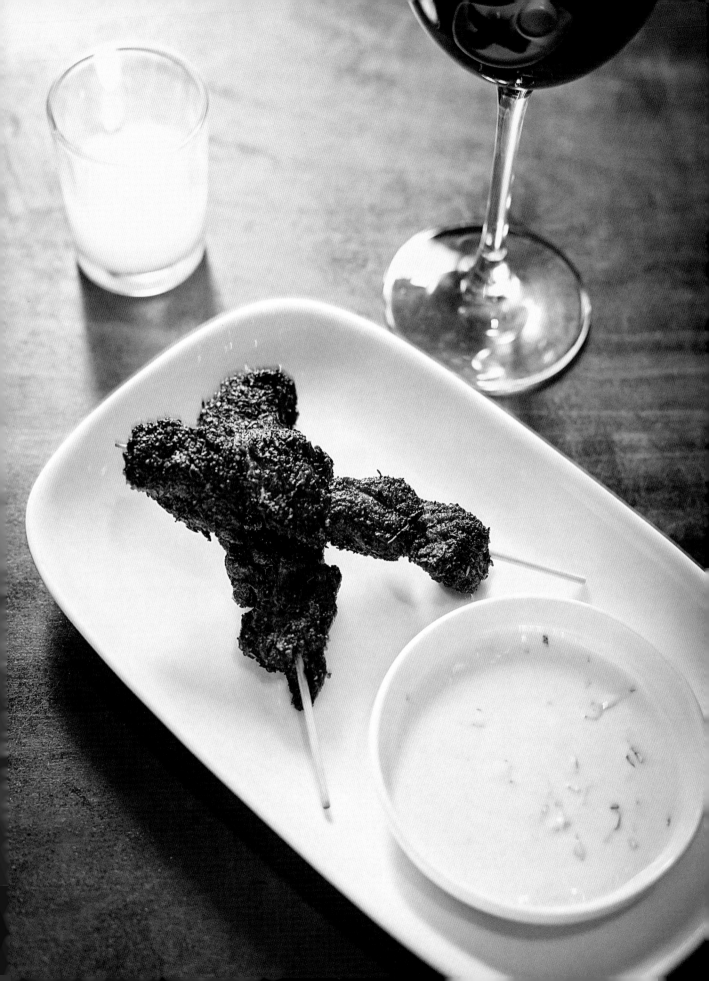

SPICED LAMB SKEWERS

At Ardesia, a welcoming wine bar and lounge on the far west side of Midtown, the style is small plates. This lamb dish is meant to be served like that. But small plates or tapas are easier to serve at restaurants than in homes. For a home cook, the succulent, spice-coated lamb, cut in somewhat larger chunks than Amorette Casaus, the chef, recommends, makes for an excellent main course. The creamy yet tangy sauce offers the perfect counterpoint to the forceful meat.

4 SERVINGS

1 tablespoon coriander seeds

1 tablespoon cumin seeds

1 tablespoon fennel seeds

1 tablespoon dried oregano

1 tablespoon dried thyme

1 tablespoon fresh rosemary leaves, chopped

½ teaspoon ground cinnamon

5 cloves garlic, crushed through a press

2 tablespoons extra virgin olive oil

2 pounds boneless lamb loin, all fat removed, in 1½-inch chunks

1 cup labne or plain Greek yogurt

2 teaspoons toasted sesame oil

1 tablespoon slivered mint leaves

Kosher salt

1 tablespoon grapeseed oil

Combine the coriander, cumin, and fennel in a spice grinder or mortar and process until the mixture is medium fine. Place it in a large bowl and add the oregano, thyme, rosemary, cinnamon, all but ½ teaspoon of the garlic, and the olive oil. Mix well. Add the lamb pieces and mix to coat them with the seasoning mixture. Your hands are the most effective utensils for doing this. Cover the bowl and set it aside at room temperature in a cooler spot in your kitchen for 2 to 4 hours.

In a small bowl, thin the labne with ¼ cup water. Season it with the reserved garlic, the sesame oil, mint, and salt to taste. Cover and refrigerate.

You will need eight 6-inch bamboo skewers. Thread 4 to 5 pieces of lamb on each skewer. Season the lamb with salt. Heat a large skillet, preferably cast iron, to very hot. Add the grapeseed oil. Reduce the heat to medium high. Place the skewers in the pan and sear them for 1½ to 2 minutes per side for medium rare. Transfer them to a serving platter. Serve the lamb with the labne sauce alongside.

COOK'S NOTES The lamb can also be seared on a grill, but then it's necessary to soak the skewers in water for at least 30 minutes before using them.

SECOND HELPINGS
If you cut the lamb in smaller chunks, about ¾ inch, and thread only two on each skewer with a pitted olive in between the pieces of meat and sear them for just a minute or so, you will have hors d'oeuvres for cocktails, enough to make about 24 skewers. Pass them on a platter with the bowl of labne in the middle, for dipping. They can be served just warm, not piping hot.

SEARED RACK OF LAMB WITH PISTACHIO TAPENADE

The Food Network, not a restaurant kitchen, is what has made Anne Burrell's career. She is now a member of the Food Council of City Harvest. Few cuts of meat are as simple or as impressive as rack of lamb. At the same time, the meat welcomes bold flavors, like the olives, capers, herbs, and nuts, giving a cook the opportunity to put seasoning skills on display.

2 SERVINGS

½ cup shelled pistachios, toasted (see Cook's Notes, page 157)

½ cup pitted green Cerignola olives

2 tablespoons drained capers

1 clove garlic, smashed

1 tablespoon minced fresh oregano leaves

2 tablespoons minced flat-leaf parsley leaves

About ⅔ cup extra virgin olive oil

Zest of 1 lemon

1 (8-rib) rack of lamb, chine bone cracked, cut into chops

Kosher salt

In a food processor, combine the pistachios, olives, capers, garlic, oregano, and parsley. Process the mixture to a puree. With the machine running, drizzle ½ cup of the oil through the feed tube. Scrape down the sides of the bowl. Add the lemon zest, pulse, and, if necessary, add a little more oil. Set aside.

Preheat the oven to 425° F.

Place a large sauté pan over medium-high heat and coat it with a slick of oil. Add the chops and cook for about 2 minutes per side to brown. Transfer the chops to a baking sheet lined with foil and coat them generously on one side with the pistachio tapenade. Roast the chops for 4 to 5 minutes, depending on their thickness, for medium rare. Let them rest for 5 minutes, then serve.

COOK'S NOTES This recipe can also be prepared with loin lamb chops.

SECOND HELPINGS
Pour on a film of olive oil to seal the top, then refrigerate any extra tapenade to use in other recipes. Try it as a garnish for soup, like the cauliflower soup on page 70. You could also toss it with pasta, add it to a vinaigrette for salad, or simply spread it on toast rounds to serve with cocktails.

PORK LOIN ROAST WITH APPLE-CRANBERRY SAUCE

Since pork can be a bland meat, brining intensifies its flavor and also enhances its texture, helping it to stay juicy. But the meat, especially if it is from a heritage breed, can be roasted without brining. A rack of veal can be used in place of pork. The tart cranberry condiment balances the lush meat.

6 TO 8 SERVINGS

1 (4-pound) pork loin, preferably a heritage breed, boned but tied back on the rack

1 cup sea salt, plus more for sauce

½ cup light brown sugar

1 cup molasses

6 bay leaves

3 tablespoons extra virgin olive oil

2 apples, preferably Macintosh, peeled, cored, and diced

1 cup fresh cranberries

1 tablespoon granulated sugar

Freshly ground white pepper

2 tablespoons good-quality balsamic vinegar

Select a container or a heavy-duty sealable plastic bag large enough to contain the meat. Heat 4 quarts of water in a large stockpot. Add 1 cup sea salt, the brown sugar, molasses, and bay leaves. Simmer gently for 30 minutes, until the ingredients are dissolved. Allow the liquid to cool to room temperature. Place the meat in your selected container and add the cooled brine. Let it marinate for 6 to 10 hours in the refrigerator.

Meanwhile, prepare the sauce. Heat a 2-quart saucepan on medium. Add 1 tablespoon of the oil, then the apples and cranberries. Sauté them for about 10 minutes, until the fruits release their juices. Stir in 1 cup water, the granulated sugar, and salt and pepper to taste. Simmer the sauce for a few minutes, until it is slightly thickened. Remove it from the heat and stir in the vinegar. Set it aside, covered.

Preheat the oven to 350° F. Heat an ovenproof skillet large enough to hold the loin (if needed, the loin can be cut in two portions). Add the remaining oil to the pan and sear the loin on top of the stove over medium-high heat until it is golden brown on all sides. Transfer the skillet to the oven.

Roast the pork for 45 minutes to 1 hour, until an instant-read thermometer registers 145 to 150° F for medium. Remove from the oven and let the pork rest for 10 minutes. Meanwhile, gently reheat the cranberry sauce. Carve the pork, arrange the slices on a platter, adding the rib bones to the platter too, if you like. Serve the sauce alongside.

COOK'S NOTES This recipe is for a good all-purpose brine that can be used with other meats, including your Thanksgiving turkey.

SECOND HELPINGS
Serving the rib bones with their borders of meat is optional. If you don't serve them, they can be saved, brushed with barbecue sauce, and roasted. Extra meat is sandwich material.

BARBECUED BABY BACK RIBS WITH ASIAN GLAZE

Top Chef contender Leah Cohen lived in Southeast Asia, hence the inspiration for her Lower East Side restaurant. The menu is a mash-up of Thai, Filipino, and Vietnamese fare, all done with the chef's personal touches. The meaty glazed ribs speak several Asian dialects.

6 SERVINGS

3 racks baby back ribs (about 3 pounds)

2 tablespoons Chinese five-spice powder

Salt and freshly ground black pepper

2 tablespoons chopped ginger

2 tablespoons chopped shallots

2 large cloves garlic, chopped

2 tablespoons soy sauce

2 tablespoons Asian fish sauce

⅓ cup rice vinegar

⅓ cup hoisin sauce

⅓ cup sugar

¼ cup cilantro leaves

2 tablespoons chopped scallions (green part only)

Preheat the oven to 300° F. Season the ribs with 1½ teaspoons five-spice powder and salt and pepper to taste. Wrap them in foil and place the packet on a baking sheet. Bake them for 2 hours, until they are fork-tender. Let the ribs cool.

Finely mince the ginger, shallots, and garlic by dropping them through the feed tube of a food processor while the machine is running. Set the mixture aside. Stir together the soy sauce, fish sauce, vinegar, and hoisin sauce. Set it aside.

Place the sugar and ¼ cup water in a small skillet. Heat the pan on low until the sugar has dissolved. Increase the heat to medium and cook, swirling the pan from time to time until the sugar caramelizes to a deep amber. Do not let it burn. Remove the pan from the heat and slowly pour in the soy sauce mixture; be careful, as it is likely to bubble up. Swirl the soy sauce in and place the pan on low until the caramelized sugar melts and mixes with the other ingredients. Add the ginger mixture. Stir in the remaining five-spice powder. Simmer the sauce for about 10 minutes. Let it cool, then brush some of it on the ribs.

About 30 minutes before serving, light your grill. Brush the ribs with more of the sauce and grill them until they are glazed. Take care not to place them too close to the heat source; baste and turn them as they cook, and do not let them char. Grilling should take no more than about 10 minutes. Transfer the ribs to a serving platter, scatter the cilantro and scallions on top, and serve.

Consider serving the ribs with Asian slaw (page 46).

COOK'S NOTES Baking the ribs fully cooks them before they are grilled, ensuring that they will be very tender. The grilling, with the basting of sauce, is strictly to impart flavor and a mahogany glaze. Chinese five-spice powder, or *wu xiang fen,* is a blend of star anise, fennel seeds, Sichuan peppercorns, cloves, and cinnamon. It's a lovely seasoning to keep on hand for a range of dishes, not necessarily Asian, that might benefit from a touch of licorice flavor.

SECOND HELPINGS
You are likely to have some sauce left over. Refrigerate it to use for basting other foods, including chicken and fish. The sauce may thicken in the refrigerator so you can thin it with a little water.

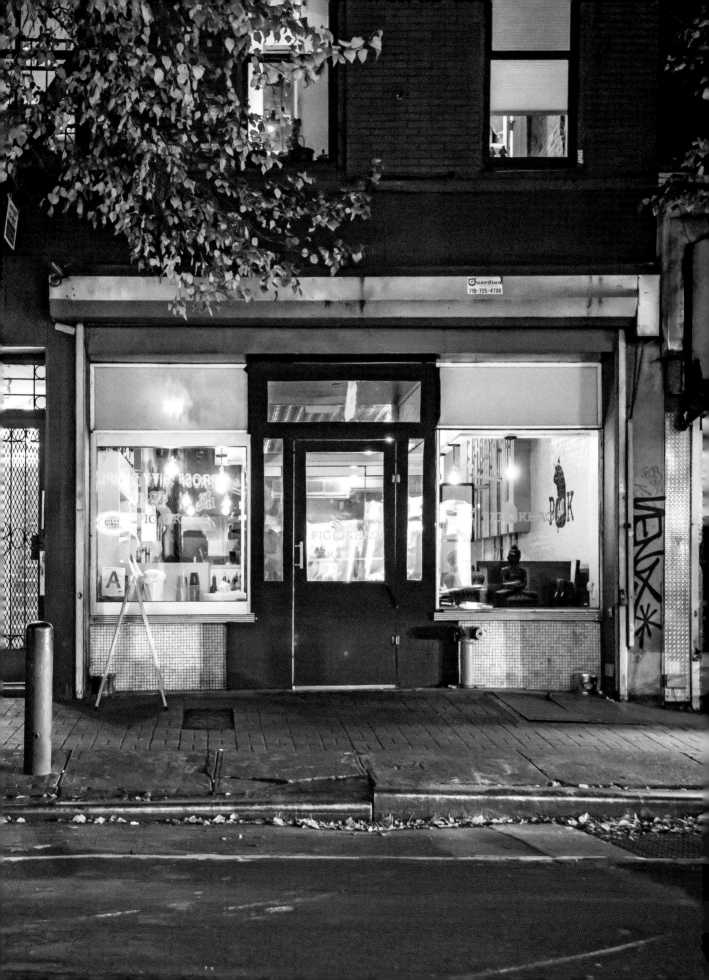

CALVES LIVER WITH BACON, PEAS, AND MAPLE

Anita Lo, a Chinese-American chef, has gradually risen to high stature and has become one of New York's top female chefs. Her restaurant, Annisa, is trendy only by virtue of being downtown. The place itself has dignity and grace. Her food is finely wrought, American, but with touches of global influence. Here a dish as simple as liver and onions welcomes bacon, peas, and a touch of maple so it flirts with haute cuisine.

4 SERVINGS

1-pound piece calves liver, about ½ inch thick

Salt and freshly ground black pepper

1 pound (about 12 slices) country bacon, ideally Nueske's brand

8 cipollini onions or shallots, peeled and halved vertically

1½ teaspoons extra virgin olive oil

2 tablespoons unsalted butter

1 large Spanish onion, thinly sliced

1 tablespoon maple syrup

24 sugar snap peas, trimmed and halved lengthwise

½ cup dry red wine

Preheat the oven to 400° F. Divide the liver into eight equal pieces. Season them with salt and pepper. Wrap each piece in bacon; you'll need about a strip and a half of bacon for each. Set aside.

Brush the cipollini onions with oil, place them cut side down on a small baking sheet, and roast until they are tender and lightly browned, about 20 minutes. Turn off the oven and leave the onions in it to keep warm. They'll brown a bit more, which is fine.

Heat 1 tablespoon of the butter in a skillet. Add the sliced onion and sauté it on medium low, moving the pieces frequently, until they are evenly and deeply browned, but not burned. Season with salt and pepper and stir in the maple syrup. Cover the pan and set it aside, off the heat.

Bring a pot of water to a boil, add the peas, cook for 1 minute, then pour off all but about ½ inch of the water. Add the remaining butter and simmer the peas in the butter for 4 minutes. Remove from the heat.

Heat one or two large, heavy skillets on medium high. You'll need enough skillet space to hold the wrapped liver in single layer, though sautéing the liver can be done in two shifts. Sear the liver on one side, about 3 minutes, until the bacon has browned. Turn the pieces and sear the other side. By the time the bacon is cooked, the liver should be medium rare to medium. You can test this with a small sharp knife; the inside should be pink. Do not overcook it.

Place a small pile of the sliced onions in the center of each of four warm dinner plates. Pour the wine into the skillet from the onions and cook it on high for a minute or so until it has reduced to a glaze. Remove it from the heat.

Top the sliced onions with two pieces of the liver. Place two cipollini on top of each serving, then spoon some of the peas alongside. Spoon a little of the red wine glaze on the other side of each plate. Serve.

SECOND HELPINGS
If you have extra cooked liver, you can mash it well, mix it with anchovy paste and minced parsley, and wind up with a Tuscan spread for toast rounds. Uncooked liver can be lightly sautéed to create the same tidbit.

COOK'S NOTES This recipe will give you a good idea of how high-end restaurant chefs function to deliver a plate with many components. Doing this in a restaurant setting requires staff. For the home cook, it requires organization. Indeed, there are more parts to this dish as it is served at Annisa—including a mound of fresh pea puree and actual maple leaves fried in tempura batter—which have not been included. The good news is that several of the elements for the dish, notably the two onion garnishes, can be prepared in advance and kept warm.

SIDES

BROCCOLI AND CAULIFLOWER GOMA-AE

Forthright Japanese food without cutting corners—they even make their own tofu—is the hallmark of this cavernous, busy restaurant. It's the opposite of the exquisitely serene stereotype presided over by a sushi master. Here the Japanese food is not only excellent, it's fun.

4 SERVINGS

2 tablespoons sesame paste, preferably Japanese

2 tablespoons soy sauce

1½ teaspoons tamari

1½ teaspoons sake

1½ teaspoons mirin

6 ounces small broccoli florets (about 2 cups)

6 ounces small cauliflower florets (about 2 cups)

1½ teaspoons sesame seeds

In a large bowl, whisk the sesame paste, soy sauce, tamari, sake, and mirin together. Set the sauce aside.

Bring a 2-quart saucepan of water to a boil. Add the broccoli and cauliflower. When the water returns to the boil, cook for 30 seconds, then drain the vegetables and transfer them to a bowl of ice water. When they are cool, drain and pat them dry.

Add the vegetables to the sesame sauce and mix gently. Transfer them to a serving dish and scatter sesame seeds on top.

COOK'S NOTES Though traditionally a cold salad, this dish also works as a warm vegetable: skip the ice water bath and transfer the blanched, drained broccoli and cauliflower directly to the bowl of sauce, mixing it and serving it immediately. Also, instead of buying sesame paste, either Japanese or Middle Eastern, you can grind 3 tablespoons of sesame seeds.

SECOND HELPINGS
Goma-ae means "sesame sauce." It's used for all sorts of vegetables. Prepare extra to keep on hand and toss it with blanched spinach, asparagus, sugar snap peas, green beans, or zucchini. It will keep for a week or so.

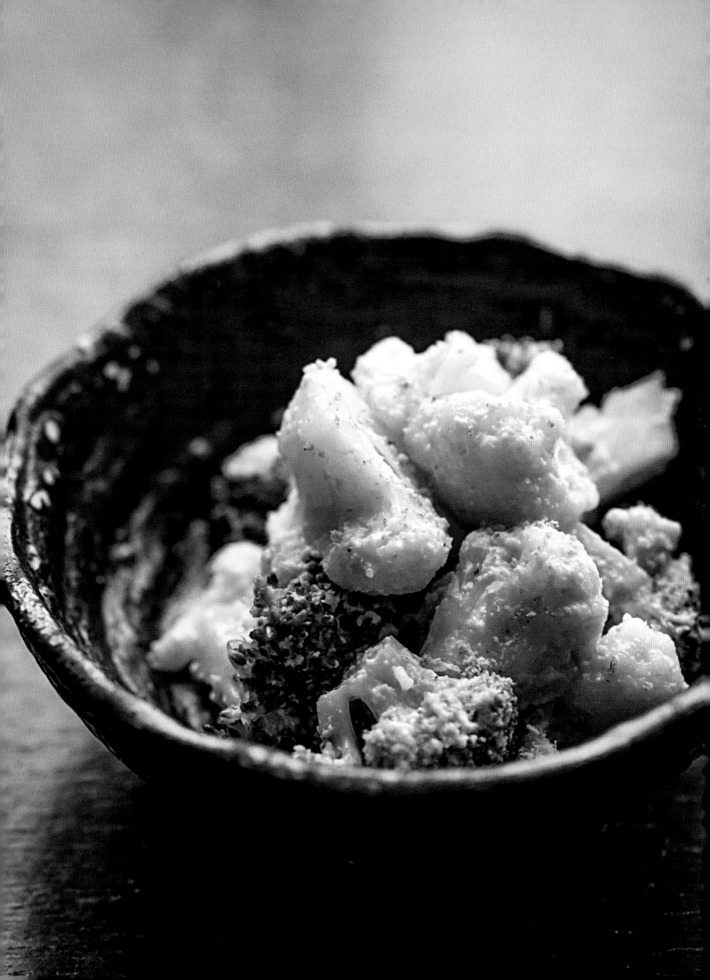

CINNAMON-SCENTED TOMATO-BRAISED CAULIFLOWER

Michael Psilakis is the premier Greek chef in New York, and his informal MP Tavernas are multiplying. There is one in Astoria, Queens; another in Brooklyn; and outposts in the suburbs, in Irvington and Roslyn. In this dish, a whiff of cinnamon is all it takes to give the cauliflower a fragrant Greek accent.

2 tablespoons extra virgin olive oil

1 medium-size head cauliflower, trimmed and broken into florets

Salt and freshly ground black pepper

⅛ teaspoon ground cinnamon

½ large sweet onion, thinly sliced

2 cinnamon sticks

1 fresh or 2 dried bay leaves

2 tablespoons tomato paste

2 tablespoons red wine vinegar

2 thyme sprigs

2 teaspoons Dijon mustard

2 teaspoons lemon juice

2 tablespoons pine nuts, toasted

¼ cup golden raisins

Heat the oil in a large sauté pan on medium high. Add the cauliflower, season it with salt, pepper, and cinnamon, and cook, stirring and shaking the pan, for about 5 minutes, until the cauliflower starts to brown. Stir in the onion, cinnamon stick, and bay leaf. Add the tomato paste and stir to distribute it. Add the vinegar and cook for a couple of minutes.

Stir in 1½ cups water. Add the thyme and mustard. Partly cover the pan and cook on low heat until the cauliflower is tender, about 15 minutes. Watch carefully and add more water if needed to keep everything moist. Remove the pan from the heat and discard the cinnamon sticks, bay leaf, and thyme. Stir in the lemon juice and check the seasoning.

Transfer the cauliflower to a serving dish and scatter the pine nuts and raisins on top.

COOK'S NOTES The best way to toast pine nuts—or any nuts, for that matter—is in a dry skillet over medium-high heat. Stir the nuts frequently and watch them like a hawk, because when they start to color, they go fast. The combination of cauliflower with golden raisins and pine nuts shows up frequently in Italy as well as in Greece, especially in Venice in fish *in saor* and in Sicily notably in pasta *con le sarde*, but also with cauliflower. The formula is very popular among American chefs.

SECOND HELPINGS
Any leftovers are delicious in salads.

SPICE-ROASTED CARROTS MARRAKECH STYLE

The Aldo Sohm Wine Bar, across a courtyard from Le Bernardin (see page 109), offers food, mostly small plates, that is totally different from what is served at Le Bernardin. There is no seafood on the menu, for example, and stronger flavors often prevail. These carrots are one example, at once sweet and rich yet kissed with spicy verve.

4 SERVINGS

2 tablespoons extra virgin olive oil

3 tablespoons sliced garlic

¾ cup sliced shallots

1 teaspoon ground cumin

1 teaspoon harissa

1 cup carrot juice

½ cup chicken stock

10 medium-size carrots, preferably organic, peeled and trimmed

Salt and freshly ground black pepper

1 tablespoon lemon juice

1 tablespoon cilantro leaves in chiffonade

Preheat the oven to 400° F. Place a shallow ovenproof saucepan over medium heat. Add the oil, then the garlic and shallots. Cook until they are tender but have not colored, about 2 minutes. Stir in the cumin and harissa. Add the carrot juice and stock.

Place the carrots in the pan in a single layer. Turn them to coat with the mixture. Season them with salt and pepper. Transfer the pan to the oven and roast the carrots for about 25 minutes, turning them a few times, until they are tender and have deepened somewhat in color.

Sprinkle the carrots with lemon juice. Check the seasoning. Transfer the carrots to a serving dish and pour the sauce over them. Scatter cilantro on top. Serve at once.

COOK'S NOTES Harissa is a spicy chili paste typical in North Africa, especially Tunisia. If you cannot find any, use chili paste from another culture—Thai, for example, Chinese, or Korean.

SECOND HELPINGS
These carrots are delicious hot or cold. Leftovers can go into a salad.

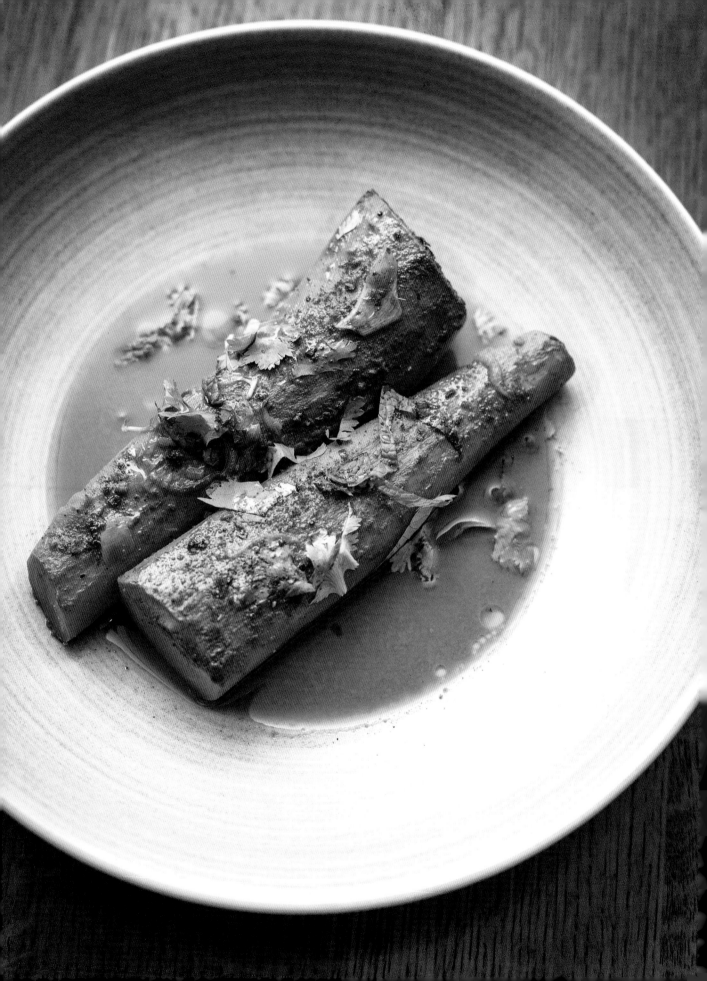

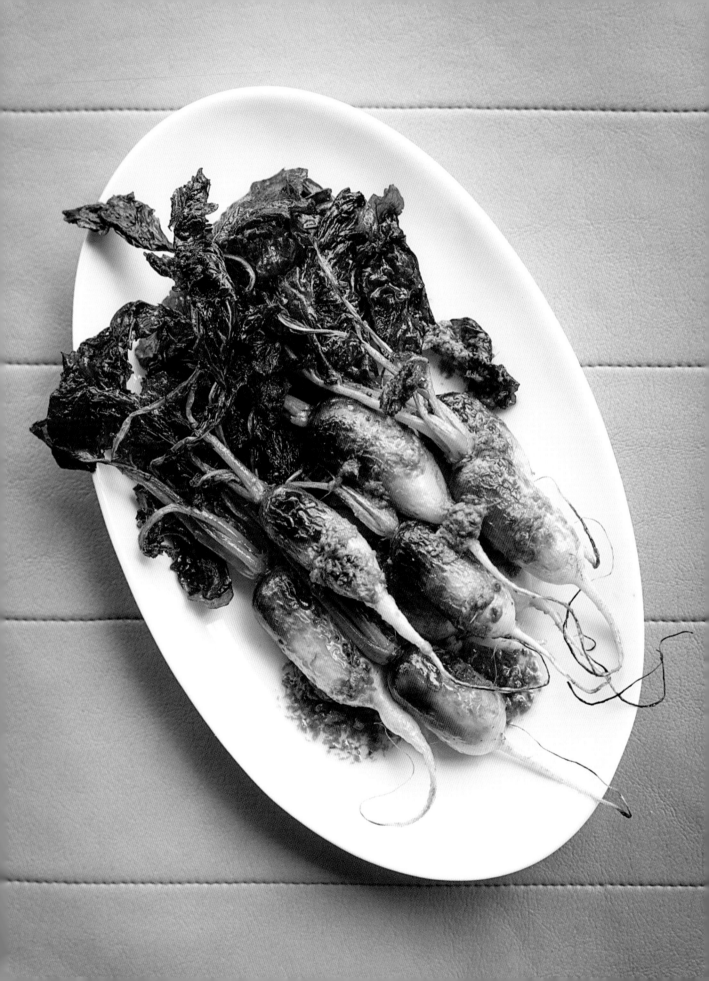

WHOLE ROASTED RADISHES WITH ANCHOVY BUTTER

Cooked radishes. Anchovies. These are a couple of examples of this chef's uncommon approaches. His dish is meant to showcase the small, delicate d'Avignon radishes the restaurant grows in its "farm," a collection of plastic milk crates filled with a growing medium that includes discarded cocoa husks. But even without those particular radishes, the recipe still works, as it balances the tangy radishes with the salt of anchovies and some lemony pucker.

4 SERVINGS

8 salt-cured anchovies, rinsed and patted dry

3 tablespoons extra virgin olive oil

24 medium-size radishes, preferably uniform in size, preferably with tops

1 clove garlic, crushed

1 tablespoon unsalted butter

1 tablespoon lemon juice

2 teaspoons minced flat-leaf parsley leaves

Place the anchovies in a small saucepan, add 2 tablespoons of the oil, and cook them on low for about 30 minutes, until the anchovies fall apart and can be stirred into the oil. Set them aside.

Preheat the oven to 375° F. Trim any wilted leaves from the radishes and wash them well.

Heat the remaining oil in a fairly small ovenproof skillet, just large enough to hold the radishes. Roll the radishes in the oil, then place the pan in the oven to roast until the radishes are tender when pierced with a knife, about 20 minutes. Turn the radishes once or twice during roasting.

Place the pan over medium heat. Add the garlic and butter and cook just long enough to coat the radishes. Stir in the lemon juice and anchovy mixture. Cook briefly, sprinkle the parsley on top, and serve.

COOK'S NOTES Try to find radishes that are uniform in size, preferably from a farm stand so they are very fresh and have attractive green leaves. The radishes can also be prepared without any greens.

SECOND HELPINGS
These radishes with their anchovy sauce, even just one per person, make a wonderful garnish for fish.

LATKES WITH APPLE PUREE AND SOUR CREAM

Larry Forgione was a pioneer when it came to promoting American food in the days when it had none of the prestige it enjoys today. His son Marc follows in his footsteps, but at a different moment in the evolution of American cooking. Global and various ethnic influences have become more typical, broadening the definition of what's American. Latkes are Eastern European Jewish potato pancakes, usually fried. Forgione bakes his. His original recipe also called for gribenes, which are chicken cracklings. That garnish requires the skin from two whole chickens baked for 15 minutes or so in a 400° F oven. If you expect to add that detail to this recipe, start collecting pieces of chicken skin in your freezer.

6 SERVINGS

2 tablespoons unsalted butter

1 sprig rosemary

1 (½-inch) piece ginger, peeled

2 tart apples, peeled, cored, and chopped

2 tablespoons sugar

Salt

1 medium-size onion

4 baking potatoes

2 large eggs

2 large egg yolks

5 tablespoons cornstarch or potato starch

4 tablespoons clarified unsalted butter

Sour cream for serving

SECOND HELPINGS
The advantage to these cakes over the traditional fried ones is not just that less fat is used in making them. These cakes can also be made in advance and reheated.

Preheat the oven to 450° F. Heat the butter with the rosemary and ginger in an ovenproof sauté pan on medium and cook for a few minutes until the butter turns nut-brown. Do not allow it to blacken or burn. Remove the rosemary and ginger and toss the apples in the butter. Season with the sugar and salt to taste. Transfer the pan to the oven and bake until the apples are very tender, about 20 minutes. Remove from the oven. Reduce the oven temperature to 400° F.

Puree the apple mixture in a blender. Transfer it to a serving bowl and set it aside.

Grate the onion. Shred the potatoes using the fine shredding disk of a food processor. Combine the onion and potatoes in a large bowl. Season them with salt.

Transfer the potato mixture to a clean kitchen towel, twist and squeeze out as much liquid as possible. Return the potato mixture to the bowl. Beat the eggs and egg yolks together. Beat in the cornstarch. Stir the egg mixture and half of the clarified butter into the potatoes.

Form the potato mixture into six disks about 4 inches in diameter and nearly 1 inch thick, using small ring molds. Place them on a baking sheet with a nonstick liner. Alternatively, the latkes can be formed in nonstick muffin tins holding 2 to 4 ounces each.

Brush the tops of the latkes with the remaining clarified butter and bake until they are golden, about 30 minutes. Unmold them onto a serving dish. Pass the apple puree and sour cream alongside.

COOK'S NOTES The potato cakes can be made with well-scrubbed unpeeled potatoes. Clarified butter is pure fat. To clarify butter, slowly melt it and let it simmer until foam rises to the top. Remove from the heat, skim off the foam, and strain the butter though a strainer lined with cheesecloth, leaving the solids behind. For 4 tablespoons clarified butter, start with 5½ tablespoons unsalted butter.

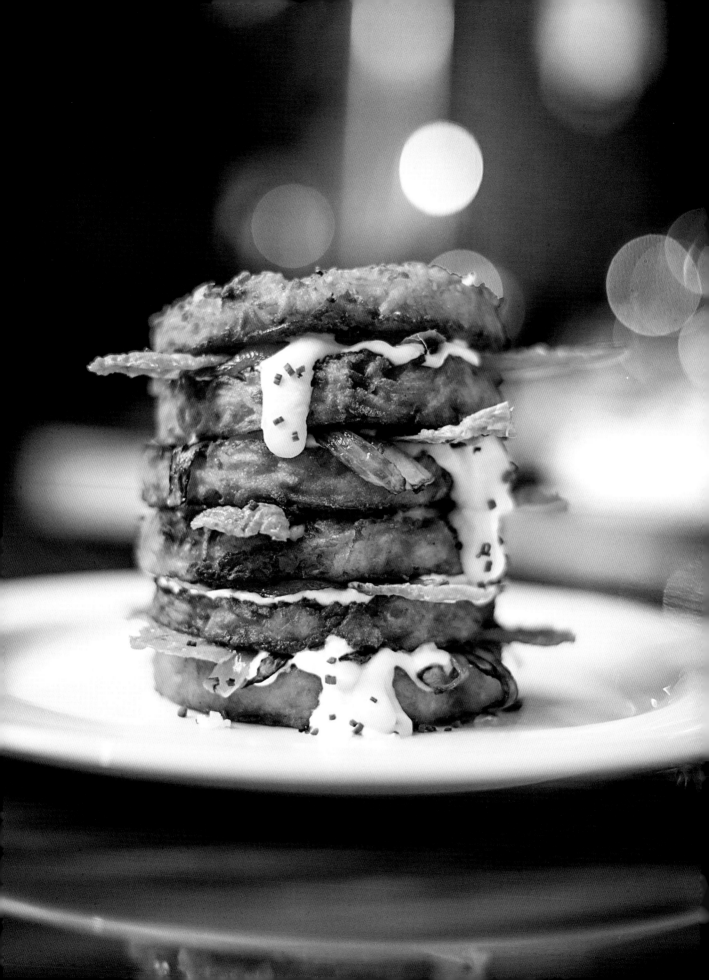

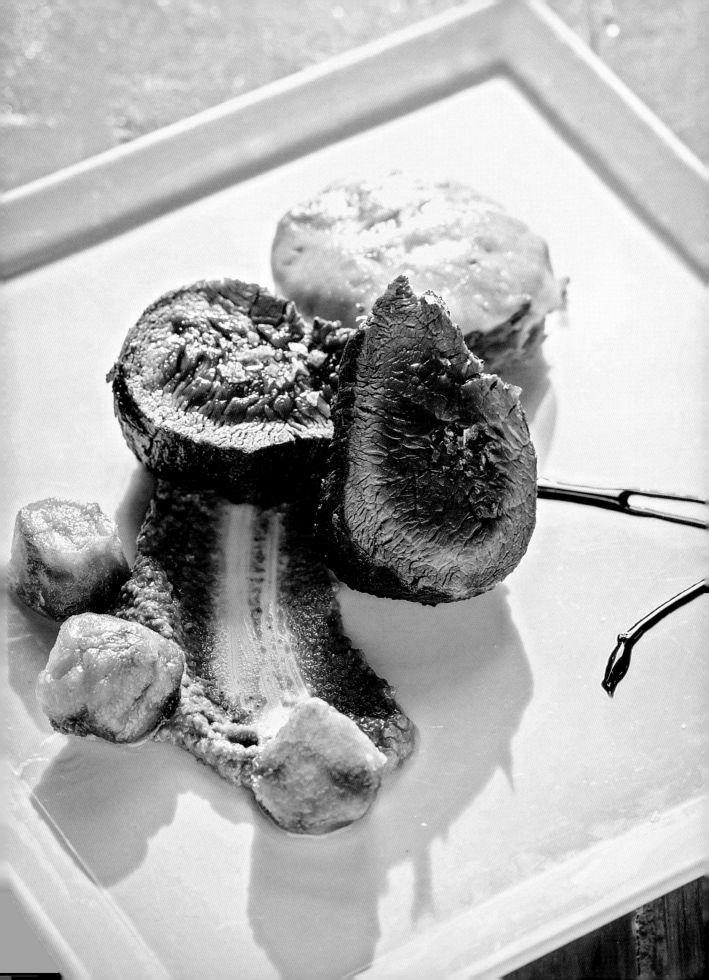

PURPLE POTATO GRATIN

This gratin is designed to be one component on a plate that also includes fillet of beef with a parsley pistou, some crispy bone marrow, and a balsamic glaze. But the potatoes (shown at the top of the plate in the photo) stand on their own and can complement many other dishes, including roast chicken, pork chops, and lamb shanks.

Unsalted butter, for baking dish

1½ pounds purple potatoes, peeled and thinly sliced

3 cups vegetable stock

3 sprigs fresh thyme

2 cloves garlic, crushed

Salt and freshly ground black pepper

1 cup freshly grated Parmigiano Reggiano

¾ cup heavy cream

1 ounce cold Italian Fontina cheese, shaved with a vegetable peeler

Preheat the oven to 350° F. Grease a 2-quart shallow baking dish with butter.

Place the potatoes, stock, thyme, and garlic in a saucepan. Season with salt and pepper. Bring the liquid to a simmer and cook for 3 minutes. Drain the potatoes, reserving the garlic. Discard the other ingredients.

Spread a layer of the potatoes in the baking dish. Season with salt and pepper. Sprinkle on one-third of the Parmigiano Reggiano. Pour on ¼ cup of the cream. Repeat the layers twice more.

Cover the baking dish with foil and bake for 25 minutes. Uncover the gratin, scatter the Fontina shards on top, then continue baking for 10 minutes longer. Allow it to rest for 10 minutes before serving.

COOK'S NOTES Though this dish can be prepared with Yukon gold, red bliss, or other potatoes, the dense texture of the purple potatoes makes for a particularly toothsome gratin.

SECOND HELPINGS
Leftovers make an alluring potato puree, thinned with milk or more cream.

SMASHED POTATOES WITH ROSEMARY VINAIGRETTE

The modern steak house can be defined as taking liberties with the classic menu. At Costata, owner Michael White offers seafood crudo as a first course and has several pastas, as well as seafood entrees, all executed by his chef, PJ Calapa. The main event remains steak along with these other options. And with that steak you need these tender potatoes, first crisped in a pan, then splashed with a vinaigrette for a little swagger so they stand up to a buttery slab of red meat.

4 SERVINGS

1 pound small red bliss potatoes, peeled

Salt

2 sprigs fresh rosemary

3 cloves garlic

Grated zest of ½ lemon

1½ teaspoons lemon juice

1½ tablespoons extra virgin olive oil

Pinch of crushed red chili flakes

Grapeseed or canola oil for frying

Place the potatoes in a pot of salted water with one sprig of the rosemary and two cloves of garlic and boil until they are tender, about 20 minutes. Drain the potatoes and discard the rosemary and garlic. Place the potatoes on a cutting board and use the side of a cleaver or the bottom of a pot to crush them lightly, keeping them as intact as possible.

Strip the leaves from the remaining rosemary sprig and chop them. Mince the remaining garlic clove. Place the rosemary and garlic in a dish with the lemon zest and juice and whisk in the oil and chili flakes. Season with salt. Set aside.

Preheat the oven to 200° F. Line a small baking sheet with a couple of layers of paper towel. Pour the grapeseed oil to a depth of ½ inch into a skillet large enough to hold the potatoes in a single layer (a 10-inch pan should do the trick); heat it to medium high. When the oil is hot, add the smashed potatoes and fry them, turning them once, until they are golden brown and crusty. Season them with salt, transfer them to the baking sheet, and keep them warm in the oven until you are ready to serve.

Transfer the potatoes to a serving dish. Give the vinaigrette another whisking and drizzle it over the potatoes. Serve.

COOK'S NOTES It's very important to select potatoes of uniform size for this recipe—not the tiniest, but about 1½ inches in diameter.

SECOND HELPINGS
Though these potatoes are delicious as a side dish with grilled meats, they can also be the centerpiece, topped with a fried egg, for a brunch. Another option is to crown each portion with sour cream and caviar for a festive first course.

⊗ PRETZEL milk

SOFT SERV

CLASSIC FLAVOR! →

$4

CEREAL milk

✳ CHOCOLATE HAZELNU

PEPPERMINT ✳

EASONAL FLAVOR! →

ADD: CORNFLAKE CRUNCH 75¢
 OR FUDGE

TAKE HOME A PINT
MILKSHAKES

$6

CEREAL milk
PRETZEL milk
CHOCOLATE HAZELNUT PEPPER

$7

$5.

E

.50

E

*

$4.50

$9.50

00

INT *

ALWAYS
A DOUBLE
SHOT →

LATTE
ESPRESSO

BEVS!

HOT CHOCOLAT

★ xtra marshn

COKE
BEER
PARKING
KLYN LAG
CHOCOLATE STO

HOT TEA
EARL GREY · CINNAMON SPICE
GREEN TEA · CHAI TEA · BLACK

DESSERTS

Happy Hour!

RED WINE-POACHED FIGS WITH BLACK PEPPER

Fresh figs, red wine, spices, and a dollop of ice cream are the components for a winning dessert. For the restaurant, Francois Payard adds crushed black pepper to the vanilla ice cream as the churning is completed. At home, simply dusting the ice cream with some pepper before serving accomplishes much the same purpose. The ice cream with its pinch of pepper has enough personality to accompany the figs in their intense red wine sauce.

4 SERVINGS

1 (750-ml) bottle dry red wine

1 cinnamon stick

1 star anise

2 whole cloves

Pinch of crushed red chili flakes

4 coriander seeds

12 fresh black figs

4 tablespoons sugar

2 tablespoons unsalted butter, softened

¼ cup all-purpose flour

⅓ cup almond flour

½ pint vanilla ice cream

Coarsely ground black pepper

Combine the wine and spices in a 3-quart saucepan. Bring the mixture to a boil on high heat and cook until the wine is reduced by about one-third, about 10 minutes. Strain the mixture into a medium-size saucepan. Add the figs. Return the liquid to a boil, reduce the heat to low, and simmer until the figs are tender, about 10 minutes. Using a slotted spoon, remove the figs to a bowl.

Add 1 tablespoon of the sugar to the liquid, place it over high heat, and boil until it becomes syrupy, about 5 minutes. Set the syrup aside to cool.

Preheat the oven to 350° F. Cream the butter and remaining sugar together until smooth. Add the flours and combine with your fingertips or a pastry blender until the mixture is crumbly. Spread it on a baking sheet lined with parchment or a silicone mat. Bake the streusel for about 10 minutes, until it is golden. Set it aside to cool and then break it into streusel crumbs.

Divide the figs among chilled dessert plates. Drizzle them with a little of the wine syrup. Place some of the crumbs alongside and top with a small scoop of ice cream. Dust the ice cream with a little pepper. Serve.

COOK'S NOTES When fresh figs are not in season, this dessert can be made with dried fruit. Try a mixture of figs, prunes, cranberries, and pears. The poaching will take considerably longer, closer to 30 minutes, so increase the amount of wine by 1 cup.

SECOND HELPINGS

Extra wine syrup will keep for days in the refrigerator and can be used as a sauce for ice cream. Similarly, any extra streusel crumbs can be saved to sprinkle on muffins, a pie, or a tea cake before baking.

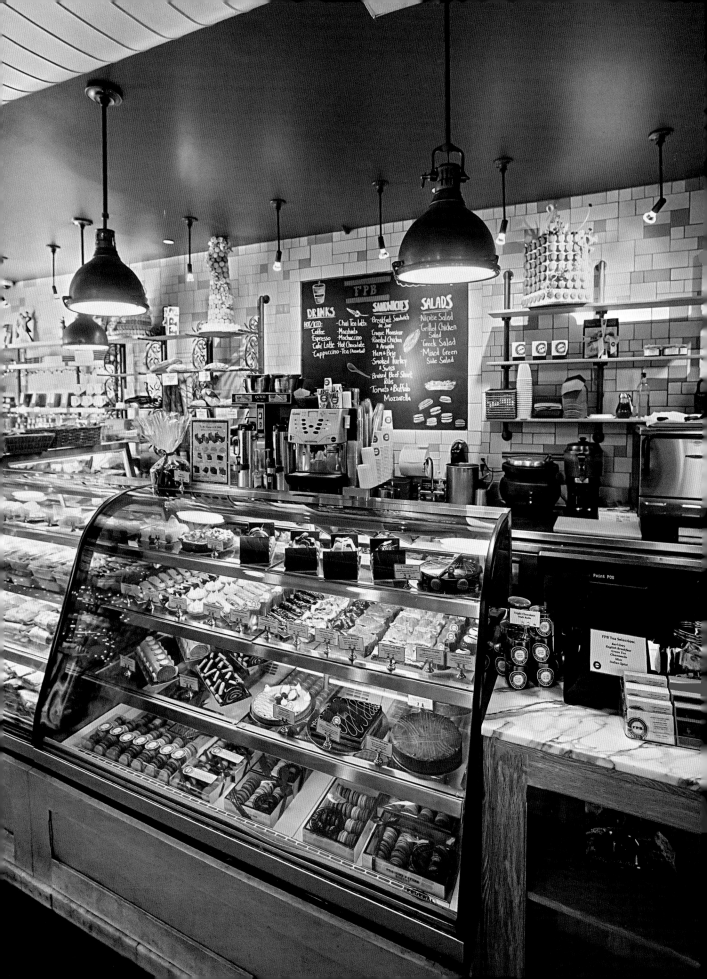

PINEAPPLE CARPACCIO WITH COCONUT GRANITÉ AND LIME

A bastion of elegance and fine food near Lincoln Center, Picholine has long been a star in New York's dining firmament. This dessert is delectable yet light. Its only drawback is that it should be prepared a day in advance. It makes for a refreshing tropical "predessert" for an important dinner, served before a pastry like the pistachio cake on page 180.

4 SERVINGS

½ pineapple (cut vertically)

1½ cups simple syrup (page 206)

Zest of 1 lime

1 cup unsweetened coconut milk

¼ cup whole milk

¼ cup sugar

½ vanilla bean, scraped

¼ cup grated unsweetened coconut

Juice of 1 lime

4 mint sprigs for garnish

Trim and peel the pineapple. Cut it in half vertically, giving you two long pineapple quarters. Remove the cores. Cut 16 thin slices from each piece (each piece being a quarter of the pineapple). You should get about 32 slices total.

Line a rimmed 10 by 15-inch baking sheet with foil. Arrange the pineapple slices in a single layer on it. Cover them with simple syrup and scatter them with lime zest. Cover the pan with plastic wrap and refrigerate it, preferably overnight.

Place the coconut milk, whole milk, sugar, and vanilla bean in a saucepan. Bring the mixture to a simmer and cook it for 3 minutes. Allow it to cool, then pour it into a shallow pan or container and place in the freezer. Use a fork to scrape and fluff the mixture about every 30 minutes, until it is firmly frozen but still granular, about 6 hours.

To serve the carpaccio, drain the pineapple slices, reserving the syrup, and arrange eight slices in a circle on each of four chilled dessert plates. Place a portion of the granité in the center. If the granité has become hard and difficult to scoop, cut it into chunks and briefly pulse it in a food processor. Mix the reserved syrup with the lime juice. Drizzle a little of the lime-flavored simple syrup on top and garnish with a sprig of mint.

COOK'S NOTES If desired, the coconut granité mixture can be chilled in the refrigerator, then churned in an ice cream maker.

SECOND HELPINGS
Any leftover lime-infused simple syrup should be saved to use in other desserts or cocktails.

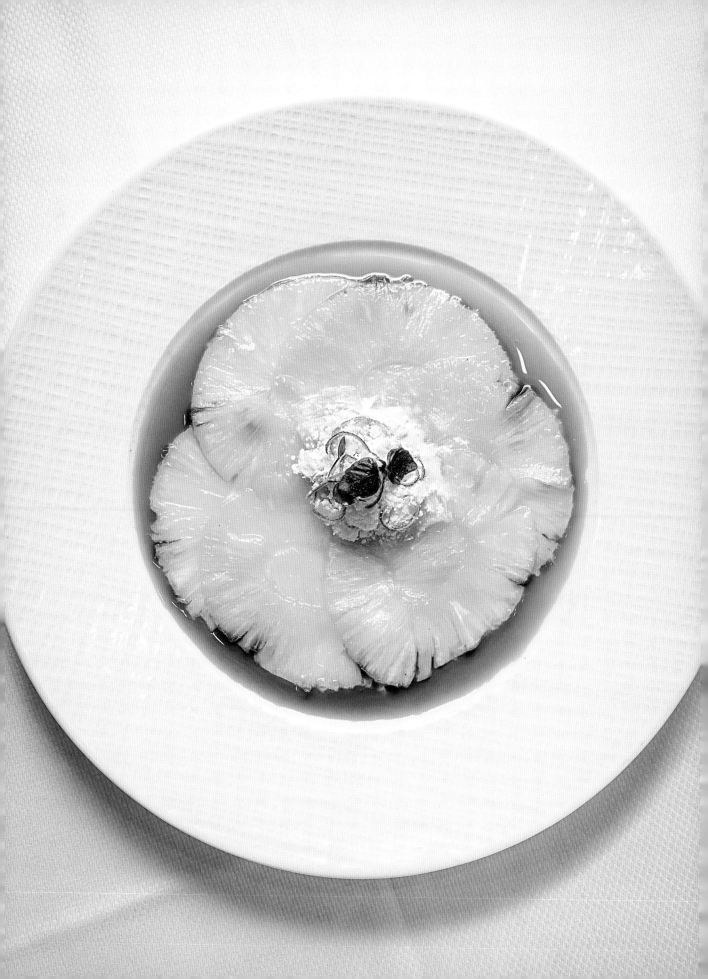

COCONUT CAKE

Commerce Street in the West Village is a small, historic U-shaped lane. The restaurant that is now called Commerce was once the Blue Mill, frequented by devotees of the Cherry Lane Theatre, a few doors away. The theater is still there, and it helps this restaurant, with its Art Deco furnishings, including some plaques from the 1939 World's Fair, to thrive. The chef, Harold Moore, is known for his killer desserts; this monumental coconut cake tops the list.

8 TO 12 SERVINGS

2 cups cake flour

½ teaspoon baking powder

¼ teaspoon baking soda

¼ teaspoon fine sea salt

1 teaspoon vanilla extract

¼ teaspoon coconut extract

4 large egg yolks, beaten

1 cup sugar

6 ounces (1½ sticks) unsalted butter, at room temperature

⅔ cup sour cream

Coconut-vanilla pudding (recipe follows)

Cream cheese frosting (recipe follows)

2½ cups sweetened shredded coconut, toasted

SECOND HELPINGS
Unused cake should be kept refrigerated. It works well in a trifle.

Preheat the oven to 350° F. Butter three 8-inch round cake pans, line the bottoms with parchment, and butter the parchment.

In a bowl, sift together the flour, baking powder, baking soda, and salt. In another bowl, whisk the vanilla and coconut extracts into the egg yolks.

Place the sugar and butter in the bowl of a stand mixer and beat them on medium speed until they are light and fluffy, about 2 minutes. Slowly drizzle in the egg yolk mixture and continue to beat until the mixture turns fluffy and pale, about 3 minutes. By hand, fold in the dry ingredients alternately with the sour cream.

Distribute the batter among the prepared pans. If possible, weigh them to be sure each pan has the same amount. Bake the cakes for 20 to 25 minutes, until they are springy to the touch and a cake tester inserted in the center comes out clean. The cakes will not brown very much.

Transfer the pans to a wire rack for 15 to 20 minutes. Remove the cakes from the pans and let them cool completely before proceeding.

Place one layer on a cake stand and cover the top with half of the pudding. Top it with another layer, the rest of the pudding, then the final layer. Spread the entire three-layer cake with the cream cheese icing. Chill the cake for 1 hour.

Coat the top and the sides with the toasted coconut. Refrigerate the cake until you are ready to serve.

COOK'S NOTES The original recipe for this cake called for baking it in two 6-inch round pans, 2 inches deep, then slicing each layer in half horizontally. But 6-inch pans are difficult for home cooks to find. If you have the pans to do it, make the four-layer 6-inch cake; it will be taller. (Bake the cakes for about 35 minutes.) When icing the cake, the best tool is an offset spatula.

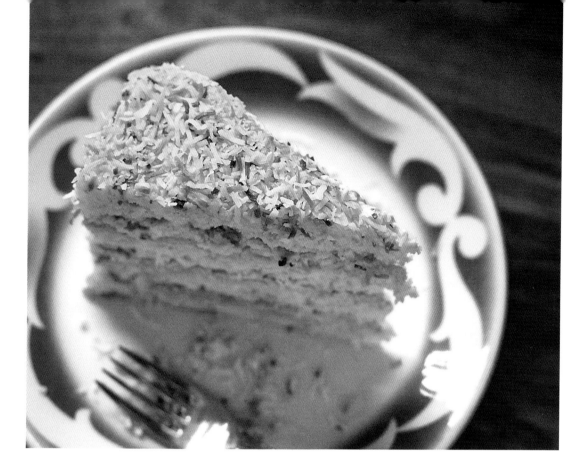

COCONUT-VANILLA PUDDING
ABOUT 3 CUPS

½ cup sugar

3½ tablespoons all-purpose flour

⅛ teaspoon fine sea salt

4 large egg yolks, beaten

2 cups whole milk

1 teaspoon vanilla extract

1 cup sweetened shredded coconut

In a medium-size saucepan, whisk together the sugar, flour, salt, egg yolks, and milk. Cook the mixture, whisking continuously, until it comes to a boil and thickens.

Remove the pan from the heat and fold in the vanilla and coconut. Cover the pudding and refrigerate until it is cool before using.

COOK'S NOTES Cover the pudding by placing a film of plastic wrap directly on the surface to prevent a skin from forming as the pudding cools.

SECOND HELPINGS
This is a delicious pudding to serve on its own.

CREAM CHEESE FROSTING
ABOUT 3 CUPS

10 ounces cream cheese, at room temperature

4 ounces (1 stick) unsalted butter, at room temperature

1¼ cups confectioners' sugar

1½ teaspoons vanilla extract

⅛ teaspoon fine sea salt

In a stand mixer or by hand, beat the cream cheese and butter together until smooth. Gradually beat in the sugar. Add the vanilla and salt.

Beat for about 2 minutes, until the icing is light and fluffy. Cover and set it aside until needed; it's best not to refrigerate it, as it will be easier to spread. If you do refrigerate it, allow it to come to room temperature before using it.

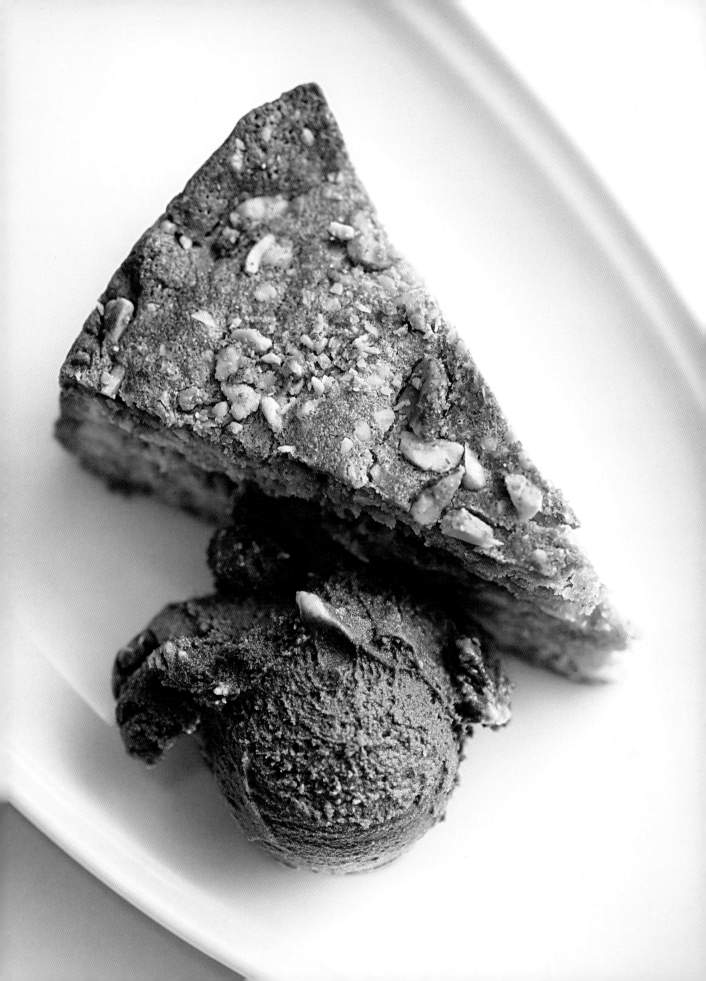

INSTITUTE OF CULINARY EDUCATION

PEANUT FINANCIER

The Institute of Culinary Education, one of the major cooking schools in New York City, offers courses for professionals and amateurs. Though this cake is called a financier, a type of cake with nuts in the batter, it's a variation on the classic, made with peanuts and baked in a round cake pan instead of traditional oblong financier molds.

1 cup roasted unsalted peanuts

1 cup all-purpose flour

½ teaspoon baking powder

6 ounces (1½ sticks) unsalted butter

2 ounces smooth peanut butter, preferably salted but not sweetened

½ cup light brown sugar

3 large eggs, separated

1 tablespoon vanilla extract

1 tablespoon dark rum

½ cup granulated sugar

½ cup chopped honey-roasted peanuts

Preheat the oven to 350° F. Butter an 8-inch round cake pan. Line the bottom with parchment.

Combine the unsalted peanuts with the flour and baking powder in a food processor and grind until the nuts are finely chopped. Transfer the mixture to a large mixing bowl.

Place the butter in a small saucepan over low heat and cook until it is browned, 10 to 15 minutes. Off the heat, add the peanut butter and brown sugar, stirring until all the ingredients are well combined. Whisk in the egg yolks, vanilla, and rum.

Beat the egg whites until frothy. Continue beating while gradually adding the granulated sugar. Beat until the egg whites hold peaks. Stir the peanut butter mixture into the flour, then fold in the egg whites. Spread the batter into the pan and sprinkle the honey-roasted peanuts on top. Bake for about 40 minutes, until the cake is springy to the touch and a cake tester inserted in the center comes out clean. Cool the cake on a rack, then unmold it.

COOK'S NOTES This cake is designed to be served with a grape sorbet, building on the theme of the usual peanut butter and jelly pairing. But other fruit sorbets, notably raspberry, are also excellent alongside.

SECOND HELPINGS
With a small amount of the cake left over—a quarter of it for example—you can slice the piece in half horizontally, slather the bottom half with grape jelly, place the other piece of cake on top, and cut slivers. You will have peanut butter and jelly pastry "sandwiches" to offer with a dessert.

CITRUS CAKE

Though he's known mostly for his lavish, exquisitely decorated custom wedding cakes, here Ron Ben-Israel shares a simpler confection, the base of many of his creations, which can stand alone for dessert at home.

8 SERVINGS

4 ounces (1 stick) unsalted butter, softened

1¾ cups sifted cake flour

1 cup sugar

½ teaspoon salt

2½ teaspoons baking powder

Finely grated zest of 1 lemon

Finely grated zest of 1 lime

Finely grated zest of 1 orange

⅓ cup whole milk

3 large egg whites, at room temperature

1½ teaspoons lemon juice

2 teaspoons lime juice

1 tablespoon orange juice

1 teaspoon lemon extract

Preheat the oven to 350° F. Use a little of the butter and flour to grease and dust a 9-inch springform pan 2 inches deep.

Place the remaining flour, the sugar, salt, baking powder, and citrus zests in the bowl of a stand mixer. Beat briefly on low to combine. Add the remaining butter and, when the mixture is well-blended, beat in the milk. Set the bowl aside.

In a separate bowl, beat the egg whites until they are very softly peaked. Stir in the citrus juices and lemon extract. Fold this mixture into the batter. Spread it into the pan. Bake the cake for about 40 minutes, until a cake tester inserted in the center comes out clean. Cool the cake on a rack, then remove the sides of the pan.

COOK'S NOTES This recipe makes a golden, delicate cake with subtle notes of citrus. Once the cake has cooled, it can be cut in half horizontally to make two layers. They can be filled with whipped cream, lemon curd, or perhaps the pudding filling used for the coconut cake (page 175). You can also frost it with whipped cream, but stabilize the cream the way Ron Ben-Israel does, by beating in a few spoonfuls of crème fraîche.

SECOND HELPINGS
The simplicity of this cake makes it an excellent base to use in desserts like trifles, baked Alaska, and ice cream cakes.

TRADITIONAL FRENCH MADELEINES

Forever associated with Marcel Proust, the madeleine is a tender little cake that has seashell fluting on one side and is rounded on the other. The name of Florian Bellanger's bakery, Mad Mac, refers to the fact that he specializes not just in madeleines, but also in macarons.

2¼ cups all-purpose flour

1 teaspoon baking powder

6 large eggs

Pinch of sea salt

½ teaspoon vanilla extract

1¼ cups sugar

10 ounces (2½ sticks) unsalted butter, melted and cooled, plus more for pans

3 DOZEN

Whisk together the flour and baking powder. In a large bowl, whisk the eggs, salt, vanilla, and sugar together until light. Fold in the flour mixture, then fold in the melted butter.

Set the batter aside in the refrigerator for at least 2 hours. It can be left overnight—in fact, the madeleines will be better if it rests for the longer time.

Preheat the oven to 375° F. Brush the madeleine pans with melted butter. If you do not have enough pans for 36 madeleines, you can bake them in shifts, but allow your pan to cool before using it again. Spoon the batter into the prepared pans, filling each mold until it's nearly full. Bake the madeleines for 18 to 20 minutes, until they are golden. Unmold them onto wire racks and let them cool.

COOK'S NOTES The funny thing about madeleines is that the longer the batter rests, the larger the characteristic hump on the little cakes will be.

SECOND HELPINGS
Madeleines go stale quite rapidly. Freeze any that are not used the day they are baked.

WARM PISTACHIO MOELLEUX

This is the bakery that's the source of the world-famous Cronut, Dominique Ansel's inspired fusion of croissant and doughnut. But this French-born pastry chef has many other strings in his bow, including this sumptuous pistachio cake, a pale green confection with nutty sweetness to spare. It can be baked as a single deep layer as in the recipe, or made into individual muffins or financiers to serve as breakfast pastries, lightly warmed with no chocolate, as shown in the photo.

8 TO 10 SERVINGS

1 cup shelled unsalted pistachios

1 cup all-purpose flour

1 teaspoon sea salt

10 ounces (2½ sticks) unsalted butter, softened

1¼ cups light brown sugar

5 large eggs, at room temperature

6 ounces bittersweet chocolate, in pieces

⅓ cup heavy cream

1 tablespoon dark rum

Preheat the oven to 350° F. Spread ⅔ cup of the pistachios on a baking sheet and toast them in the oven for about 10 minutes. Allow the nuts to cool, then roughly chop them. Set them aside.

Place the remaining ⅓ cup pistachios in a food processor and process them to a paste, scraping the bowl a few times. Set the paste aside. Combine the flour and salt and set them aside.

Lightly butter a 9-inch springform pan.

Place the butter in the bowl of a stand mixer. Beat in the brown sugar until the mixture is light and fluffy, 3 to 5 minutes. Add the eggs, one at a time, beating well after each. Beat in the pistachio paste. Fold in the flour mixture, either by hand or on the lowest mixer speed. Fold in ½ cup of the toasted chopped pistachios.

Spread the batter in the pan and bake until the cake is nicely browned and a tester inserted in the center comes out clean, about 45 minutes. Allow it to cool on a rack and then unmold it.

When the cake has cooled, combine the chocolate and cream in a small saucepan. Heat the mixture gently until the chocolate is nearly melted. Remove the pan from the heat and stir until the mixture is smooth and shiny. Stir in the rum. Spread this ganache over the top and sides of the cake. Decorate the top with the remaining pistachios.

COOK'S NOTES Commercial pistachio paste can be used instead of making your own; you will need 5 ounces. Another way to decorate the cake is by covering the sides with finely chopped, toasted pistachios. Do not refrigerate this cake. To bake individual cakes use 4- or 6-ounce muffin or financier cups to make two dozen or more. Bake them about 25 minutes.

SECOND HELPINGS
There might, just might, be a little cake left over. If you do not wish to keep it for late-night snacking, consider freezing it to use in a trifle or other layered dessert.

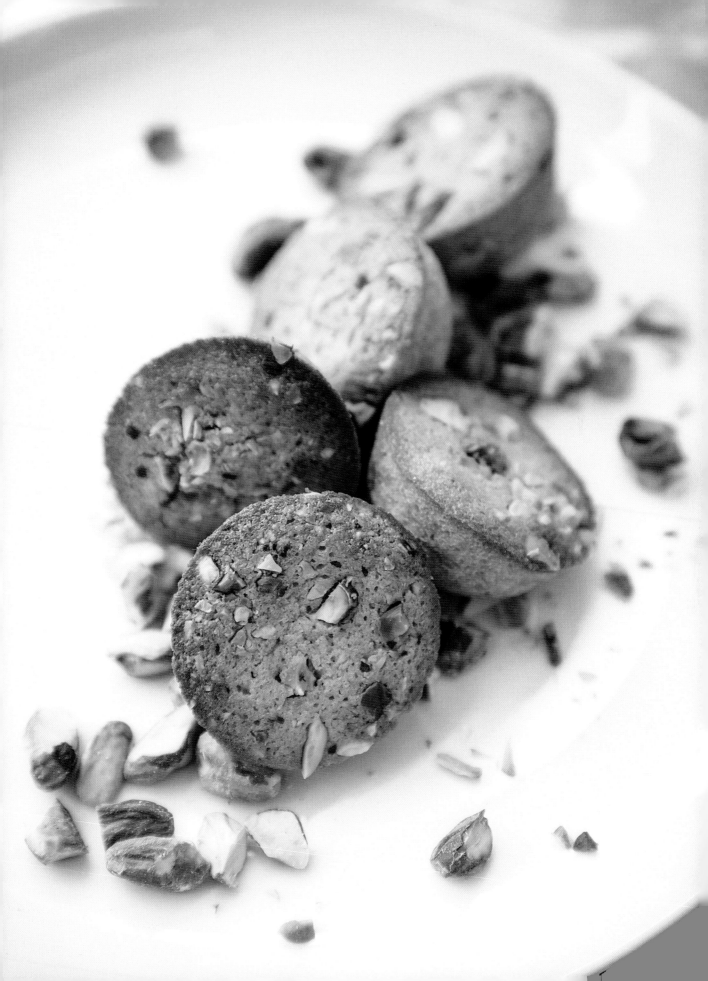

CLASSIC APPLE PIE WITH CHEDDAR LATTICE CRUST

Marc Glosserman's Texas barbecue and chicken restaurants specialize in pie for dessert. The pies are also sold retail to take away. They have been the work of Elizabeth Karmel, whose versatile background has given her expertise on the barbecue and bakery fronts. This apple pie benefits from its rich Cheddar pastry. Ms. Karmel is no longer at Hill Country; she now runs a company that sells North Carolina barbecue.

8 SERVINGS

Cheddar crust (recipe follows)

5 cups peeled, sliced Granny Smith apples

¼ cup light brown sugar

4 tablespoons unsalted butter

1 tablespoon cornstarch

2 teaspoons cinnamon

Pinch of salt

1 tablespoon lemon juice

Preheat the oven to 400° F. Separate the dough into two pieces, one twice as large as the other. Roll out the larger piece on a lightly floured surface and use it to line a 9-inch pie plate. Refrigerate both the reserved pastry and the pie shell.

Place the apples in a bowl and toss them with the brown sugar. Melt the butter in a heavy 12-inch sauté pan or skillet. Add the apples. Cook them on medium high, stirring, for about 10 minutes, until they start to caramelize. Dissolve the cornstarch, cinnamon, and salt in the lemon juice and add it to the pan. Stir until the juices start to thicken.

Spoon the apple filling into the prepared crust. Roll out the reserved dough on a lightly floured surface, cut it into inch-wide strips, and weave a lattice crust to top the pie. Alternatively, you can cover the pie with a top crust, crimping the top and bottom edges together and cutting some decorative slits to allow steam to escape.

Bake the pie for 15 minutes. Reduce the oven temperature to 350° F and continue baking for another 40 minutes or so, until the crust is golden brown. Let the pie cool for at least 30 minutes before serving.

CHEDDAR CRUST
CRUST FOR A 9-INCH DOUBLE-CRUST PIE

2 cups all-purpose flour

1 teaspoon fine sea salt

2 teaspoons granulated sugar

Pinch of cayenne

9 tablespoons unsalted butter, in pieces

1⅔ cups grated sharp white Cheddar cheese (about 5 ounces)

Place the flour, salt, sugar, and cayenne in the bowl of a food processor. Pulse briefly to mix. Add the butter and pulse until the mixture has a mealy texture. Add the cheese and pulse again a few times to incorporate it.

Drizzle in ¼ cup ice water. Pulse briefly. At this point, see whether the mixture is moist enough to be gathered together. If not, add another tablespoon or two of the water, and pulse until the dough comes together. Shape the dough into a ball, wrap it in plastic, and refrigerate it until you are ready to use it.

COOK'S NOTES Thanks to the cheese, this dough is extremely easy to handle.

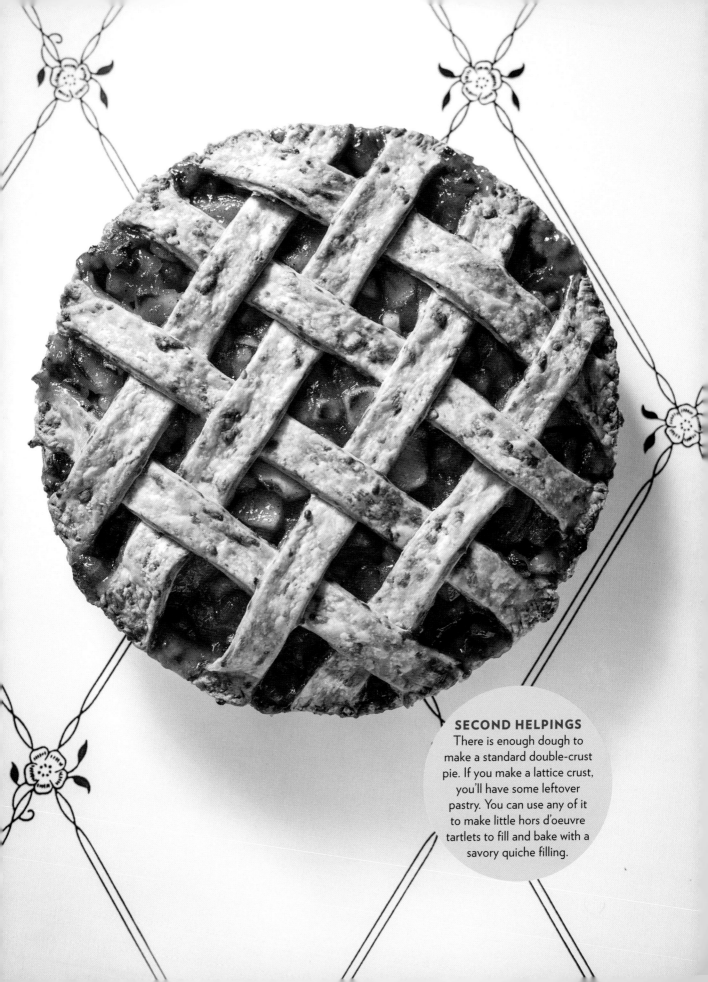

SECOND HELPINGS
There is enough dough to make a standard double-crust pie. If you make a lattice crust, you'll have some leftover pastry. You can use any of it to make little hors d'oeuvre tartlets to fill and bake with a savory quiche filling.

EARL GREY CRÈME BRÛLÉE

Creative American fare is the specialty of Alex Guarnaschelli, one of New York's outstanding female chefs (a category that is underpopulated). Her midtown restaurant is named Butter and is among the better dining options in the Theater District. The tea infusion gives this crème brûlée an alluring smokiness.

⅔ cup whole milk

2 cups heavy cream

1½ tablespoons loose Earl Grey tea leaves

6 large egg yolks

⅔ cup sugar

Zest of 1 lemon

Place the milk and cream in a 2- or 3-quart saucepan. Heat it on medium until it starts to simmer. Add the tea, remove the pan from the heat, and allow the mixture to steep for 1 hour. Strain the milk and cream and pour it back into the saucepan, pressing on the tea leaves to extract the maximum flavor. Discard the leaves.

Preheat the oven to 350° F. Select six 6-ounce ramekins or eight 4-ounce ramekins. Place them in a roasting pan with sides.

Use an electric mixer to beat the egg yolks and ⅓ cup of the sugar in a bowl until the mixture is thick and pale. Rewarm the milk and cream mixture and slowly pour about half of it into the egg mixture, beating constantly. Then pour this mixture into the saucepan with the rest of the milk and cream.

Heat the mixture on medium, stirring constantly with a wooden spoon, until it thickens to a custard. Steam will begin to rise, and the liquid will coat the spoon; do not overcook it. Pour it into the ramekins.

Boil several quarts of water and pour enough of it into the pan holding the ramekins to come halfway up the sides of the dishes. Bake the custards for about 45 minutes, until they have set. The tops should still be smooth. Remove from the oven, allow to cool to room temperature, then refrigerate the custards.

Shortly before serving time, dust the top of the custards with the remaining sugar. Use a blowtorch or place them under a hot broiler to caramelize the sugar. Dust them with lemon zest.

COOK'S NOTES Another way to make the topping is to cook 1 cup of sugar with 1 cup of water in a skillet, swirling it until it turns amber. Then pour the caramel on top of each custard.

SECOND HELPINGS
If you have extra custard—suppose you only needed four servings—you can refrigerate it without baking it and use it as a sauce for another dessert, like the citrus cake on page 178.

PANNA COTTA WITH BLOOD ORANGES

Chef Kurt Gutenbrunner is almost single-handedly responsible for the resurgence of Austrian cooking in New York. His approach is classic—Wiener schnitzel, tafelspitz, and so forth, along with desserts like apple strudel—though he adds modern touches to many of his dishes. But this dessert, a creamy panna cotta dressed with tart-sweet blood oranges, is a departure with a more universal inspiration.

6 SERVINGS

1 (¼-ounce) packet unflavored gelatin

1½ cups heavy cream

5 tablespoons sugar

1 vanilla bean, scraped

1 cup crème fraîche or Greek-style yogurt

⅔ cup blood orange juice

2 tablespoons cornstarch

2 blood oranges

Soften the gelatin in 3 tablespoons cold water in a small dish. Place the cream, 3 tablespoons of the sugar, and the vanilla scrapings in a saucepan and bring the mixture to a simmer. Remove it from the heat. Stir a little of the cream mixture into the gelatin to liquefy it, then whisk the gelatin into the warm cream until the mixture is smooth. Stir in the crème fraîche. Pour the mixture into six 6-ounce ramekins. Cover and refrigerate it for at least 4 hours.

Mix the remaining 2 tablespoons sugar and the orange juice together in a small saucepan. Dissolve the cornstarch in 1 tablespoon cold water. Bring the orange juice to a simmer and whisk in the cornstarch slurry. Simmer until the sauce has thickened. Transfer it to a bowl and refrigerate it.

Grate the zest from the oranges and set it aside. Remove and discard the skin and pith from the oranges, then cut them into segments. Refrigerate the segments until serving time.

Unmold the panna cottas onto dessert plates. Dust each with grated zest. Spoon some of the sauce around each panna cotta and place a few orange segments on each plate. Serve.

COOK'S NOTES Blood oranges are not sold year-round. The dessert can be made with regular oranges instead. But when not using blood oranges, it's nice to give the sauce that alluring blush. Just add a spoonful or two of Campari or grenadine to the orange juice. The panna cotta can also be made in a single 4-cup mold and portioned at the table.

SECOND HELPINGS
Prepare extra sauce to spoon over vanilla ice cream or onto the citrus cake on page 178.

BLACKBERRY CREMA ICE CREAM

This ice cream company started when Fany Gerson made paletas, Mexican-style ice pops, and sold them at street fairs. Eventually she set up a small production plant in Red Hook, Brooklyn, the pops started to be sold in stores, and she expanded her line to include Mexican ice creams, pastries, and other confections.

1 QUART

1 cup blackberries, plus more for garnish

½ cup confectioners' sugar

2 teaspoons light corn syrup

Salt

⅔ cup granulated sugar

3 large egg yolks

1 cup heavy cream

1 cup Mexican crema or crème fraîche

½ teaspoon vanilla extract

2 teaspoons fresh lime juice

Combine the blackberries, confectioners' sugar, and corn syrup in a small saucepan, stir to mix, add a pinch of salt, and bring to a boil over medium heat. Reduce the heat and simmer slowly, stirring occasionally, until the berries have a jam-like consistency, about 30 minutes. Remove from the heat and let cool. Refrigerate until cold before using.

While the blackberries cool, whisk the granulated sugar and egg yolks in a medium-size bowl until smooth. Bring the heavy cream to a simmer in a saucepan over medium heat. Remove from the heat. Slowly whisk about half the hot cream into the yolks until smooth, then pour this mixture back into the saucepan. Place over medium-low heat and stir continuously for about 10 minutes, until the custard mixture thickens and coats the back of a spoon. Do not allow it to come to a simmer or the eggs will overcook. Strain the custard into a bowl, preferably stainless steel, and whisk in the crema, vanilla, lime juice, and salt to taste. Cover by placing plastic wrap directly on the surface of the custard so a skin doesn't form as it cools. Transfer to the refrigerator to chill completely.

Pour the chilled custard into an ice cream maker and process according to the manufacturer's instructions until it is churned and thickened. Transfer the soft ice cream to a bowl and swirl in the blackberry mixture with a spoon or spatula. Pack into an airtight container. Cover and freeze until set, at least 4 hours or overnight.

Served topped with lightly crushed fresh blackberries.

COOK'S NOTE: This type of ice cream, with a custard base, is French ice cream. (Ice cream made without custard is Philadelphia style). Making custard can be tricky; if the eggs are overcooked, they scramble and your custard is ruined. One safety measure is to cook the custard in a pan set over a boiling water bath, but the cooking will take much, much longer. A useful guideline is that when the very first wisp of steam starts to rise from the custard, it's done. Take it off the heat at once. This custard can be made a little lighter by using half-and-half in place of heavy cream. The Mexican crema called for in this recipe is essentially the same as French crème fraîche, though sometimes made with a touch of salt. Neither type of soured cream is as tart as American sour cream; they also will not break down when heated. If you prefer seedless blackberries in the ice cream, start with 1½ cups of berries and strain them once they are cooked.

THAI FIGHTER ICE CREAM SANDWICHES

The owners of this specialty bakery that sells inventive ice cream sandwiches have come up with more than thirty varieties. They bake their own cookies and churn their own ice cream to create combinations like banana ice cream with peanut butter cookies that are popular year-round. The sandwich they call the Thai Fighter combines curried coconut cookies and chocolate chili ice cream. The ice cream with a kick, pairing chili and chocolate, is inspired by a Mexican tradition, and it has become extremely popular.

1 teaspoon salt

1 teaspoon baking powder

¼ teaspoon baking soda

1½ teaspoons curry powder

1 cup sugar

4 ounces (1 stick) unsalted butter, softened

2 large eggs

1 teaspoon vanilla extract

1 cup all-purpose flour

1¾ cups unsweetened shredded coconut

Chocolate Chili Ice Cream (recipe follows)

Preheat the oven to 350° F. Adjust rack to the center of the oven. Line two baking sheets with parchment. Mix the salt, baking powder, baking soda, and curry power together. Whisk in the sugar. Set aside.

Place the butter in a large bowl. Beat with an electric mixer until it is light and creamy. Add the sugar mixture. Beat on low until the ingredients are blended, then increase the speed and beat until the mixture is well aerated and creamy. Add the eggs, one at a time, beating well after each addition. Beat in the vanilla.

Add the flour and beat on low speed until it is incorporated, then increase the speed to medium and beat for about 20 seconds. Fold in the coconut by hand.

Drop scant 2 tablespoon scoops of the dough onto the baking sheets, leaving about 2 inches of space between each cookie. You should have enough dough for 18 cookies. Place one of the sheets in the oven, or both if they fit on a single rack, and bake for about 15 minutes, until the cookies are nicely golden. Repeat with the second sheet if necessary. Allow the cookies to cool for a couple of minutes, then remove them from the parchment and place them on racks to finish cooling.

To assemble ice cream sandwiches, allow the ice cream to soften until it reaches spreading consistency, about 2 hours in the refrigerator. As soon as the sandwiches are made they must be frozen for about one hour.

SECOND HELPINGS
Any unused ice cream is best kept with a layer of plastic wrap directly on its surface in a freezer container, to prevent drying.

COOK'S NOTES The idea of adding curry powder to cookies might sound freakish, but the seasoning simply delivers a little zing. It sends them in the direction of gingersnaps but much less aggressively. Most markets sell sweetened shredded coconut. For the unsweetened kind, you may have to head to the health food store.

CHOCOLATE CHILI ICE CREAM
1½ QUARTS

½ cup sugar

1½ cups whole milk

¾ cup heavy cream

½ teaspoon kosher salt,
or more to taste

1 teaspoon vanilla extract

1 teaspoon chili powder, preferably
chipotle, more or less to taste

1 large egg

2 large egg yolks

⅓ cup cocoa powder,
preferably Dutch-process

Place the sugar, milk, cream, salt, vanilla, and chili in a saucepan. Lightly beat the egg and egg yolks in a heatproof bowl. Place the cocoa in another heatproof bowl.

Heat the milk mixture on medium high. When bubbles appear around the edges, whisk about ½ cup of it into the cocoa. Keep whisking to dissolve the cocoa. Pour this mixture back into the saucepan. Heat the mixture again until it bubbles. Slowly pour about ½ cup of the mixture into the eggs, whisking constantly. When the egg mixture is smooth, pour it back into the pot. Place the pot over low heat and, stirring constantly with a wooden spoon, gently heat it until it thickens enough to coat the spoon. When this happens, you may see a little steam rise from the mixture. Do not overheat it, or your eggs will scramble. As soon as the custard has thickened, transfer it to a bowl, preferably metal. Cover and refrigerate until it is very cold, preferably overnight.

Check the seasoning and adjust the chili and salt to taste. Churn the custard in your ice cream maker according to the manufacturer's directions. Transfer it to a container and freeze until it is firm.

COOK'S NOTES The chocolate ice cream is delicious without the addition of the chili powder as well.

PICKLED STRAWBERRY JAM

Count on Christina Tosi to come up with dessert items that are out of the ordinary. Crack Pie and Compost Cookies give you some idea. This tart-sweet jam is delicious on ice cream or, for a change of pace, alongside a vanilla panna cotta (page 186).

3 CUPS

1 teaspoon salt

1¾ cups sugar

1 tablespoon pectin

2 tablespoons sherry vinegar

1 tablespoon rice vinegar

1 cardamom pod

5 coriander seeds

3 cups strawberries, hulled and quartered

In a small bowl, mix together the salt, sugar, and pectin. Set it aside.

Combine the vinegars, cardamom, and coriander in a 3-quart saucepan. Bring the mixture just to a boil, skim out the spices, and stir in the sugar mixture. Whisk to dissolve it. Add the strawberries. Bring the liquid to a simmer, then reduce the heat to low and cook, stirring, just until the strawberries start to collapse, about 3 minutes.

Transfer the jam to a bowl and allow it to cool completely. Pour it into jars or containers and refrigerate.

COOK'S NOTES Do not compromise on your strawberries. Wait for seasonal berries in late spring or ever-bearing Tristars, which are sold throughout the summer. Since the jam is not heat-processed, it must be refrigerated.

SECOND HELPINGS
This jam is an eye-opener at breakfast with muffins, scones, or croissants.

HAVE A *MEAL DEAL!*

$7 ANY BREAD
with a SIDE & DRINK

$9 VEG BUN ½ EGG
with a SIDE & DRINK

$10 PORK BUN ½ EGG
with a SIDE & DRINK

egg & cheddar bomb

bagel bomb

volcano

pastrami & rye bomb

PERFECT
10
FEED

COCKTAILS

THAI BASIL COCKTAIL

You could call this drink a basil daiquiri. Add club soda, and you'd have a riff on a mojito. Either way, using fresh herbs in cocktails is an ongoing trend, leading to drinks, and not just tropical ones, that have an attractive freshness.

16 leaves basil, preferably Thai, finely shredded

4 ounces white rum

3 tablespoons lime juice

3 tablespoons simple syrup (page 206)

Pinch of salt

Place the basil in a cocktail shaker and muddle it. Add the remaining ingredients to the shaker, along with ice. Shake for 10 seconds, then strain the cocktail into two chilled coupes or cocktail glasses.

COOK'S NOTES Thai basil delivers more pungency than regular basil. Purple opal basil is another option that can add a new allure to the cocktail.

SECOND HELPINGS
Store basil as you would a small bunch of flowers, submerging the stems in a water-filled glass or small vase, preferably in the refrigerator. Do not expect it to stay fresh for more than a couple of days.

FOREST FIX

Epicurean Management is the umbrella for a collection of Italian restaurants in the East and West Villages, among them Dell'anima, L'Artusi, L'Apicio, and Anfora.

<div style="writing-mode: vertical">1 COCKTAIL</div>

⅓ cup sugar

Peel of 1 red apple

1 cinnamon stick

2 ounces bourbon

1½ ounces Cynar liqueur (or other amaro liqueur)

3 drops maple bitters

Combine the sugar, ⅓ cup water, apple peel, and cinnamon in a small saucepan. Simmer for 15 minutes. Strain, reserving the peel.

Place 1 tablespoon of the apple syrup in a mixing glass with the bourbon, Cynar, and bitters. Add ice, stir, and strain into a cocktail glass. Garnish with a piece of the apple peel.

COOK'S NOTES Lately, chefs have taken to exploiting the peelings of vegetables, fruits, poultry, fish, and meat to use as ingredients and garnishes, instead of sending them to compost. Crispy eggplant skin (see Second Helpings, Russian Eggplant, page 19) may be strewn over a pasta dish or other preparation, shards of crackling chicken-skin-garnish latkes (page 162) or a salad, and here, the peel of an apple flavors a syrup.

SECOND HELPINGS
The leftover apple-flavored simple syrup can be used in other drinks or to sweeten iced tea.

GOLD RUSH COCKTAIL

The stunning simplicity of this drink should make it as familiar as an old-fashioned, but it's not quite a classic. This version is from Geoffrey Zakarian's sexy midtown bar in a hotel that was a Theater District clubhouse. It's a trifle less sweet than some, adding to its refreshment factor. Zakarian is also chairman of the City Harvest Food Council.

3 tablespoons lemon juice

1½ tablespoons honey dissolved in 1½ tablespoons boiling water

4 ounces bourbon

Combine all the ingredients in a cocktail shaker. Add ice. Shake vigorously. Strain into two double rocks glasses filled with ice cubes.

COOK'S NOTES If possible, use a single giant cube or ball of ice in each glass. Molds for these newfangled cubes adored by bartenders are sold in shops that carry bar supplies, and there are many online sources. The drink can also be served straight up, without the rocks. Your choice of honey will affect the outcome; for instance, a light honey, like acacia or lavender, will give the cocktail a graceful allure, while a more robust variety, like buckwheat or chestnut, will contribute heft.

SECOND HELPINGS
If you like the drink, it pays to make a bigger batch of the honey syrup—see the honey variation for simple syrup (page 206) to keep on hand.

HARRY LIME

Who can resist a drink named the Harry Lime from a bar called the Third Man? (Think of the Orson Welles film if you need a hint.) It's all so mysteriously shadowy Vienna. Serve the drink with slices of landjaeger or other sausage, with strong mustard and dark bread.

2 COCKTAILS

1½ ounces mezcal

1½ ounces green Chartreuse

1½ ounces maraschino

1½ ounces lime juice

Combine all the ingredients in a cocktail shaker. Add ice. Shake and strain into a coupe or cocktail glass to serve it straight up, or into a rocks glass with an oversize ice cube.

COOK'S NOTES Maraschino is a cherry liqueur usually made in Italy and Croatia, sometimes in the United States. It's clear, austere, and syrupy but not very sweet, since the marasca, a type of sour cherry, is distilled to make it. Do not use a dark, sweet cherry liqueur in this recipe, but kirsch can be substituted.

SECOND HELPINGS
Once you have smoky mezcal on hand you can assemble all sorts of other drinks. Try it on the rocks with pineapple juice for an especially felicitous pairing. As for the Chartreuse and maraschino, they are increasingly in demand for cocktails, notably the latter in the Hemingway daiquiri.

GURKE (CUCUMBER COCKTAIL)

Cucumber and dill are two natural components of Kurt Gutenbrunner's Austrian cooking. So why not combine them in a drink?

1 Kirby cucumber, peeled

1 ounce St-Germain elderflower liqueur

2 ounces vodka

½ ounce lemon juice

½ ounce simple syrup (page 206)

Sprig of dill for garnish

Run the cucumber through a vegetable juicer, if you have one. Otherwise, finely mince it by hand or machine and place it in a strainer over a small container. Let it sit for 1 hour, then press as much liquid as possible from the puree. You will need about 1½ ounces for the cocktail.

Combine the cucumber juice with the St-Germain, vodka, lemon juice, and simple syrup in a shaker with ice. Shake, then strain into a cocktail glass. Garnish with dill.

COOK'S NOTES Your local health food store or juice bar might also be a source for fresh cucumber juice. Among the many bottled juices available, there doesn't seem to be one that's just cucumber. You could substitute a wheel of cucumber for the dill as the garnish.

SECOND HELPINGS
If you have leftover cucumber juice, add it to a bloody Mary or gazpacho (such as the strawberry gazpacho on page 67).

QUEBEC GOES TO PARIS

Sarah Obraitis and Hugue Dufour attract much attention with their M.Wells restaurants in Long Island City, Queens. Their original M.Wells, a diner, closed, but they have the cafeteria at MoMA PS1 and, nearby, a brash steak house in a former auto-body shop.

2 SERVINGS

1 stalk lovage or center stalk of celery with leaves, plus a couple of leaves for garnish

6 dashes celery bitters

3 ounces Chartreuse, preferably yellow

3 ounces grapefruit juice

½ ounce lemon juice

¼ ounce simple syrup

Muddle the lovage or celery in a cocktail shaker. Add the remaining ingredients, mix, and add ice. Shake. Strain the cocktail into double old-fashioned glasses and add crushed ice. Garnish with lovage or celery leaves.

COOK'S NOTES Lovage is a somewhat uncommon herb that has the distinctive aroma and flavor of celery, making celery a fine substitute for it in this drink.

Yellow Chartreuse is sweeter and not as strong as the green variety (page 202).

SECOND HELPINGS
Using leftover celery stalks poses no challenge. But consider exploiting the leaves to add to a salad or to garnish a seafood dish. The same goes for lovage.

SIMPLE SYRUP

Simple syrup is a half-and-half mixture of granulated sugar and water, simmered just until the sugar dissolves.

3 CUPS

2 cups granulated sugar

Combine the sugar with 2 cups water in a saucepan. Bring the mixture to a simmer and cook until the sugar dissolves completely and the syrup is clear.

COOK'S NOTES A honey version of simple syrup can be made by substituting a light honey like clover for the sugar. Maple syrup, brown sugar, agave, and coconut sugars are some other sweeteners that can be transformed into simple syrup.

SECOND HELPINGS
Simple syrup keeps for several weeks in the refrigerator. Store it, covered, in a jar or bottle.

INDEX OF RESTAURANTS BY NEIGHBORHOOD

UPTOWN EAST
Rao's
The Regency Bar and Grill
Ristorante Morini
T-Bar Steak and Lounge

UPTOWN WEST
The Cecil
Dizzy's Club Coca-Cola
Ed's Chowder House
Jean-Georges
Landmarc
Lido
Nice Matin
Ouest
Picholine
Red Rooster
Salumeria Rosi
Telepan

MIDTOWN
Aldo Sohm Wine Bar
Ardesia
Benoit
Butter
El Colmado
Eleven Madison Park
Gramercy Tavern
Hill Country
Lambs Club
Le Bernardin
Maialino

Oceana
Riverpark

DOWNTOWN EAST
Booker and Dax
DBGB Kitchen and Bar
Dirt Candy
Ed's Lobster Bar
Hecho en Dumbo
Ivan Ramen
Lafayette
L'Apicio
Melt Bakery
Momofuku Milk Bar
Momofuku Ssäm Bar
Moscow 57
Pig and Khao
Rosa Mexicano
Saxelby Cheesemongers
Stanton Social
Third Man
Uncle Boons
Union Square Cafe
Yerba Buena

DOWNTOWN WEST
American Cut
Annisa
Bâtard
Blue Hill
Bouley
Charlie Bird

Colicchio & Sons
Commerce
Costata
Dell'anima
Ditch Plains
Dominique Ansel Bakery
Dos Caminos
EN Japanese Brasserie
FP Patisserie
Murray's Cheese Bar
Recette
Serafina
Toro
Wallsé

BROOKLYN
Benchmark
Dinosaur Bar-B-Que
Franny's
James
La Newyorkina
Mile End
Saul

QUEENS
Butcher Bar
MP Taverna
M.Wells Steakhouse

RESTAURANT GUIDE

ALDO SOHM WINE BAR
151 West Fifty-first Street
212-554-1143
aldosohmwinebar.com
Recipes on pages 122 and 158.
Chef Eric Ripert

AMERICAN CUT
363 Greenwich Street
212-226-4736
americancutsteakhouse.com
Recipe on page 162.
Chef Marc Forgione

ANNISA
13 Barrow Street
212-741-6699
annisarestaurant.com
Recipe on page 150.
Chef Anita Lo

ARDESIA
510 West Fifty-second Street
212-247-9191
ardesia-ny.com
Recipe on page 145.
Chef Amorette Casaus

BÂTARD
239 West Broadway
212-219-2777
myriadrestaurantgroup.com
Recipe on page 94.
Chef Markus Glocker

BENCHMARK
339 Second Street
Brooklyn
718-965-7040
benchmarkrestaurant.com
Recipe on page 165.
Chef Ryan Jaronik

BENOIT
60 West Fifty-fifth Street
646-943-7373
benoitny.com
Recipe on page 40.
Chef Philippe Bertineau

BLUE HILL
75 Washington Place
212-539-1776
bluehillfarm.com
Recipe on page 96.
Chef Dan Barber

BOOKER AND DAX
at Momofuku Ssäm
207 Second Avenue
212-254-3500
momofuku.com
Recipe on page 197.
Chef Dave Arnold

BOULEY
163 Duane Street
212-964-2525
davidbouley.com
Recipe on page 34.
Chef David Bouley

BUTCHER BAR
37–10 Thirtieth Avenue
Astoria
butcherbar.com
718-606-8140
Recipe on page 147.
Chef Matthew Katakis

BUTTER
70 West Forty-fifth Street
212-253-2828
butterrestaurant.com
Recipe on page 185.
Chef Alex Guarnaschelli

THE CECIL
210 West 118th Street
212-866-1262
thececilharlem.com
Recipe on page 102.
Chef Alexander Smalls

CHARLIE BIRD
5 King Street
212-235-7133
charliebirdnyc.com
Recipe on page 69.
Chef Ryan Hardy

COLICCHIO & SONS
85 Tenth Avenue
212-400-6699
craftrestaurantsinc.com
Recipe on page 60.
Chef Tom Colicchio

COMMERCE
50 Commerce Street
212-542-2301
commercerestaurant.com
Recipe on page 174.
Chef Harold Moore

COSTATA
206 Spring Street
212-334-3320
costatanyc.com
Recipe on page 166.
Chef PJ Calapa

D'ARTAGNAN, INC.
1-800-327-8246
dartagnan.com
Recipe on page 128.
Chef Ariane Daguin

DAVID BURKE GROUP
davidburke.com
Recipe on page 37.
Chef David Burke

DBGB KITCHEN AND BAR
299 Bowery
212-933-5300
dbgb.com/nyc
Recipe on page 72.
Chef Daniel Boulud

DELL'ANIMA
38 Eighth Avenue
212-366-6633
dell'anima.com
Recipe on page 56.
Chef Gabe Thompson

DINOSAUR BAR-B-QUE
604 Union Street
Brooklyn
347-429-7030
plus another location in Harlem
dinosaurbarbque.com
Recipe on page 126.
Chef John Stage

DIRT CANDY
86 Allen Street
212-228-7732
dirtcandynyc.com
Recipe on page 80.
Chef Amanda Cohen

DITCH PLAINS
29 Bedford Street
212-633-0202
ditch-plains.com
Recipe on page 113.
Chef Marc Murphy

DIZZY'S CLUB COCA-COLA
Jazz at Lincoln Center
10 Columbus Circle
212-258-9595
jazz.org/dizzys
Recipe on page 115.
Chef Liz Neumark

DOMINIQUE ANSEL BAKERY
189 Spring Street
212-219-2773
dominiqueansel.com
Recipe on page 180.
Chef Dominique Ansel

DOS CAMINOS
675 Hudson Street
212-699-2400
plus other locations
doscaminos.com
Recipes on pages 16 and 81.
Chef Ivy Stark

ED'S CHOWDER HOUSE
The Empire Hotel
44 West Sixty-third Street
212-956-1288
chinagrillmgt.com
Recipe on page 117.
Chef Ed Brown

ED'S LOBSTER BAR
222 Lafayette Street
212-343-3236
lobsterbarnyc.com
Recipe on page 88.
Chef Ed McFarland

EL COLMADO
600 Eleventh Avene
212-582-7948
elcolmadonyc.com
Recipe on page 33.
Chef Seamus Mullen

ELEVEN MADISON PARK
11 Madison Avenue
212-889-0905
elevenmadisonpark.com
Recipe on page 67.
Chef Daniel Humm

EN JAPANESE BRASSERIE
435 Hudson Street
212-647-9196
enjb.com
Recipe on page 154.
Chef Jesse Alexander

FP PATISSERIE
116 West Houston Street
212-995-0888
plus other locations
payard.com
Recipe on page 170.
Chef Francois Payard

FRANNY'S
348 Flatbush Avenue
Brooklyn
frannysbrooklyn.com
718-230-0221
Recipe on page 86.
Chef Andrew Feinberg

GRAMERCY TAVERN
42 East Twentieth Street
212-477-0777
gramercytavern.com
Recipe on page 63.
Chef Michael Anthony

HECHO EN DUMBO
354 Bowery
212-937-4245
hechoendumbo.com
Recipe on page 106.
Chef Danny Mena

HILL COUNTRY
30 West Twenty-sixth Street
212-255-4544
plus another location in
Brooklyn
hillcountryny.com
Recipe on page 182.

**INSTITUTE OF CULINARY
EDUCATION**
225 Liberty Street
212-847-0700
ice.edu
Recipe on page 177.
Chefs Cara Tannenbaum and
Andrea Tutunjian

IVAN RAMEN
25 Clinton Street
646-678-3859
plus another location in
Hell's Kitchen
ivanramen.com
Recipe on page 50.
Chef Ivan Orkin

JAMES
605 Carlton Avenue
Brooklyn
718-942-4255
jamesrestaurantny.com
Recipe on page 93.
Chef Bryan Calvert

JEAN-GEORGES
Trump International
Hotel and Tower
1 Central Park West
212-299-3900
jean-georgesrestaurant.com
Recipe on page 104.
Chef Jean-Georges
Vongerichten

LAFAYETTE
380 Lafayette Street
212-533-3000
lafayetteny.com
Recipe on page 49.
Chef Andrew Carmellini

THE LAMBS CLUB
132 West Forty-fourth Street
212-997-5262
thelambsclub.com
Recipe on page 201.
Chef Geoffrey Zakarian

LANDMARC
Time Warner Center
10 Columbus Circle, Third Floor
212-823-6123
plus another location in Tribeca
landmarc-restaurant.com
Recipes on pages 113 and 138.
Chef Marc Murphy

LA NEWYORKINA
61 Commerce Street
Brooklyn
917-669-4591
plus other locations
lanewyorkina.com
Recipe on page 188.
Chef Fany Gerson

LE BERNARDIN
155 West Fifty-first Street
212-554-1515
le-bernardin.com
Recipe on page 109.
Chef Eric Ripert

LIDO
2168 Frederick Douglass
Boulevard
646-490-8575
lidoharlem.com
Recipe on page 76.
Chef Serena Bass

L'APICIO
13 East First Street
212-533-7400
lapicio.com
Recipes on pages 125 and 198.
Chef Gabe Thompson

MAD MAC
973-225-0930
madmacnyc.com
Recipe on page 179.
Chef Florian Bellanger

MAIALINO
Gramercy Park Hotel
2 Lexington Avenue
212-777-2410
maialinonyc.com
Recipe on page 91.
Chef Nick Anderer

MELT BAKERY
132 Orchard Street
646-535-6358
plus other locations
meltbakery.com
Recipe on page 190.
Chefs Julian Plyter and
Kareem Hamady

MILE END
97A Hoyt Street
Brooklyn
718-852-7510
plus another location in NoHo
mileenddeli.com
Recipe on page 120.
Chef Eli Sussman

MOMOFUKU MILK BAR
251 East Thirteenth Street
347-577-9504 extension 4
plus other locations
milkbarstore.com
Recipe on page 192.
Chef Christina Tosi

MOMOFUKU SSÄM BAR
207 Second Avenue
212-254-3500
momofuku.com
Recipe on page 21.
Chef Matthew Rudofker

MOSCOW 57
168 ½ Delancey Street
212-260-5775
moscow57.com
Recipe on page 19.
Chefs Ellen Kaye and
Seth Goldman

MP TAVERNA
31–29 Ditmars Boulevard
Astoria
718-777-2187
michaelpsilakis.com
Recipe on page 157.
Chef Michael Psilakis

MURRAY'S CHEESE BAR
254 Bleecker Street
212-243-3289
murrayscheese.com
Recipe on page 84.
Chef Amy Stonionis

M.WELLS STEAKHOUSE
43–15 Crescent Street
Long Island City
718-786-9060
magasinwells.com
Recipe on page 206.
Chef Hugue Dufour

NICE MATIN
201 West Seventy-ninth Street
212-873-6423
nicematinnyc.com
Recipe on page 38.
Chef Andy D'Amico

OCEANA
120 West Forty-ninth Street
212-759-5941
oceanarestaurant.com
Recipe on page 110.
Chef Ben Pollinger

OUEST
2315 Broadway
212-580-8700
ouestny.com
Recipe on page 131.
Chef Tom Valenti

PICHOLINE
35 West Sixty-fourth Street
212-724-8585
picholinenyc.com
Recipe on page 172.
Chef Terrance Brennan

PIG & KHAO
68 Clinton Street
212-920-4485
pigandkhao.com
Recipes on pages 46 and 148.
Chef Leah Cohen

**PORTER HOUSE NEW
YORK**
Time Warner Center
10 Columbus Circle
212-823-9500
porterhousenewyork.com
Recipe on page 137.
Chef Michael Lomonaco

RAO'S
455 East 114th Street
212-722-6709
raosrestaurants.com
Recipe on page 140.
Chef Frank Pellegrino

RECETTE
328 West Twelfth Street
212-414-3000
recettenyc.com
Recipe on page 23.
Chef Jesse Schenker

RED ROOSTER
310 Lenox Avenue
212-792-9001
redroosterharlem.com
Recipe on page 134.
Chef Marcus Samuelsson

THE REGENCY BAR & GRILL
Loews Regency Hotel
540 Park Avenue
212-339-4050
regencybarandgrill.com
Recipe on page 58.
Chef Brian Kevorkian

RISTORANTE MORINI
1167 Madison Avenue
212-249-0444
restorantemorini.com
Recipe on page 75.
Chef Michael White

RIVERPARK
450 East Twenty-ninth Street
212-729-9790
riverparknyc.com
Recipe on page 161.
Chef Sisha Ortúzar

RON BEN-ISRAEL CAKES
247 West Thirty-eighth Street,
Floor 13
(by appointment only)
212-625-3369
weddingcakes.com
Recipe on page 178.
Chef Ron Ben-Israel

ROSA MEXICANO
9 East Eighteenth Street
212-533-3350
plus other locations
rosamexicano.com
Recipe on page 25.
Chef Joe Quintana

SALUMERIA ROSI
283 Amsterdam Avenue
212-877-4801
salumeriarosi.com
Recipe on page 70.
Chef Cesare Casella

SAUL RESTAURANT
Brooklyn Museum
200 Eastern Parkway
Brooklyn
718-935-9842
saulrestaurant.com
Recipe on page 82.
Chef Saul Bolton

SAXELBY CHEESEMONGERS
120 Essex Street
212-228-8204
saxelbycheese.com
Recipe on page 99.
Chef Anne Saxelby

SERAFINA
7 Ninth Avenue
646-964-4494
plus other locations
serafinarestaurant.com
Recipe on page 44.
Chef Vittorio Assaf

STANTON SOCIAL
99 Stanton Street
212-995-0099
stantonsocial.com
Recipe on page 28.
Chef Chris Santos

T-BAR STEAK AND LOUNGE
1278 Third Avenue
212-772-0404
tbarnyc.com
Recipe on page 26.
Chef Ben Zwicker

TELEPAN
72 West Sixty-ninth Street
212-580-4300
telepan-ny.com
Recipe on page 52.
Chef Bill Telepan

THE THIRD MAN
116 Avenue C
212-598-1040
thethirdmannyc.com
Recipe on page 202.
Chefs Eduard Fraudener and
Wolfgang Ban

TORO
85 Tenth Avenue
212-692-2360
toro-nyc.com
Recipe on page 142.
Chefs Ken Oringer and
Jamie Bissonnette

UNCLE BOONS
7 Spring Street
646-370-6650
uncleboons.com
Recipe on page 30.
Chef Matt Danzer and
Ann Redding

UNION SQUARE CAFÉ
21 East Sixteenth Street
212-243-4020
unionsquarecafe.com
Recipe on page 66.
Chef Carmen Quagliata

WALLSÉ
344 West Eleventh Street
212-352-2300
kg-ny.com
Recipes on pages 186 and 205.
Chef Kurt Gutenbrunner

YERBA BUENA
23 Avenue A
212-529-2929
plus another location in the
West Village
ybnyc.com
Recipe on page 55.
Chef Julian Medina

ACKNOWLEDGMENTS

City Harvest provided much more than inspiration for this cookbook. The organization was at my side from start to finish, developing the list of supportive chefs and restaurants, reaching out to them for recipes, and fielding my constant barrage of questions.

I owe a debt of gratitude to Naomi Giges Downey, who has moved on from City Harvest to the Food Bank of Westchester Country but who was there for me from start to finish. Nicole Sumner provided much-needed backup, as did Cara Taback, City Harvest's Director of Communications.

Eric Ripert's involvement with City Harvest offered a gracious vote of confidence for this project.

The book was made possible by all the other the chefs and restaurateurs who so generously participated. They provided their recipes, permitted me to adapt them for the home cook, and responded to queries. They also opened their doors and kitchens so Noah Fecks and his team could perform their magic with cameras to give the book its visual finesse.

At Rizzoli, Christopher Steighner led the way, with strong guidance to shape the book but with a measure of restraint to permit my personal voice to stand out on every page. Jono Jarrett seconded this approach.

My daughter, Patricia Fabricant, who designed this, the sixth book on which we have seamlessly collaborated, has created another elegant, well-organized volume. I am very proud of her work.

I am dedicating this book to team Fabricant. Not just Patricia, and my husband, Richard who is ever the willing taster, but also to my son, Robert Fabricant, his wife, Jill Herzig, and their daughters Julia Fabricant and Evie Fabricant, who helped with some of the recipe testing during the summer of 2014, and who were also on the informal tasting panel when the dishes were served at lunches and dinners. Julia was the hands-on sous-chef for macaroni and cheese, which she thought was "the best," and she and Evie both validated the recipes for apple pie with a cheddar crust and the coconut cookies among many others.

—FLORENCE FABRICANT

Thank you to Florence Fabricant for connecting City Harvest with Rizzoli and providing us this unique opportunity to illuminate the issue of hunger in our city. We enjoyed working with Florence to identify chefs and collect recipes and watched her vision for second helpings unfold. We are also grateful to Eric Ripert for his commitment to ensuring that all New Yorkers have access to good food and for taking time outside his kitchen to write the foreword. Chefs across New York City peppered these recipes with originality, imagination, and inspiration, and we appreciate how they've embraced this project as wholeheartedly as they do City Harvest's mission. Noah Fecks has captured the beauty of these dishes and cocktails magically in his photos, and Rizzoli's Jono Jarrett and Christopher Steighner guided us smoothly through the publishing process from concept to completion. Along the way there were many people who contributed to the creation of this cookbook and we extend a warm thanks to each of them for believing in the value and importance of this project.

—CITY HARVEST

CONVERSION CHART

All conversions are approximate.

LIQUID CONVERSIONS

U.S.	METRIC
1 tsp	5 ml
1 tbs	15 ml
2 tbs	30 ml
3 tbs	45 ml
¼ cup	60 ml
⅓ cup	75 ml
⅓ cup + 1 tbs	90 ml
⅓ cup + 2 tbs	100 ml
½ cup	120 ml
⅔ cup	150 ml
¾ cup	180 ml
¾ cup + 2 tbs	200 ml
1 cup	240 ml
1 cup + 2tbs	275 ml
1¼ cups	300 ml
1⅓ cups	325 ml
1½ cups	350 ml
1⅔ cups	375 ml
1¾ cups	400 ml
1¾ cups + 2 tbs	450 ml
2 cups (1 pint)	475 ml
2½ cups	600 ml
3 cups	720 ml
4 cups (1 quart)	945 ml
	(1,000 ml is 1 liter)

WEIGHT CONVERSIONS

U.S./U.K.	METRIC
½ oz	14 g
1 oz	28 g
1½ oz	43 g
2 oz	57 g
2½ oz	71 g
3 oz	85 g
3½ oz	100 g
4 oz	113 g
5 oz	142 g
6 oz	170 g
7 oz	200 g
8 oz	227 g
9 oz	255 g
10 oz	284 g
11 oz	312 g
12 oz	340 g
13 oz	368 g
14 oz	400 g
15 oz	425 g
1 lb	454 g

OVEN TEMPERATURES

°F	GAS MARK	°C
250	½	120
275	1	140
300	2	150
325	3	165
350	4	180
375	5	190
400	6	200
425	7	220
450	8	230
475	9	240
500	10	260
550	Broil	290

INDEX

Page references in *italic* refer to illustrations.

A

Afro-Asian Salmon with Lentil Salad and Ginger-Soy Dressing, 102
almond flour, in streusel crumbs, 170
almonds, in Fideos with Mussels and Chorizo, 81
almonds, Marcona, in Stuffed Dates Wrapped in Bacon, 33
amaro liqueur, in Forest Fix, 198, *199*
anchovy(ies):
 Butter, Whole Roasted Radishes with, *160*, 161
 Spaghetti with Butter and, *90*, 91
Ansel, Dominique, 180
Anthony, Mike, 63
appetizers, 14–41
 Comté Cheese Soufflés, Twice-Baked Upside-Down, 40–41
 Dates, Stuffed, Wrapped in Bacon, *32*, 33
 Eggplant, Russian, *18*, 19
 Guacamole, 16, *17*
 Hamachi, Marinated, with Harissa and Uni, *22*, 23
 Hen-of-the-Woods Mushrooms, Roasted, 37
 Kimchi Deviled Eggs, 20
 Lamb Skewers, Spiced, *144*, 145
 Mushrooms, Wild, Forager's Treasure of, 34
 Shrimp, Chipotle Grilled, with Tomatillo, Roasted Corn, and Feta Salsa, 28
 Shrimp Ceviche, *24*, 25
 Smashed Potatoes with Rosemary Vinaigrette (with sour cream and caviar), 166
 Squid Stuffed with Pork in Lime Broth, 30–31
 Tarte Menton, 38–39, *39*
 Tuna Tartare, 26, *27*
apple(s):
 Cranberry Sauce, 147
 Pie, Classic, with Cheddar Lattice Crust, 182, *183*
 Puree, Latkes with Sour Cream and, 162, *163*
 syrup, in Forest Fix, 198, *199*
 Warm Mushroom Salad with Celery and, *62*, 63
artichoke:
 hearts, in Couscous Salad, 120
 Salad with Shaved Parmesan, 44
arugula:
 in Chicken Paillard, 122, *123*
 in Quinoa Salad, 58, *59*
Asian flavors:
 Afro-Asian Salmon with Lentil Salad and Ginger-Soy Dressing, 102
 Asian Slaw, 46
 Barbecued Baby Back Ribs with Asian Glaze, 148
 Broccoli and Cauliflower Goma-ae, 154, *155*
 Homeschooled BBQ Chicken Wings with Korean Glaze, 126, *127*
 Kimchi Deviled Eggs, 20
 Squid Stuffed with Pork in Lime Broth, 30–31
 Sushi Bar Wedge Salad, 50, *51*
 Tuna Tartare, 26, *27*
Asparagus:
 and Prosciutto Salad with Baked Eggs, 52
 in Quinoa Salad, 58
avocados:
 Cabbage Salad, 107
 Guacamole, 16, *17*
 Migliorelli Farms Snap Pea Salad, 49
 Shrimp Ceviche, *24*, 25

B

Baby Back Ribs, Barbecued, with Asian Glaze, 148
bacon:
 Calves Liver with Peas, Maple and, 150–51
 Poached Wild Striped Bass with Tomatoes, Potatoes and, 110, *111*
 Rosemary Mussels, *112*, 113
 Stuffed Dates Wrapped in, *32*, 33
Barbecued Baby Back Ribs with Asian Glaze, 148
Barber, Dan, 96
Basil, Thai, Cocktail, *196*, 197
Bass, Serena, 76
BBQ Chicken Wings with Korean Glaze, Homeschooled, 126, *127*
Beans, Cannellini, in Fusilli with Sausage and Chilis, 86, *87*
beef:
 Burgers, Big Marc, 138
 Frankie's Meatballs, 140
 Skirt Steak Tortilla with Chimichurri Sauce, 137
 Stir-Fry, Ethiopian-Style, 134, *135*
beet:
 and Goat Cheese Risotto, *92*, 93

Roasted, Salad with Beet
 Vinaigrette, 60
Bellanger, Florian, 179
Ben-Israel, Ron, 178
Bernamoff, Noah, 120
Bertineau, Philippe, 40
The Big Marc, 138–39
Bissonnette, Jamie, 142
Blackberry Crema Ice Cream,
 188–89, 189
Blood Oranges, Panna Cotta with,
 186, 187
blue-veined cheese, in Stuffed
 Dates Wrapped in Bacon,
 32, 33
Bolton, Saul, 82
Bouillabaisse, Seafood in, 114
Bouley, David, 34
Boulud, Daniel, 72
bourbon:
 Forest Fix, 198, 199
 Gold Rush Cocktail, 200, 201
Broccoli and Cauliflower Goma-
 ae, 154, 155
Broccolini
 in Ethiopian-Style Beef Stir Fry,
 134, 135
 Fettuccine, 80
Brussels Sprouts Salad, 55
Bucatini Ricci di Mare, 82, 83
Buns, Cheddar and Black Pepper,
 139
Burgers, Big Marc, 138
Burke, David, 37
Burrell, Anne, 146

C
cabbage:
 Asian Slaw, 46
 Salad, 107
 Squab with French Lentils and,
 131
Cajun cooking: Seafood Gumbo,
 115
cakes:
 Citrus, 178
 Coconut, 174–75, 175
 Madeleines, Traditional French,
 179
 Peanut Financier, 176, 177

Pistachio Moelleux, Warm,
 180, 181
Calapa, PJ, 166
Calvert, Bryan, 93
Calves Liver with Bacon, Peas,
 and Maple, 150–51
Cannellini Beans, Fusilli with
 Sausage, Chilis and, 86, 87
Carmellini, Andrew, 49
Carpaccio, Pineapple with Lime
 and Coconut Granité, 172,
 173
carrot(s):
 dressing, 50
 Spice-Roasted, Marrakech
 Style, 158, 159
Casaus, Amorette, 145
Casella, Cesare, 70
cauliflower:
 and Broccoli Goma-ae, 154, 155
 Cinnamon-Scented Tomato-
 Braised, 157
 Soup with Capers and Black
 Olives, 70
celery:
 Quebec Goes to Paris, 206, 207
 Warm Mushroom Salad with
 Apples and, 62, 63
Ceviche, Shrimp, 24, 25
Chang, David, 20
Chartreuse:
 green, in Harry Lime, 202, 203
 yellow, in Quebec Goes to
 Paris, 206, 207
Cheddar:
 and Black Pepper Buns, 139
 Classic Macaroni and Cheese,
 84, 85
 Lattice Crust, Classic Apple Pie
 with, 182, 183
cheese:
 Artichoke Salad with Shaved
 Parmesan, 44
 Beet and Goat Cheese Risotto,
 92, 93
 blue-veined, in Stuffed Dates
 Wrapped in Bacon, 32, 33
 Cheddar and Black Pepper
 Buns, 139
 Cheddar Lattice Crust, Classic

Apple Pie with, 182, 183
 Comté, Soufflés, Twice-Baked
 Upside-Down, 40–41
 Feta, Tomatillo, and Roasted
 Corn Salsa, 28
 Goat, Garnish, 73
 Macaroni and, Classic, 84, 85
 Parmesan Risotto, 94, 95
 "Pawlie" Grilled Cheese and
 Pickle Sandwich, 98, 99
 Purple Potato Gratin, 164, 165
 queso fresco or feta, in
 Cabbage Salad, 107
Chermoula Spice, 121
chicken:
 Chermoula-Rubbed, with
 Couscous Salad, 120–21
 Paillard, 122, 123
 skin, in gribenes, 162
 Whole Roasted, with Fennel,
 Potatoes, and Olives,
 124, 125
 Wings, BBQ, with Korean
 Glaze, Homeschooled,
 126, 127
Chimichurri Sauce, 137
Chipotle Grilled Shrimp with
 Tomatillo, Roasted Corn,
 and Feta Salsa, 28
chocolate:
 Chili Ice Cream, 191
 Warm Pistachio Moelleux,
 180, 181
Chorizo, Fideos with Mussels,
 Almonds and, 81
Cinnamon-Scented Tomato-
 Braised Cauliflower, 157
citrus:
 Cake, 178
 Dressing, 56
 see also specific citrus fruits
clams:
 Linguine with, 88, 89
 Seafood in Bouillabaisse, 114
cocktails, 194–207
 Forest Fix, 198, 199
 Gold Rush, 200, 201
 Gurke (Cucumber Cocktail),
 204, 205
 Harry Lime, 202, 203

Quebec Goes to Paris, 206, *207*
Simple Syrup for, 206
Thai Basil, *196*, 197
coconut:
Cake, 174–75, *175*
curried cookies, in Thai Fighter
Ice Cream Sandwiches,
190–91
Granité, Pineapple Carpaccio
with Lime and, 172, *173*
Vanilla Pudding, 175
Codfish with Vegetable Marinère
and Aromatic Sauce, 104–5
Cohen, Amanda, 80
Cohen, Leah, 46, 148
Colicchio, Tom, 60
Comté cheese:
Classic Macaroni and Cheese,
84, *85*
Soufflés, Twice-Baked Upside-
Down, 40–41
cookies, curried coconut, in
Thai Fighter Ice Cream
Sandwiches, 190–91
corn:
Puree, Grain Risotto with
Grilled Corn and, 96, *97*
Roasted, Tomatillo, and Feta
Salsa, 28
Soup, Cold, 66
court bouillon, 109
Couscous Salad, 120
crab(meat)(s):
blue, in Seafood in
Bouillabaisse, 114
Seafood Gumbo, 115
Soup Serena, 76, *77*
Cranberry-Apple Sauce, 147
Cream Cheese Frosting, 175
Crème Brûlée, Earl Grey, 185
cucumber:
Cabbage Salad, 107
Gurke (Cucumber Cocktail),
204, 205
Strawberry Gazpacho, 67
curried coconut cookies, in
Thai Fighter Ice Cream
Sandwiches, 190–91
Cynar liqueur, in Forest Fix, 198,
199

D
Daguin, André, 128
D'Amico, Andy, 38
Dates, Stuffed, Wrapped in
Bacon, *32*, 33
desserts, 168–93
Apple Pie, Classic, with
Cheddar Lattice Crust, 182,
183
Blackberry Crema Ice Cream,
188–89, *189*
Citrus Cake, 178
Coconut Cake, 174–75, *175*
Earl Grey Crème Brûlée, 185
Ice Cream Sandwiches, Thai
Fighter, 190–91
Madeleines, Traditional French,
179
Panna Cotta with Blood
Oranges, 186, *187*
peanut butter and jelly pastry
"sandwiches" to offer with,
177
Peanut Financier, *176*, 177
Pickled Strawberry Jam, 192
Pineapple Carpaccio with
Coconut Granité and Lime,
172, *173*
Pistachio Moelleux, Warm,
180, *181*
Red Wine–Poached Figs with
Black Pepper, 170
dressings:
Beet Vinaigrette, 60
carrot, 50
Citrus, 56
Ginger-Soy, 102
Rosemary Vinaigrette, 166
soy, 63
Ducasse, Alain, 40
duck breasts, in Magret à la
d'Artagnan, 128
Dufour, Hugue, 206

E
Earl Grey Crème Brûlée, 185
Eastern European Jewish cooking:
Latkes with Apple Puree and
Sour Cream, 162, *163*
Eggplant, Russian, *18*, 19

eggs:
Baked, Asparagus and
Prosciutto Salad with, 52
Broccolini Fettuccine, 80
Kimchi Deviled, 20
Endive, Grilled, Salad with Citrus
Dressing, 56
Ethiopian-Style Beef Stir-Fry,
134, *135*

F
farro, in Grain Risotto with Corn
Puree and Grilled Corn,
96, 97
Feinberg, Andrew, 86
Fennel, Whole Roasted Chicken
with Potatoes, Olives and,
124, 125
Feta, Tomatillo, and Roasted
Corn Salsa, 28
Fettuccine, Broccolini, 80
Fideos with Mussels, Chorizo,
and Almonds, 81
Figs, Red Wine–Poached, with
Black Pepper, 170
Financier, Peanut, 176, *177*
fish and seafood, 100–117
Clams, Linguine with, 88, *89*
Codfish with Vegetable
Marinère and Aromatic
Sauce, 104–5
Crab Soup Serena, 76, *77*
Fish alla Talla with Cabbage
Salad, 106–7
Halibut, Poached, in Warm
Herb Vinaigrette, *108*, 109
Hamachi, Marinated, with
Harissa and Uni, *22*, 23
Lobster Roll, Ed's, 117
Mussels, Rosemary-Bacon,
112, 113
poaching liquid for (court
bouillon), 109
Salmon, Afro-Asian, with
Lentil Salad and Ginger-Soy
Dressing, 102
Seafood Gumbo, 115
Seafood in Bouillabaisse, 114
Squid Stuffed with Pork in
Lime Broth, 30–31

Striped Bass, Poached Wild, with Tomatoes, Potatoes, and Bacon, 110, *111*
testing for doneness, 109
Tuna Tartare, 26, *27*
see also shrimp
Forager's Treasure of Wild Mushrooms, 34
Forest Fix, 198, *199*
Forgione, Larry and Marc, 162
Fortuna, Tony, 26
French cooking:
 Comté Soufflés, Twice-Baked Upside-Down, 40–41
 Madeleines, Traditional, 179
 Magret à la D'Artagnan, 128
 Seafood in Bouillabaisse, 114
 Squab with Cabbage and French Lentils, 131
 Tarte Merton, 38, *39*
 Warm Pistachio Moelleux, 180, 181
Frosting, Cream Cheese, 175
Fusilli with Sausage, Cannellini Beans, and Chilis, 86, *87*

G
Gazpacho, Strawberry, 67
Gerson, Fany, 188
Ginger-Soy Dressing, 102
Glocker, Markus, 94
Glosserman, Marc, 182
goat cheese:
 and Beet Risotto, *92*, 93
 Garnish, 73
Gold Rush Cocktail, *200*, 201
Goma-ae, Broccoli and Cauliflower, 154, *155*
Grain Risotto with Corn Puree and Grilled Corn, *96*, 97
Granité, Coconut, Pineapple Carpaccio with Lime and, 172, *173*
grapefruit juice, in Quebec Goes to Paris, 206, *207*
Gratin, Purple Potato, *164*, 165
Greek flavors:
 Cinnamon-Scented Tomato-Braised Cauliflower, 157
 Poached Wild Striped Bass with

Tomatoes, Potatoes, and Bacon, 110, *111*
gribenes, 162
grilled:
 Baby Back Ribs, Barbecued, with Asian Glaze, 148
 Burgers, Big Marc, 138
 Cheese and Pickle Sandwich, "Pawlie," *98*, 99
 Chipotle Shrimp with Tomatillo, Roasted Corn, and Feta Salsa, 28
 Endive Salad with Citrus Dressing, 56
 Fish alla Talla with Cabbage Salad, 106–7
 Lamb Skewers, Spiced, *144*, 145
 Skirt Steak Tortilla with Chimichurri Sauce, 137
Guacamole, 16, *17*
Guarnaschelli, Alex, 185
Gumbo, Seafood, 115
Gurke (Cucumber Cocktail), *204*, 205
Gutenbrunner, Kurt, 186

H
Halibut, Poached, in Warm Herb Vinaigrette, *108*, 109
Hamachi, Marinated, with Harissa and Uni, *22*, 23
Hardy, Ryan, 69
Harissa:
 Marinated Hamachi with Uni and, *22*, 23
 Marrakech-Style Spice-Roasted Carrots, 158, *159*
Harry Lime (cocktail), 202, *203*
Heffernan, Kerry, 114
Hen-of-the-Woods Mushrooms, Roasted, 37
Herb Vinaigrette, Warm, *108*, 109
honey syrup, 201
Humm, Daniel, 67

I
iceberg lettuce, in Sushi Bar Wedge Salad, 50, *51*
ice cream:
 Blackberry Crema, 188–89, *189*

Chocolate Chili, 191
 in Red Wine Poached Figs with Black Pepper, 170
 Sandwiches, Thai Fighter, 190–91
Italian cooking:
 Artichoke Salad with Shaved Parmesan, 44
 Meatballs, Frankie's, 140
 Panna Cotta with Blood Oranges, 186, *187*
 see also pasta; risotto

J
Jam, Pickled Strawberry, 192
Japanese flavors: Broccoli and Cauliflower Goma-ae, 154, *155*

K
Karmel, Elizabeth, 182
Kaye, Ellen, 19
Ketchup, Spiked, 139
Kimchi Deviled Eggs, 20
Korean flavors:
 Homeschooled BBQ Chicken Wings with Korean Glaze, 126, *127*
 Kimchi Deviled Eggs, 20

L
lamb:
 Paella with, 142–43, *143*
 Seared Rack of, with Pistachio Tapenade, 146
 Skewers, Spiced, *144*, 145
Latkes with Apple Puree and Sour Cream, 162, *163*
Le Coze, Gilbert, 109
lemon:
 Citrus Cake, 178
 Gold Rush Cocktail, *200*, 201
lentil(s):
 French, Squab with Cabbage and, 131
 Salad with Ginger-Soy Dressing, Afro-Asian Salmon with, 102
 Soup with Pancetta, 74
lime:

Broth, Squid Stuffed with Pork in, 30–31
Citrus Cake, 178
Harry Lime (cocktail), 202, *203*
Pineapple Carpaccio with Coconut Granité and, 172, *173*
Thai Basil Cocktail, *196*, 197
Linguine with Clams, 88, *89*
Lo, Anita, 150
Lobster Roll, Ed's, 117
Lomonaco, Michael, 137
lovage, in Quebec Goes to Paris, 206, *207*

M

Macaroni and Cheese, Classic, 84, *85*
Magret à la d'Artagnan, 128
Maitake (Hen-of-the-Woods) Mushrooms, Roasted, 37
maraschino, in Harry Lime, 202, *203*
Marrakech-Style Spice-Roasted Carrots, 158, *159*
Mascarpone, with Parmesan Risotto, 94
McFarland, Ed, 88
Meatballs, Frankie's, 140
Medina, Julian, 55
Mexican flavors:
 Brussels Sprouts Salad, 55
 Chipotle Grilled Shrimp with Tomatillo, Roasted Corn, and Feta Salsa, 28
 Chocolate Chili Ice Cream, 191
 Fish alla Talla with Cabbage Salad, 106–7
 Guacamole, 16, *17*
 Shrimp Ceviche, *24*, 25
Meyer, Danny, 66
mezcal, in Harry Lime, 202, *203*
Migliorelli Farms Snap Pea Salad, 49
Moelleux, Warm Pistachio, 180, *181*
monkfish, in Seafood in Bouillabaisse, 114
Moore, Harold, 174
Mullen, Seamus, 33
Murphy, Marc, 113, 138

mushroom(s):
 Bouche, 75
 Broccolini Fettuccine, 80
 Hen-of-the-Woods, Roasted, 37
 Salad with Apples and Celery, Warm, *62*, 63
 Wild, Forager's Treasure of, 34
mussels:
 Fideos with Chorizo, Almonds and, 81
 Rosemary-Bacon, *112*, 113

N

North African flavors:
 Chermoula-Rubbed Chicken with Couscous Salad, 120–21
 Spice-Roasted Carrots Marrakech Style, 158, *159*
nuts, toasting, 157

O

Obraitis, Sarah, 206
olives:
 Black, Cauliflower Soup with Capers and, 70
 Codfish with Vegetable Marinière and Aromatic Sauce, 104–05
 Pistachio Tapenade, 146
 Tarte Menton, 38–39, *39*
 Whole Roasted Chicken with Fennel, Potatoes and, *124*, 125
onion(s):
 garnishes, for Calves Liver with Bacon, Peas, and Maple, 150–51
 Tarte Menton, 38–39, *39*
orange(s):
 Blood, Panna Cotta with, 186, *187*
 Citrus Cake, 178
Oringer, Ken, 142
Orkin, Ivan, 50
oysters, in Seafood Gumbo, 115

P

Paella with Lamb, 142–43, *143*
Pancetta, Lentil Soup with, 74
Panna Cotta with Blood Oranges, 186, *187*

Parmesan (Parmigiano Reggiano):
 Artichoke Salad with Shaved Paremesan, 44
 Beet and Goat Cheese Risotto, *92*, 93
 Forager's Treasure of Wild Mushrooms, 34
 Migliorelli Farms Snap Pea Salad, 49
 Purple Potato Gratin, *164*, 165
 Risotto, 94, *95*
 Tarte Menton, 38
 Twice-Baked Upside-Down Comté Cheese Soufflé, 40–41
pasta, 78–91
 Broccolini Fettuccine, 80
 Bucatini Ricci di Mare, 82, *83*
 Fideos with Mussels, Chorizo, and Almonds, 81
 Fusilli with Sausage, Cannellini Beans, and Chilis, 86, *87*
 Linguine with Clams, 88, *89*
 Macaroni and Cheese, Classic, 84, *85*
 Spaghetti with Butter and Anchovies, 90, *91*
Pastry:
 Cheddar Crust, 182, *183*
 "Pawlie" Grilled Cheese and Pickle Sandwich, *98*, 99
Payard, Francois, 170
Peanut Financier, *176*, 177
peas in Parmesan Risotto, 94
peas, see sugar snap pea(s)
Pecorino Romano:
 in Frankie's Meatballs, 140
 in Grilled Endive Salad with Citrus Dressing, 56
peelings, as ingredients and garnishes, 198
Pickled Strawberry Jam, 192
Pie, Classic Apple, with Cheddar Lattice Crust, 182, *183*
Pineapple Carpaccio with Coconut Granité and Lime, 172, *173*
pine nuts, toasting, 157
pistachio:
 Moelleux, Warm, 180, *181*

Tapenade, 146
Pizza Dough, 39
pork:
 Baby Back Ribs, Barbecued,
 with Asian Glaze, 148
 Loin Roast with Apple-
 Cranberry Sauce, 147
 Squid Stuffed with, in Lime
 Broth, 30–31
potato(es):
 in Cauliflower Soup with
 Capers and Black Olives, 70
 Latkes with Apple Puree and
 Sour Cream, 162, *163*
 Poached Wild Striped Bass
 with Tomatoes, Bacon and,
 110, *111*
 Purple, Gratin, *164*, 165
 Smashed, with Rosemary
 Vinaigrette, 166, *167*
 Whole Roasted Chicken with
 Fennel, Olives and, *124*, 125
poultry, 118–27
 Magret à la d'Artagnan, 128
 Squab with French Lentils and
 Cabbage, 131
 see also chicken
Prosciutto and Asparagus Salad
 with Baked Eggs, 52
Psilakis, Michael, 157
Pudding, Coconut-Vanilla, 175

Q
Quebec Goes to Paris (cocktail),
 206, *207*
Quinoa Salad, 58, *59*

R
raclette, in Classic Macaroni and
 Cheese, 84, *85*
Radishes, Whole Roasted, with
 Anchovy Butter, *160*, 161
Redding, Ann, 30
red wine:
 Magret à la d'Artagnan, 128
 –Poached Figs with Black
 Pepper, 170
rice, in Paella with Lamb, 142–43,
 143
Ripert, Eric, 109

risotto:
 Beet and Goat Cheese, *92*, *93*
 cook's notes for, 94
 Grain, with Corn Puree and
 Grilled Corn, 96, *97*
 Parmesan, 94, *95*
rosemary:
 Bacon Mussels, *112*, 113
 Vinaigrette, 166
roux, 115
rum, white, in Thai Basil Cocktail,
 196, *197*
Russian Eggplant, *18*, *19*

S
St-Germain elderflower liqueur, in
 Gurke (Cucumber Cocktail),
 204, 205
salads, 42–63
 Artichoke, with Shaved
 Parmesan, 44
 Asian Slaw, 46
 Asparagus and Prosciutto, with
 Baked Eggs, 52
 Beet, Roasted, with Beet
 Vinaigrette, 60
 Brussels Sprouts, 55
 Cabbage, 107
 Couscous, 120
 Eggplant, Russian, *18*, *19*
 Endive, Grilled, with Citrus
 Dressing, 56
 Lentil, with Ginger-Soy
 Dressing, Afro-Asian Salmon
 with, 102
 Mushroom, Warm, with Apples
 and Celery, *62*, 63
 Quinoa, 58, *59*
 Snap Pea, Migliorelli Farms, 49
 Sushi Bar Wedge, 50, *51*
 Salmon, Afro-Asian, with Lentil
 Salad and Ginger-Soy
 Dressing, 102
 Salsa, Tomatillo, Roasted Corn,
 and Feta, 28
Samuelsson, Marcus, 134
sandwiches:
 Lobster Roll, Ed's, 117
 "Pawlie" Grilled Cheese and
 Pickle, *98*, 99

sauces:
 Apple-Cranberry, 147
 Aromatic, 104–5
 Asian Glaze, 148
 Chimichurri, 137
 Goma-ae (sesame sauce), 154
 Ketchup, Spiked, 139
 Pistachio Tapenade, 146
 see also dressings
sausage:
 Andouille, in Seafood Gumbo,
 115
 Chorizo, Fideos with Mussels,
 Almonds and, 81
 Fusilli with Cannellini Beans,
 Chilis and, 86, *87*
Saxelby, Anne, 99
seafood, see fish and seafood;
 shrimp
sea urchins (uni):
 in Bucatini Ricci di Mare, 82, *83*
 Marinated Hamachi with
 Harissa and Uni, 23
sesame, in Broccoli and
 Cauliflower Goma-ae, 154,
 155
shrimp:
 Ceviche, *24*, 25
 Chipotle Grilled, with Tomatillo,
 Roasted Corn, and Feta
 Salsa, 28
 Seafood Gumbo, 115
 Sushi Bar Wedge Salad with,
 50, *51*
sides, 152–67
 Broccoli and Cauliflower
 Goma-ae, 154, *155*
 Carrots, Spice-Roasted,
 Marrakech Style, 158, *159*
 Cauliflower, Cinnamon-
 Scented Tomato-Braised, 157
 Couscous Salad, 120
 Latkes with Apple Puree and
 Sour Cream, 162, *163*
 Lentil Salad with Ginger-Soy
 Dressing, 102
 Potatoes, Smashed, with
 Rosemary Vinaigrette, 166,
 167
 Purple Potato Gratin, *164*, 165

Radishes, Whole Roasted, with
 Anchovy Butter, *160*, 161
Vegetable Marinère, 104
Simple Syrup, 206
skewers:
 Lamb, Spiced, *144*, 145
 Stuffed Dates Wrapped in
 Bacon, *32*, 33
Skirt Steak Tortilla with
 Chimichurri Sauce, 137
slaws:
 Asian, 46
 Cabbage Salad, 107
Smalls, Alexander, 102
snails, in Paella with Lamb, 142–43,
 143
Sohm, Aldo, 122
Soufflés, Comté Cheese, Twice-
 Baked Upside-Down, 40–41
soups, 64–77
 Cauliflower, with Capers and
 Black Olives, 70
 cold, cook's notes for, 66
 Corn, Cold, 66
 Crab, Serena, 76, *77*
 Lentil, with Pancetta, 74
 Mushroom Bouche, 75
 Squash, Fall, 72–73
 Strawberry Gazpacho, 67
 Tomato, Warm, *68*, 69
South American flavors:
 Shrimp Ceviche, *24*, 25
 Skirt Steak Tortilla with
 Chimichurri Sauce, 137
soy:
 dressing, 63
 Ginger Dressing, 102
Spaghetti with Butter and
 Anchovies, *90*, 91
Spanish flavors:
 Fideos with Mussels, Chorizo,
 and Almonds, 81
 Paella with Lamb, 142–43, *143*
 Stuffed Dates Wrapped in
 Bacon, *32*, 33
spelt, in Grain Risotto with Corn
 Puree and Grilled Corn, *96*,
 97
spice(d):
 Chermoula, 121

Lamb Skewers, *144*, 145
 -Roasted Carrots Marrakech
 Style, 158, *159*
spinach:
 in Lentil Salad with Ginger-Soy
 Dressing, 102
 in Poached Wild Striped Bass
 with Tomatoes, Potatoes, and
 Bacon, 110, *111*
Squab with French Lentils and
 Cabbage, 131
Squash Soup, Fall, 72–73
Squid Stuffed with Pork in Lime
 Broth, 30–31
Stephens, Francine, 86
strawberry:
 Gazpacho, 67
 Jam, Pickled, 192
streusel crumbs, 170
Striped Bass, Poached Wild, with
 Tomatoes, Potatoes, and
 Bacon, 110, *111*
sugar snap pea(s):
 Calves Liver with Bacon, Maple
 and, 150–51
 Salad, Migliorelli Farms, 49
Sushi Bar Wedge Salad, 50, *51*
sweet potatoes, in Lentil Salad with
 Ginger-Soy Dressing, 102
syrups:
 apple, 198
 honey, 201
 Simple, 206
 wine, 170

T
Tapenade, Pistachio, 146
Tarte Menton, 38–39, *39*
tea, in Earl Grey Crème Brûlée,
 185
Telepan, Bill, 52
Thai Basil Cocktail, *196*, 197
Thai Fighter Ice Cream
 Sandwiches, 190–91
Thai flavors: Squid Stuffed with
 Pork in Lime Broth, 30–31
Thompson, Gabe, 56, 125
toasting nuts, 157
Tomatillo, Roasted Corn, and Feta
 Salsa, 28

tomato(es):
 -Braised Cinnamon-Scented
 Cauliflower, 157
 Poached Wild Striped Bass with
 Potatoes, Bacon and, 110, *111*
 Russian Eggplant, *18*, 19
 Seafood in Bouillabaisse, 114
 Soup, Warm, *68*, 69
 Tarte Menton, 38–39, *39*
Tortilla, Skirt Steak, with
 Chimichurri Sauce, 137
Tosi, Christina, 192
Truffle Paste, in Forager's Treasure
 of Wild Mushrooms, 34
Tuna Tartare, 26, *27*

U
Uni, Marinated Hamachi with
 Harissa and, *22*, 23

V
Valenti, Tom, 131
Vanilla-Coconut Pudding, 175
veal, in Frankie's Meatballs, 140
Vegetable Marinère, 104
vinaigrettes, 52, 55
 Beet, 60
 Herb, Warm, *108*, 109
 Rosemary, 166
vodka, in Gurke (Cucumber
 Cocktail), *204*, 205
Vongerichten, Jean-Georges, 104

W
White, Michael, 75, 166
wine, red:
 in Magret à la d'Artagnan, 128
 –Poached Figs with Black
 Pepper, 170
 syrup, 170

Z
Zakarian, Geoffrey, 201

First published in the United States of America in 2015
by Rizzoli International Publications, Inc.
300 Park Avenue South
New York, NY 10010
www.rizzoliusa.com

Photographs © 2015 Noah Fecks
Page 6: Photograph © Benjamin Norman
Page 7: Photograph © Michael Ian
Page 9: Photograph © Nigel Parry

2015 2016 2017 2018 / 10 9 8 7 6 5 4 3 2 1

Distributed in the U.S. trade by Random House, New York
Printed in China
ISBN-13: 978-0-8478-4622-1

Library of Congress Catalog Number: 2015935640

MARC HAEBERLIN

EMERIL LAGASSE

PAUL BOCUSE

ANDRÉ SOLTNER